Double Vision

Christopher Weston

Double Vision

Nigel Hicks

GUILD OF MASTER CRAFTSMAN PUBLICATIONS

First published 2002 by
Guild of Master Craftsman Publications Ltd,
166 High Street, Lewes,
East Sussex, BN7 1XN

ISBN 1 86108 278 9

A catalogue record of this book is available from the British Library.

Cover and book design by Phil and Traci Morash of Fineline Studios

Typeface: Myriad

Colour origination by Viscan Graphics (Singapore)

Printed in Hong Kong by H & Y Printing Ltd

Dedication

For Claire, you are the passion that makes my
spirit dance, and for Leo: you touched our lives
for just a moment and left memories that will
last forever.

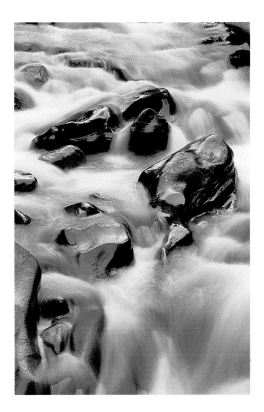

Acknowledgements

This book would not have been possible without the help of others. I would particularly like to thank Claire for not giving up on me; my father for his honesty and my mother for her support; the staff at GMC Publications for their patience and belief; Steve Knight at Okefenokee Pastimes for his stamina; Marius for his alpine expertise and encouragement; Ann and Don Speedy for their guidance and hospitality in New Zealand, and Lakeside Aviation for a turbulence-free flight; Jane Nicholson and the staff at Intro2020 for their continued support; and, finally, special thanks to David, my sometime assistant and long-time friend… for everything.
I am indebted to you all.

Chris Weston

The photographs I have included in this book were, for the most part, taken over a number of years for a variety of projects and in a range of locations. The number of people who helped to make all of them possible are just too numerous to list by name, but include: my Tibetan companions who drove me in a rickety jeep across Tibet, the staff of Dragonair who flew me between Hong Kong and a host of points across China and Japan for free; the Hong Kong and Philippines branches of the Worldwide Fund for Nature; Fauna and Flora International; rangers at Yushan National Park, Taiwan; and staff at the National Integrated Protected Areas Programme and the Protected Areas and Wildlife Bureau in the Philippines.

Nigel Hicks

*C*ompared with painting, photography might seem too mechanical an art form, too hedged in by its limitations of physics and chemistry, and the burdens of its cumbersome instruments, to inspire truly creative work. Yet paradoxically, these very limitations are its strength. Because the camera's lens draws light with unfailing accuracy time after time, photographers cannot rely on the flourishes of their own handiwork, or the intrinsic inconsistencies of water, oil, pigments or pencil to determine their individual style.

Ultimately, the photographer can only achieve self-expression through originality of vision. Whereas the landscape painter can choose to work in front of the landscape, or in the comfort of the studio from sketches and photographs, the landscape photographer has no choice but to witness the facts of light. These facts are interpreted through choice of viewpoint, high or low angle, selection of lens (and consequently, perspective), balance of composition, moderation of tone and colour through filter selection, type of camera used, the moment of exposure selected, and so on. Numerous decisions must be made and, at its best, this is a process of the utmost artistic and

intellectual rigour. While further aesthetic options lie at the printing stage, the fieldwork is the crucial element. The fact that the photograph may in the end be exposed in a fraction of a second does not, in my view, diminish it as an art form compared with painting. There is no less creative endeavour involved, it is just different.

Having led photographic courses for some years now, I have taken people to the same place and have yet to see two people produce an identical photograph. There are an infinite number of photographs that can be taken of the natural world, and no-one sees it in exactly the same way. Double Vision illustrates this truth with a gallery of wonderful photographs by two fine photographers. For many, the photographs alone will make the point, and give hours of pleasurable viewing as Chris Weston and Nigel Hicks conduct us on a tour of some of the world's most spectacular landscapes. There is a section on equipment to guide those aspiring to follow in their footsteps, but the real fascination of this book lies in the words that accompany the images.

Insights into the geological, climatic and environmental background of these landscapes are welcome, but more

fascinating still is to discover the motives and emotions that drove the authors in their landscape encounters. With confidence, passion and enthusiasm, both photographers share their thoughts and feelings on the symbolism intrinsic in particular images, the emotional power of light, and how camera and lens were used to strengthen or emphasize the potential qualities of each place.

Landscape photography is about many things – the open space and natural beauty that make landscape a spiritual resource, the relationship of people to the land, the cycles of the seasons, the power of the elements, and so on. But in this intriguing collaboration, Chris Weston and Nigel Hicks also show us that landscape photography is about the desire for self-expression, and how photographing the natural world can help deepen our respect, love and appreciation for it. In this respect at least, they speak as one.

Joe Cornish

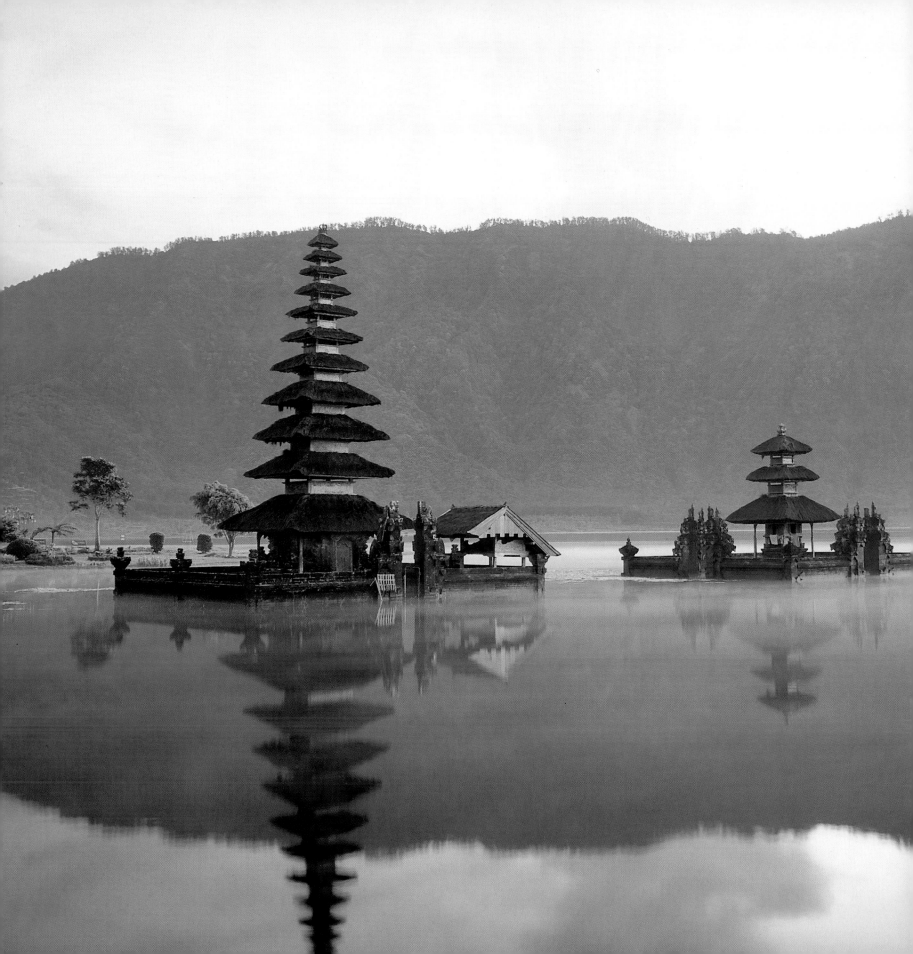

contents

nh Ulu Danau Temple,
Lake Bratan, Bali, Indonesia

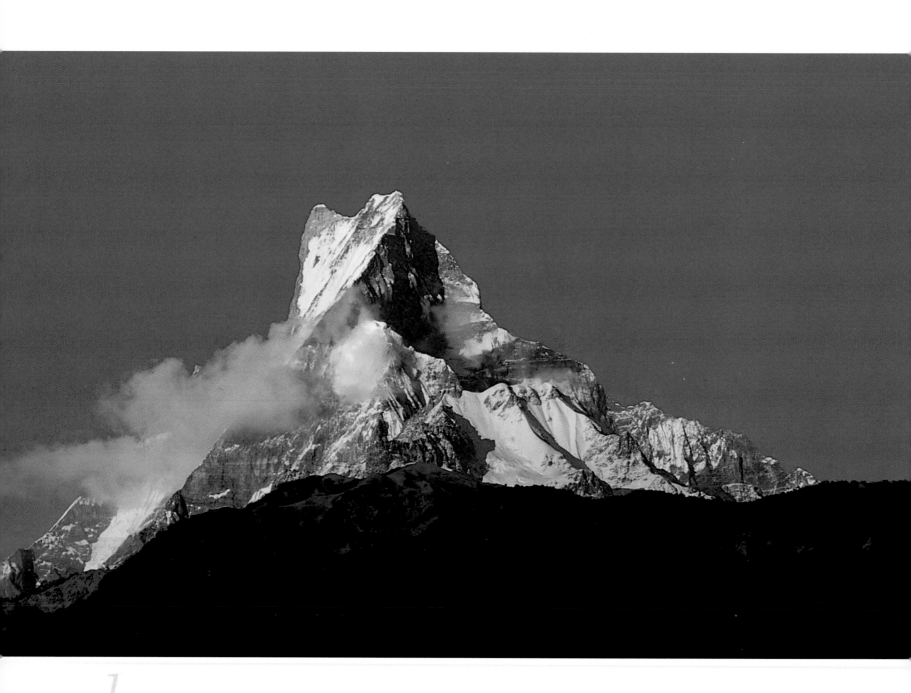

nb Macchapucchre (the Fish
Tail Mountain), Annapurna, Nepal

*T*ake two photographers and put them in the same place at the same time and the pictures they take will often be quite different. This is because we each view the world in a unique way. What we see with our eyes is coloured by life's experiences, our preconceptions and desires, our memories and passions. Like photographic filters that change the light entering the lens, these emotional filters change the landscape we see and inform our interpretation of it. Capturing powerful, emotive photographs is dependent on our ability to interpret what we see in our mind's eye, and translate that emotion onto film through aesthetic composition and the creative use of light. Without that ability, no camera, however sophisticated, can take a compelling image.

In this book, we have taken pre-defined natural themes and include a single image each per theme to show how both our minds and senses affect the kinds of pictures we take. Without being overly technical, we describe how we approach the subject; what influences us in our decision-making; and how we combine the intricacy of light, the rules of composition and camera technology to record our images on film. We do not pretend that our respective approaches to photography are the *best* ways to photograph a subject. Rather, what we hope to show – whether you are new to photography or a seasoned practitioner of the art – is that the best way to photograph a subject is *your own* way and, in the process, divulge a secret or two to help guide you.

The themes we explore in this book are generic to landscape photography. While many of our pictures have been taken around the globe, no subject is unique to a particular country and most can be found close to home. Forests to rivers, seashores to valleys, waterfalls to the sky above – these themes are familiar to everyone. What is consistent about each of them is their ability to move us if we are willing to allow them into our souls.

No doubt you will have your preferences, as did we. An interesting result of writing this book is that we have an enhanced appreciation of the type of landscapes that attract us most. Equally, the challenge of photographing subjects less close to our heart proved absorbing and, in meeting that challenge, has improved our own skills. The lesson here is that we should, at all times, aim to stretch ourselves creatively. Only by working outside our comfort zone do we really discover our true photographic potential.

It has also become apparent to us both that many of the images we selected for the book would fit alternative themes as well, thus highlighting another facet of landscape photography. Unlike the painter who starts with a blank canvas and builds a picture by adding elements, photographers start with a complete image and then subtract those parts that detract from the composition in order to focus the viewer on the subject as it is perceived. By choosing specific images for certain themes – even though they could have been chosen for others – we make a personal statement. As Freeman Patterson once said so eloquently, 'The camera always points both ways. In expressing the subject, you also express yourself.'

Successful photographs are not made by chance. Nor are they made by the camera alone. Powerful, compelling images are made when we combine artistic and technical skills with an efficacious appreciation of the subject. Nature and the landscape touch our senses in innumerable ways: by the thunder of towering waterfalls, the rainbow colours of a flowering meadow, the pungent aroma of sulphur from a geothermal spring, the taste of morning dew in the air, the texture of sand on naked skin. There are an infinite variety of natural phenomena that fill our imaginations and invite each of us to spend a moment in their midst.

This book is the story of the time we have spent dancing with nature; a magical journey that has assailed our senses. Share in our discoveries and catch a glimpse of the landscape through our minds' eyes.

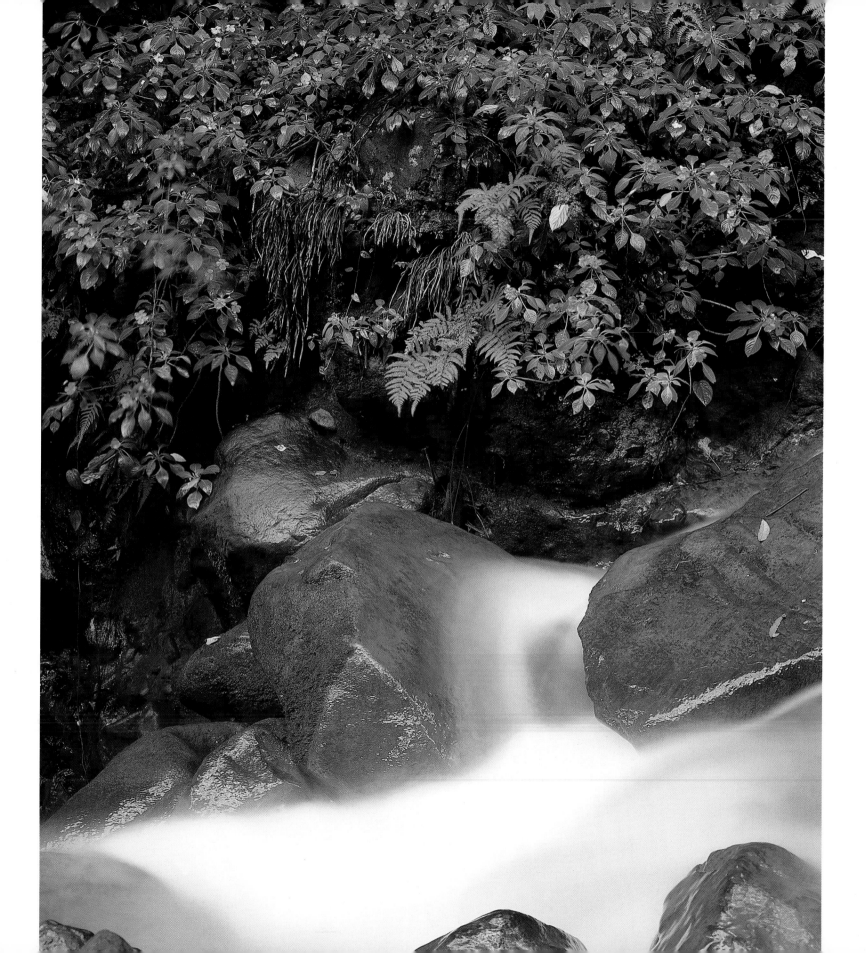

Selecting the right cameras, lenses, film and accessories for landscape photography is an important part of turning one's visions into successful images. But remember, they are simply tools. With the pressure of advertising and ever-changing trends, we are subject to the dangers of having to keep up-to-date with the latest technological wizardry, the camera of the moment. Do not be seduced by this; cameras are a means to an end, not the end in itself.

Choosing a camera

When considering the type of camera you need for any photographic specialism, you need to think about its main criteria; this will help you identify the features you need. When it comes to landscape photography, you should consider the following:

➤ you will often be shooting subjects that, while essentially static, may be subject to changing lighting conditions

➤ parts of the subject may be moving, such as flowing water or plants blowing in a breeze

➤ you will often need to use a series of filters, such as polarizers and graduated filters

➤ you may often have to shoot in very low light conditions

➤ many publishers or advertisers who want to use your work still expect images to be on medium-format film, not 35mm, despite the improvements in film technology in recent years

➤ you may need to carry your camera equipment long distances over rough terrain

➤ you may be exposed to difficult weather conditions while on location

If you were to take all of the above into account, the ideal camera would need to:

➤ be very easy and quick to set up
➤ have sensitive and accurate light metering
➤ have a very wide range of shutter speeds
➤ shoot on medium-format film
➤ be light and portable
➤ be easily handled, even with very cold fingers
➤ be impervious to the elements

Unfortunately, such a camera does not exist. As with many things, choosing the right camera amounts to deciding which compromises you can live with.

On the face of it, the most obvious camera to choose might be a medium-format rangefinder model. Much lighter and more portable than the chunky reflex cameras that allow you to see the view through the lens, they provide medium-format images quickly and efficiently. But, crucially, they fail the filter test; it is very difficult to use graduated filters on a rangefinder camera, so landscape photographers usually stick to reflex cameras and put up with the extra weight, although many use the larger 5 x 4in format cameras. These produce superb images but they are comparatively slow to use, and the film is more expensive.

nb Yangmingshan National Park, Taiwan

3

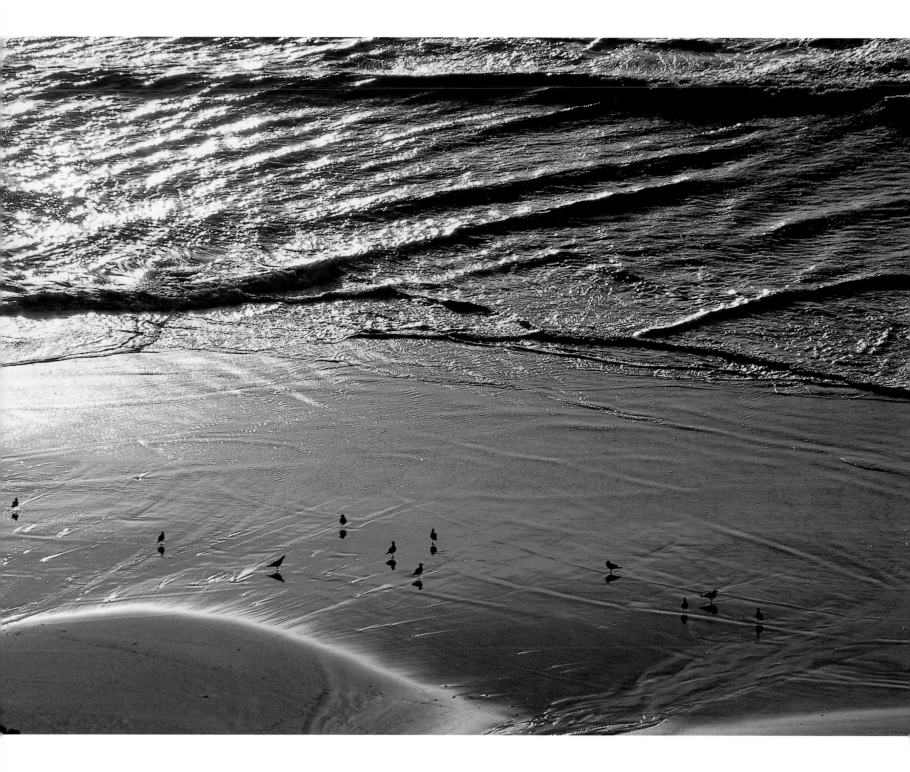

Most medium-format reflex cameras are quite heavy and may present problems if long-distance hiking is required. Travel on long-haul flights may incur excess baggage charges which can cause serious wallet damage. Presented with the problem of weight, there is an irresistible temptation to stick with the trusty 35mm camera and risk the incredulity and exasperation of picture editors and designers when presented with 35mm format shots rather than medium-format. The 35mm camera fits all the desired criteria, except that it doesn't generate medium-format quality images.

Choosing lenses

Whichever camera you opt for, it is important to remember that in terms of image quality, the camera body is secondary to the lenses. The body is simply a black, light-tight box for holding and advancing the film and metering the available light. If budgets are tight, funds should be concentrated into buying the best lenses possible. The primary considerations when choosing a lens are the following:

➤ it should produce images that are pin-sharp, not just in the centre, but right across to the outer edge of the frame, something that is not as obvious as one might think
➤ the pictures must be 'punchy', with the right amount of contrast; poor-quality lenses produce rather flat, dull images

➤ it must deliver accurate colour rendition; failure in this respect is not always down to the film
➤ when shooting towards the sun, there should be an absolute minimum of flare; this is normally reduced with coatings on the lens elements
➤ whether to have a zoom or fixed-focal length lens
➤ whether to have autofocus or manual focusing

With medium-format cameras, choosing between zoom and fixed-focal length and between auto- and manual focusing is quite straightforward. Despite recent developments, zoom lenses are still relatively few and there is only a limited range of autofocus models on the market. Besides, autofocus is not generally crucial for landscape photography; light and environmental conditions may change unexpectedly, but essentially the subject remains a consistent, static distance from the camera.

When it comes to 35mm cameras, it is almost impossible to buy one these days that does not have an autofocus facility, and zoom lenses are more or less standard. Zoom lenses offer immense flexibility when framing the subject, and greatly reduce the number of lenses you would otherwise have to carry. However, there are a couple of limitations you should keep in mind. The minimum focusing distance on a zoom lens is usually longer than that on equivalent fixed-focal length lenses; this might be an important consideration for someone doing

nb Near Bedruthan Steps, Cornwall, UK

lots of close-up work. Additionally, the minimum f-number on a zoom lens is generally not as low as that of a fixed-focal length lens, which may be an important consideration for low-light photography. Many consumer lenses have a minimum f-number of only f/5.6, which is simply not low enough for professional work – even landscape photography – so it is important to buy one that goes as low as f/2.8.

Filters

A polarizing filter is an essential item in every landscape photographer's kit. It is good for removing reflections from leaves and water and for strengthening and improving the contrasts in colour on sunny days. Green vegetation can often look rather blue without a polarizer. With one mounted to the front of the lens, many reflections disappear, and the vegetation takes on the same dynamic, vivid green in the final image that you saw with your eyes.

The degree of polarization can be varied by rotating the filter on the front of the lens, thus giving control over the intensity of its effects.

Warming filters: the lightly pink 81A, 81B and 81C filters are very useful for removing the overall blue cast on images shot either on bright overcast days or in areas of shadow in otherwise sunny weather.

Graduated filters, especially graduated neutral density filters, are another essential accessory, particularly where one part of a view is considerably brighter than the rest, such as a view of a bright, but overcast sky above a poorly lit landscape. Without a graduated neutral density filter, either the sky will be massively overexposed and devoid of detail, or the landscape will be lost in darkness. In this or similar situations, a graduated filter sufficiently dims the image's brighter elements, making the exposure more balanced across the whole image.

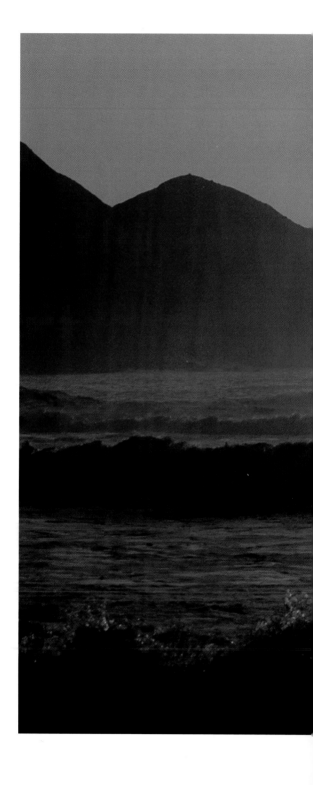

 Crackington Haven, Cornwall, UK

While this was shot straight into the sun, the image is completely free of flare, partly due to the high-quality lens.

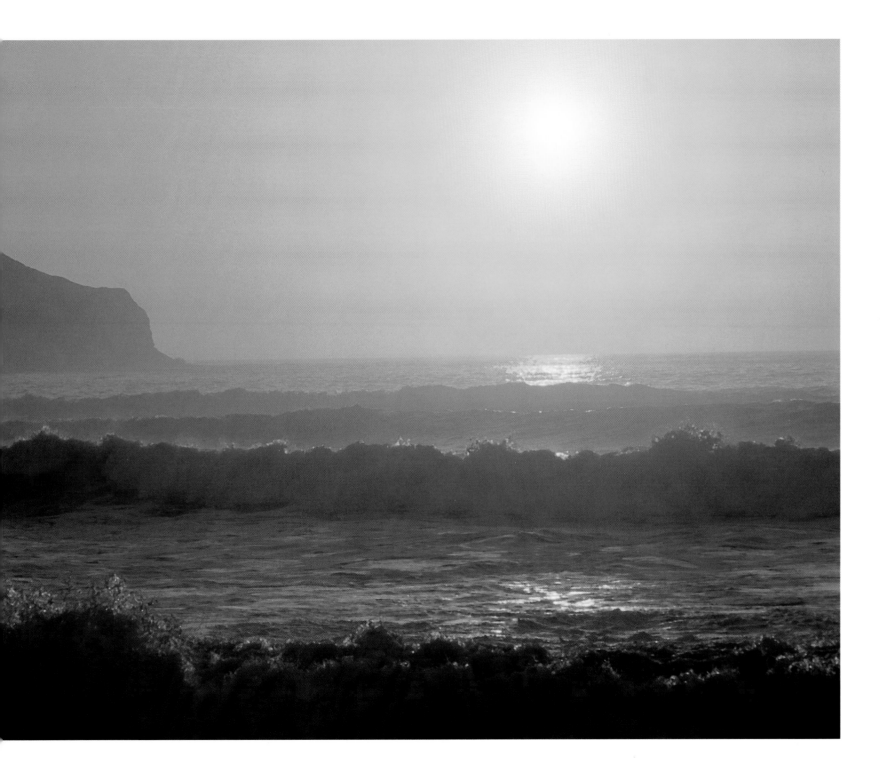

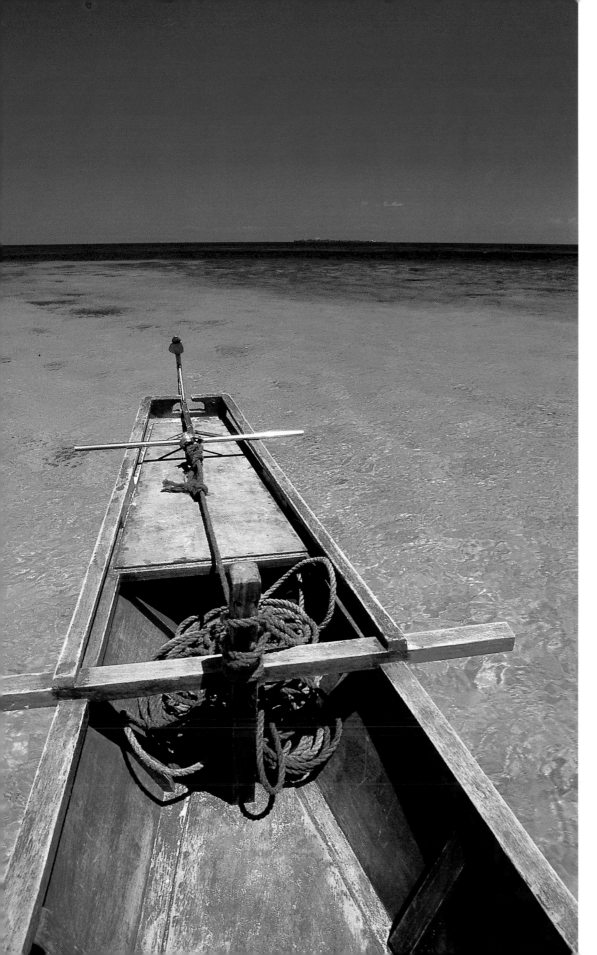

Apo Reef Marine Natural
Park, Mindoro, Philippines

A polarizing filter is very effective on a brilliantly sunny day. The reflection coming off the water has completely disappeared, leaving only stunning blues and making the seabed visible.

Lake District National Park, Cumbria, UK

Warming filters help to remove the blue cast caused by bright, overcast sky or heavy shadow.

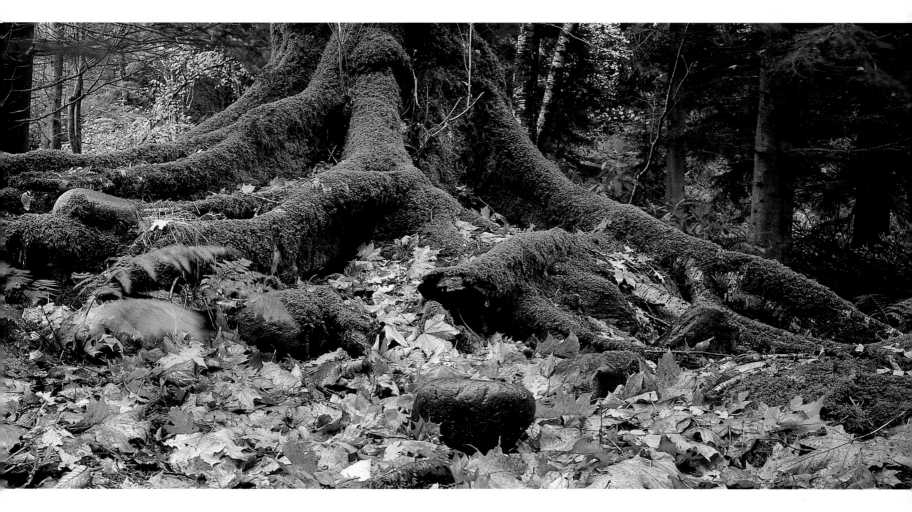

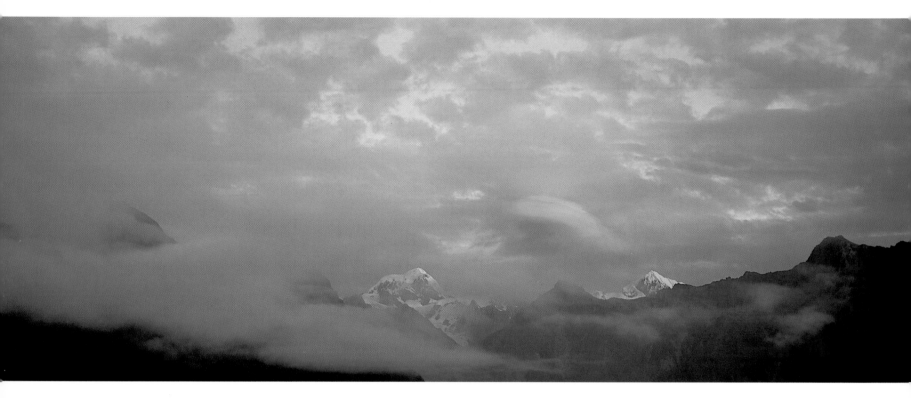

Tripods

The final word on equipment is the tripod. No-one likes to heave a tripod around with them, but for landscape photography it is absolutely essential. Most medium-format cameras require a tripod, simply because they are too heavy and cumbersome to be used handheld. Even a 35mm camera should be fitted to a tripod to ensure the images are as sharp as possible; an essential step to overcoming editorial objections to images that are not medium-format.

Many landscape images require a great depth of field to ensure that subjects near to the camera are just as sharp as something on the horizon. Achieving this means using a narrow aperture – at least f/16 – which requires a slow shutter speed. This makes a tripod essential, even for a 35mm camera.

Film

The first consideration when selecting the right film is whether to use transparency or negative film. The majority of professional photographers working in the publishing world opt for the former because it has better colour saturation, and is the industry standard.

CW Aoraki/Mount Cook, Mount Cook National Park, South Island, New Zealand

Graduated neutral density filters help to even out the tones between a light sky and dark foreground.

The second consideration is which brand of film to use; usually either Kodak or Fuji. Don't believe the myth that all films are pretty much the same; they certainly are not. In my view, Fuji films produce better greens than Kodak, and have an overall 'warm' cast compared to the colder 'bluish' cast characteristic of Kodak films. These days, because of its colour quality, Fuji transparency films dominate the market for outdoor photographers, although Kodak's latest products have made headway to close the gap.

A third consideration is film speed. One might assume that the faster the film, the better; that this will mean faster shutter speeds, narrower apertures, greater depth of field, greater ability to shoot in low light conditions, and less need for a tripod. Alas, life is not that simple, especially when shooting with transparency film. The sharpness of the final image depends not just on the quality of the lens or on the accuracy of one's focusing, but also on the film's grain: the size of the crystals that generate the shapes and colours in the picture. The larger the grain, the coarser the resolution. Unfortunately, grain size increases with film speed, particularly with transparency film. To minimize film grain and thereby maximize the sharpness of an image, it is important to use the slowest film possible.

For landscape photographers shooting primarily static subjects, most often with the camera mounted on a tripod, a slow shutter speed is not a problem; they can use 50ASA or even 25ASA films. However, film quality is improving all the time, particularly the grain, making it possible to use faster films.

These days, it is rare for photographers to need to use 25ASA film; even Fuji's popular 50ASA Fujichrome Velvia – the film which captured the outdoor photography market for Fuji – is less prominent. Recently, Fuji has developed a new generation of fine-grained films, including a 100ASA film called Fujichrome Provia 100F, which is at least as fine as the slower Velvia. And, until very recently, it was impossible to do fine-resolution photography with a transparency film faster than 100ASA, but a 400ASA film is now available with a grain fine enough to produce quite acceptable results for many uses.

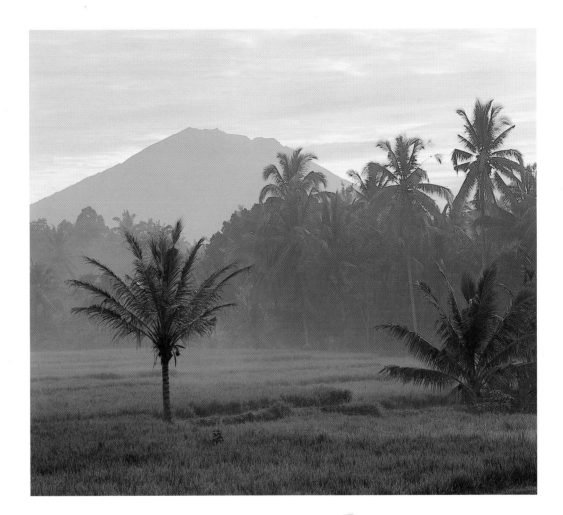

nb View to Mount Agung, Bali, Indonesia

The soft lighting, just after dawn, is caught beautifully by Fujichrome Velvia.

Digital photography

This chapter would not be complete without some discussion of digital photography. While digital cameras reign supreme in news and sports photography where speed of delivery is of the essence, for subjects like landscape photography, image quality is paramount. At present, there is no portable digital camera on the market capable of achieving the high resolution and tonal range and, therefore, image quality, that is standard with film. Digital cameras are improving rapidly and they may eventually achieve the desired quality, but with film also continually breaking down the quality barriers, digital technology is chasing a constantly moving target.

However, where digital is increasingly important is in the field of scanning to disk images originally shot on film. Using the technology for this purpose, it is possible to generate high-quality digital images, and this is becoming an increasingly important part of many photographers' work. While many scanners are capable of generating digital images of sufficient quality for print production, only the best drum or dedicated film scanners are good enough for publishing's exacting standards. A scanner must be capable of both scanning at high resolution and of resolving all the tonal ranges found on film, something that until recently has been difficult to achieve in equipment affordable to photographers. Progress with dedicated film scanners has recently brought this work within the remit of the landscape photographer.

Choosing the basic kit

Within the framework outlined above, there is plenty of leeway for individual preferences for equipment and film, and it sometimes takes many years of experience before one's basic photographic kit is honed down to a few favoured essentials. The section that follows outlines our own preferences which will, perhaps, give you some foresight when planning your own.

nb

Nigel Hicks

I confess now that I really cannot bear to carry a tripod all the time and, over the years, have become heartily tired of hauling a medium-format camera, too. That said, the owner of the first photo library I ever worked for so thoroughly impressed upon me the importance of putting images onto 120mm film as opposed to 135mm film, that I have persisted with larger, heavier cameras, albeit with occasional rebellions, ever since. I have a similar relationship with tripods. One of the first picture editors I worked with hammered into me the absolute importance of pin-sharp images. Regardless of the present penchant for fuzzy images in fashion and advertising photography, for the vast majority of outdoor photography getting a pin-sharp image is king. It does not matter how well-composed an image of Mount Everest may be; if it is not sharp, it will not rate a second glance from a picture editor. At the commercial level, this means lost sales;

the picture editor will choose the images of my competitor, not mine. At the personal level, it means my own loss of pride and confidence in the quality of my work.

That is not to say that I never shoot with a 35mm camera. I certainly do – because landscape photography is not my only specialism. Shooting with a 35mm camera is undoubtedly faster and more flexible than almost any medium-format camera. With 35mm, I can grab shots in a rapidly changing situation, whether the subject is people, wildlife, events or landscape. And the equipment is much more compact and lightweight than with medium-format. There have been many situations when, confronted with a plan to head into some remote region, I simply cannot face the prospect of carrying an unwieldy, heavy, medium-format camera and have opted instead for the lighter 35mm.

There have been many occasions, however, when, having shot a view on 35mm film, I see the images and wish that I had used medium-format, with the knowledge that the larger image would look even more spectacular than it does on 35mm (and would therefore sell better!). So, on the whole, I continue to work with the larger cameras, even though this usually means having to travel with both 35mm and medium-format equipment: a combination that can add up to a hefty pile, conducive neither to minimizing excess airline baggage nor to long-distance hiking!

In terms of using a 35mm camera, most professional photographers opt for Canon or Nikon and, once the choice is made, it is

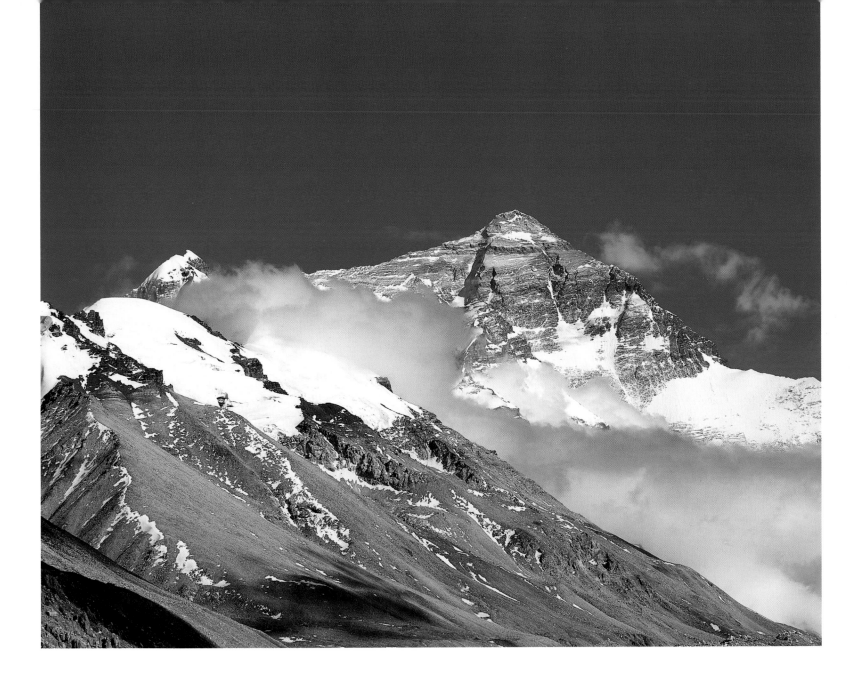

usually the cost implication that dissuades from making a later switch to the other brand. I chose Canon right at the beginning of my professional career, and this rested on two principal facts: firstly, that the choice of lenses available at the time more closely suited the kind of work I wanted to do, and secondly, that the top-of-the-range Canon camera bodies were a lot lighter and more compact than the equivalent Nikon bodies. The latter still seems valid today. When I made the change from manual to autofocus cameras, I could have bought a Nikon, but stayed with Canon, again because of the more compact body, but also because it was widely recognized that Canon's autofocusing system was superior to that of Nikon.

nb View of Mount Everest from the north face base camp, Tibet

The detail in this view of Mount Everest in evening sunlight is captured beautifully on my Mamiya 6 x 7cm format camera.

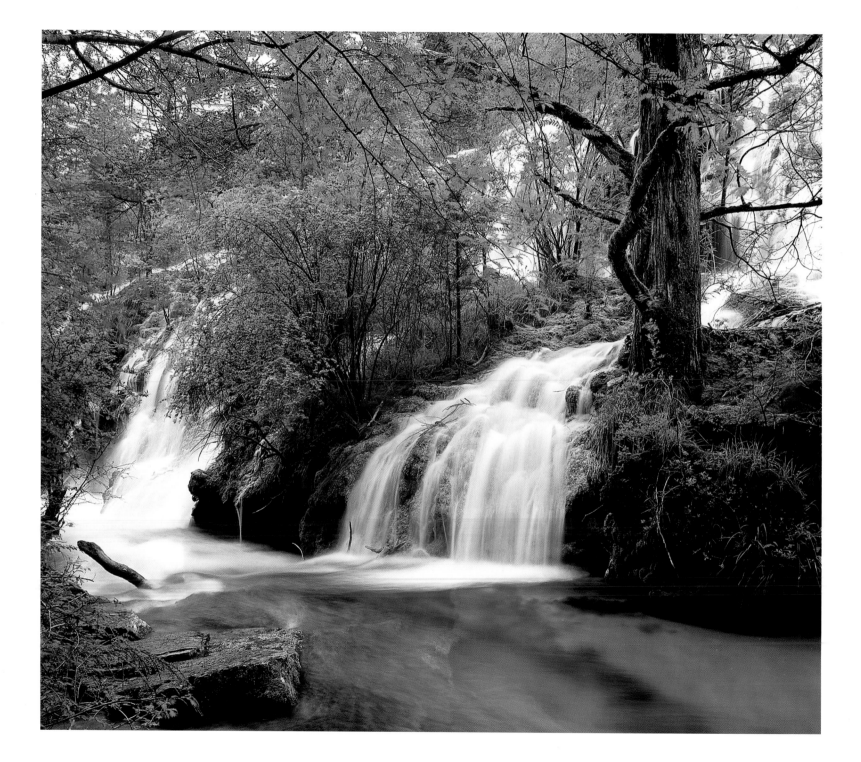

My first medium-format camera was an ancient Mamiya RB67: a chunky, 6 x 7cm format camera, obtained from the father of a friend while I was living in Japan. It served very well as an introduction to the world of medium-format photography and launched my career as a professional landscape and travel photographer. It finally died while in Tibet, just as I was finishing a series of spectacular evening shots of Mount Everest; its mechanical failures no longer worth the cost of repairs. The images it produced, however, were pin-sharp and have subsequently sold again and again.

Hooked on Mamiya's 6 x 7cm format reflex cameras, I replaced my old RB with a considerably more up-to-date RZ camera. The essential difference is that the RZ is electronic, while the RB is mechanical. This, of course, put me at the mercy of battery or other electronic failures while out in the wilds, and I really should have opted for another RB camera. However, the RZ has a wider choice of lenses and accessories than the older RB system, which has been

shrinking steadily in recent years. The RZ, like the RB, is a large and cumbersome camera. It is really meant for use in a studio, not hauling across vast countries such as China. Yet, no other camera in the 6 x 7cm or 6 x 9cm formats seems to be as versatile. It has a good range of lenses that cater for macro through wideangle to long telephoto photography, and the standard lens has an incredibly short minimum focusing distance, enabling close-up photography with minimal macro equipment. The weight does make it difficult to use in a hurry, and is tiring to carry at the same time as 35mm equipment (which I often need for urban, people or wildlife photography).

Over the past couple of years, I have made it my goal to overcome the problem of utility versus weight. After considering a number of options, including rangefinder cameras, I have recently started using a Mamiya 645 camera, which produces images with 6 x 4.5cm dimensions, and have found it to be the ideal compromise. It still provides medium-format images on

120mm film, but its smaller size and weight makes it infinitely more portable, and quicker and easier to use. I have found it possible to use it almost like a 35mm camera, including hand-held for fast-moving situations, although its squarish shape makes it less ergonomic than a 35mm camera.

The downside, however, is the smaller image size compared to the 6 x 7cm format, but recent film improvements have reduced the advantage of the larger medium-formats, making them less important.

In terms of film, I was a very early convert to Fujichrome for the superb colours it gives landscape images, at a time when most publishers and agencies were still asking for images on what was then the leading film: Kodachrome. In those early Fuji years, I had numerous arguments with picture editors and other photographers over the relative merits of Fuji or Kodak films, but the advent of Fujichrome Velvia, a superbly fine, colour-saturated film, brought most of the profession over to my side.

nb Pearl Shoals Falls, Jiuzhaigou Nature Reserve, northern Sichuan province, China

Today, I use Fuji's latest range of Provia F films. The 100ASA Provia 100F film is at least as fine as Velvia, possibly finer, and it is, of course, a full stop faster; something that can make a crucial difference in conditions where both a large depth of field and a reasonably fast shutter speed are required.

The latest 400ASA Provia 400F film is a major improvement over earlier 400ASA films, but for 35mm work I have found it to be still a touch too grainy for really great landscape photography. However, when used in the medium-format camera, where the larger 120mm film makes the grain size less significant, it produces quite acceptable results. In truly bad conditions, such as a raging storm, it can make the difference between obtaining an image that works and no image at all.

Thus far, I have dismissed digital cameras, but have been using a Nikon film scanner for digitization of film-originated images. Such fast-changing technology means that I will soon have to update it to allow me to generate very high-quality digital files. Although most of my work with publishers still revolves around transparencies,

the importance of digital technology is steadily increasing, mostly in the field of on-line photo libraries. It is quite possible that, as scanning technology improves and a greater proportion of my work involves digital images, so the need for medium-format camera equipment will diminish – something I look forward to very much.

Chris Weston

I am no better than most when it comes to photographic equipment. I love buying it and I love having it, though there are times when carrying it that I wished I owned less!

My photography has improved the more I have understood the equipment and material I am using. Now, rather than being a kind of passive bystander to my image-making, film and equipment play an integral part in the creation of the final photograph.

My kit bag contains several cameras and lenses. Each, however, has a specific role. My preferred format is the standard 35mm. This is due, in part, to having grown up with 35mm cameras (my first serious camera was

a Nikkormat) which means I am familiar with the format and the equipment that is reassuring in the field when I am under pressure to get the right shot. Equally, the versatility of the 35mm format makes it an ideal medium for handling the diverse challenges I face, combining landscape photography with wildlife and natural history photography. On an assignment that might combine all three elements, it is easier to carry one camera format that will cover each with minimal sacrifice to vision.

Having said that, there are times when I use a different format camera. For example, the photograph of the waterfall on page 56 was deliberately shot using a panoramic format camera to enhance the impression of majesty that the falls demanded. Similarly, for the photograph of the Emerald Lake in New Zealand on page 50, I wanted to emphasize the colour in its environment. The panoramic format helped to achieve this by allowing me to include more of the surrounding landscape than the standard 35mm frame would permit. Comparing the two images, the panoramic format recreates the vista as I saw it with more realism.

Emerald Lakes, Tongariro National Park, North Island, New Zealand

The standard 35mm format simply did not do justice to this landscape in the way the panoramic format did (see page 50).

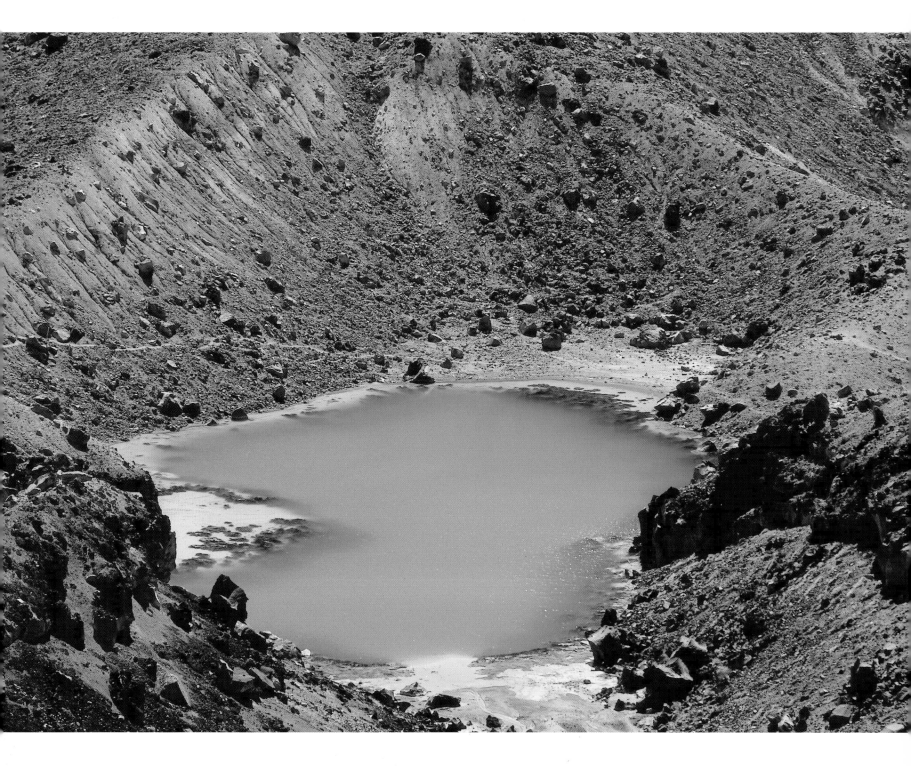

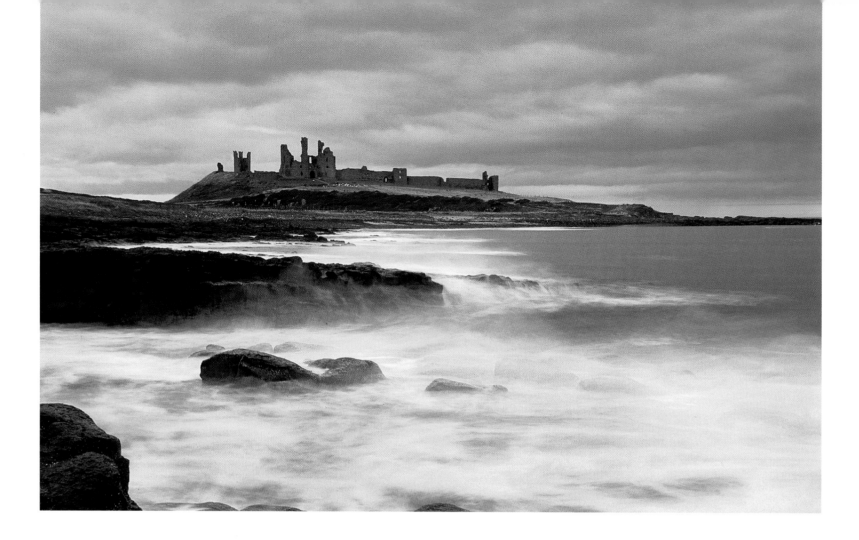

Dunstanburgh Castle, Dunstanburgh, Northumberland, UK

A 24–120mm zoom lens adds versatility to my kit bag when travelling light or, as with this shot, if my movement is restricted. The incoming tide kept me from my preferred shooting position.

Increasingly, I am beginning to use medium-format cameras for landscape photography. There are two factors that encourage me to do so: firstly, the purist in me argues, quite convincingly, that the larger area of a medium-format transparency creates a much sharper image than 35mm, particularly if an enlargement of the final image for publication is a key consideration. Most publishers favour medium-format over 35mm. As a professional photographer, it is important that I give my pictures the best chance of being sold and medium-format helps to achieve this. Even so, the limitations of medium-format – particularly large

medium-format (6 x 7cm and 6 x 9cm) – such as the extra weight and speed of use caused by fewer lens options, means that, currently, 35mm is still my preferred choice for everyday work.

Ultimately, the most important consideration when choosing a camera is that the image and the environment dictate your choice rather than vice versa. Good photographs are taken by good photographers, not by cameras. By being in control of the picture-taking process, which includes having an understanding of how different formats affect the final image, you can ensure you achieve high standards in your photography.

The lenses I use vary from 20mm wideangle to 400mm telephoto. As with my choice of format, my choice of lens is dictated by the image I want to create, or by my environment. Again, the quality of my photography has improved with a better understanding of how different focal lengths affect the image.

I use prime lenses where possible; I believe their quality to be superior to that of zoom lenses. However, I do carry a single zoom lens for versatility – a 24–120mm wideangle to short telephoto zoom – that I use for critical framing when the environment restricts my movement, and also as a general-purpose lens when travelling light: an increasingly rare occurrence.

Of accessories I use, I cannot emphasize enough the importance of using a tripod. I never work without one and almost all of my photographs in this book were taken mounted on one. The considerations for selecting a tripod are that it be sturdy and light – in that order. I once made the mistake of buying a lightweight, but less sturdy tripod only to have it fall over, breaking a particularly expensive lens. Modern carbon-fibre tripods combine sturdiness and lightness and I now use one when hiking with equipment for long periods.

Tongariro National Park, North Island, New Zealand

I prefer not to use creative filters in my landscape work; instead, I let Mother Nature do the painting, while I record it. Technical filters, however, have a place in my kit bag. A graduated neutral density filter evens out the tones between the bright sky and dark foreground.

CW Rata tree, Fiordland
National Park, South Island,
New Zealand

*I sometimes use specialist filters. The bright overcast sky
was giving the scene a bluish cast. An 81B/20CC green
combination filter reduced the blueness and added
extra punch.*

CW Pancake Rocks, Paparoa
National Park, South Island,
New Zealand (*see over the page*)

I also regularly use filters. I carry exclusively
technical filters, as opposed to creative
ones; in other words, to enhance the light
that exists or to correct lighting conditions
that will adversely affect the image.
Principally, this includes a set of graduated
neutral density filters to even the tones
between light and dark subjects, such as a
mountain range and the sky; an 81 series
of 'warm' filters to reduce the level of blue
tone from reflected light; and a polarizing
filter to remove reflections from shiny
surfaces such as water. I also have some
special-purpose filters for particular
environments. For example, when shooting
in rainforest, the green we see with our eyes
is difficult to record faithfully on film due to
high levels of reflected blue light. A green
20 colour-correction filter combined with
an 81B warm filter ensures that what is
recorded on the film is more natural.

My reticence about using creative filters
(e.g. starburst and defraction filters) came
after much experimentation. For me, Mother
Nature does an excellent job of creating her
own beautiful patterns and designs in the
landscape if we look hard enough to see
them. I encourage you to do your own
experimentation and decision-making, never
forgetting that filters, like all photographic
equipment, are there as a means to an end
and are not an end in themselves.

In terms of film types, I understood the
basic differences early on, but it took longer
to acquire a true feeling for the technical

nuances of different emulsions. Today, three
things dictate my choice: my environment,
preference and commercial reality.

Like Nigel, my transparency preference
is Fuji's Provia 100F. Despite being one
stop faster than Fuji Velvia, which can
often be vital, Provia 100F is more finely
grained. In addition, I find it more tolerant
of contrast, and the colours, while well-
saturated, are more true to nature than
the sometimes 'unreal' look of Velvia.
Having said that, many of my images in
this book were taken using Velvia
emulsion. I generally use it when the
contrast or colour tone is low and needs
'oomph'. I also use – if rarely – Fuji's Provia
400F. Typically, I use this emulsion to gain
the extra two stops over Provia 100F in
low light or night photography. It has an
exceptional grain count for a 400ISO film
and, similar to its slower counterpart, has
excellent colour reproduction.

My preference is for film and not digital
media. While I believe that digital media will
play an increasingly important role in all
areas of photography, including landscape,
I am yet to be convinced that, commercially,
it is a good substitute.

What I have found to be a primary
consideration with film – much like
equipment – is that my best results come
when I am working with a medium that I
know well. While I do, at times, experiment
with new or alternative options, I only do so
when my reputation doesn't depend on it.

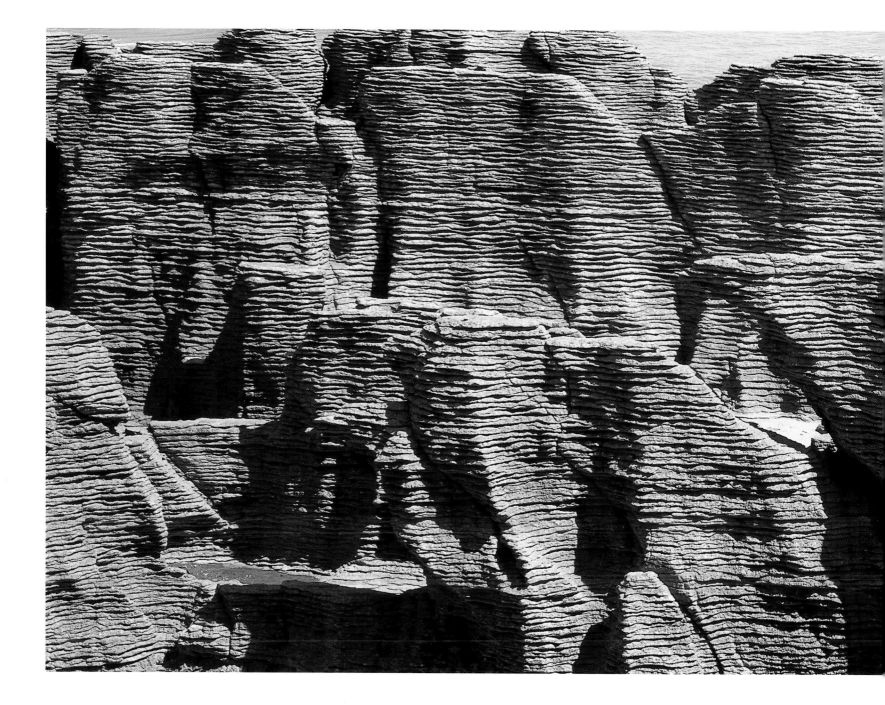

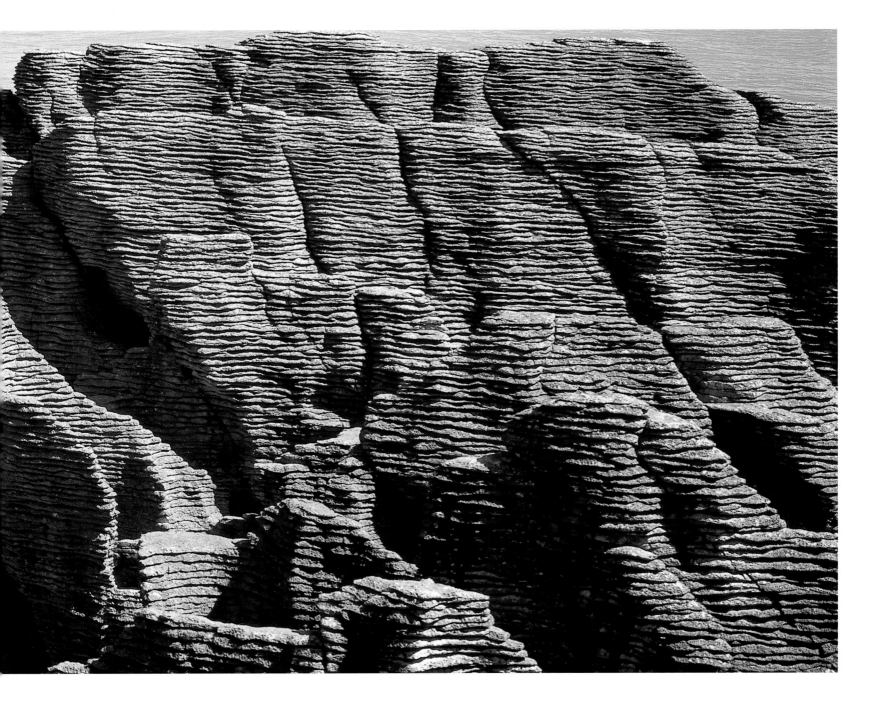

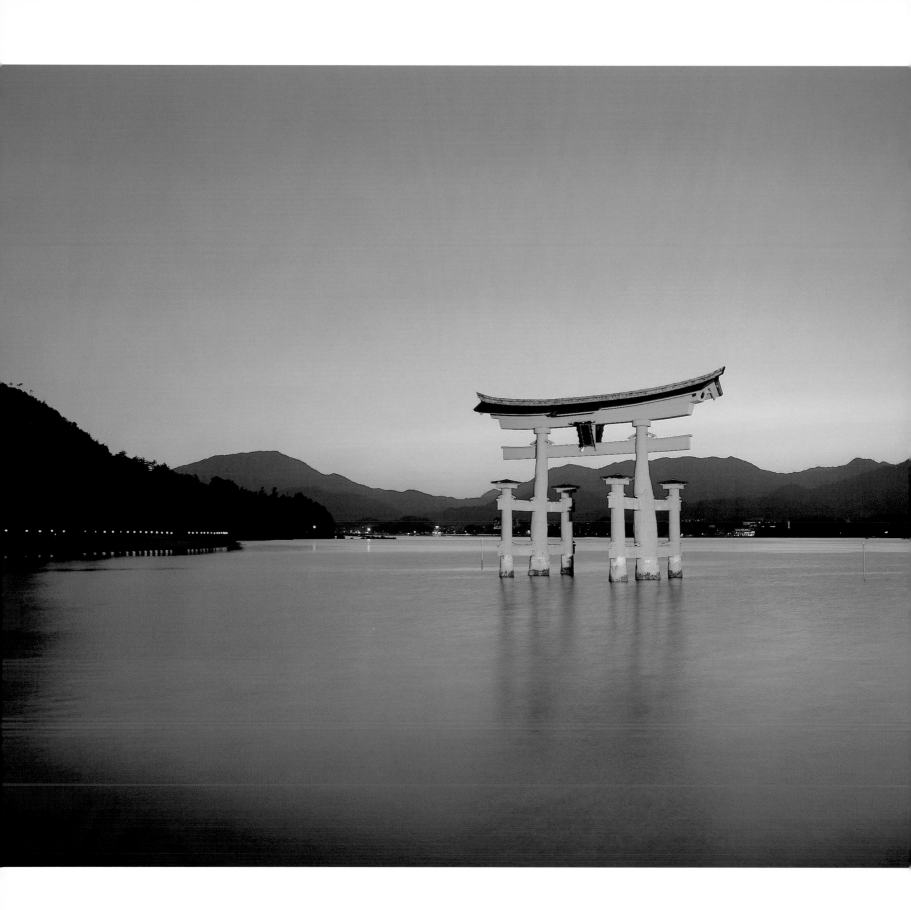

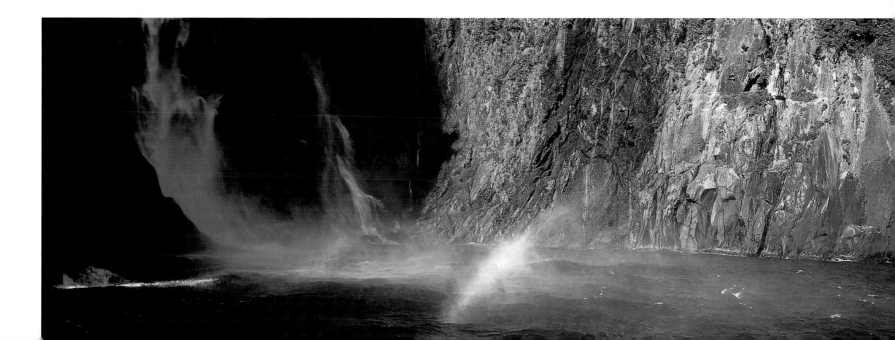

nb O-Torii (the Great Sacred Gateway), Miyajima Island, near Hiroshima, Japan (*facing opposite*)

One of the icons of Japanese tourism, it is hard to imagine more evocative lighting in which to photograph this view.

cw Stirling Falls, Milford Sound, Fiordland National Park, South Island, New Zealand

Sometimes ever-changing light means having to work quickly; the lighting in this scene lasted about ten seconds and then was gone.

With all photography, the difference between a mediocre and a great image is often how well the subject is lit. It does not matter how perfectly composed the main subject, whether in the studio or in a landscape; if the light is all wrong, the image will be second-rate. In portraiture or commercial photography, the photographer can arrange their own artificial lighting but, for landscape photographers, there is no alternative but to work with whatever the heavens provide.

Working with available light can be a frustrating experience. It is quite common to spot a view that, though perhaps not well lit when you discover it, would clearly be fantastic under different lighting conditions. You may then wait days, weeks or even months for the perfect conditions, travel to the spot and then have everything wrecked by a last-minute change in weather, or even the badly timed movement of a single cloud across the sun, just as you have readied the camera.

The list of 'how things can go wrong with landscape lighting' is virtually endless, but these examples illustrate how obtaining great landscape images is unpredictable; that at the very least it requires patience, combined with an opportunistic ability to work quickly when things do go right, and a ready acceptance that often you will finish a day with little to show for your efforts.

Sometimes the mark of a good photographer is knowing when not to press the shutter. This can be difficult even for experienced landscape photographers; the temptation to use the camera at least a few times can be quite overwhelming, even when it is clear that, with deteriorating weather conditions, one should not bother.

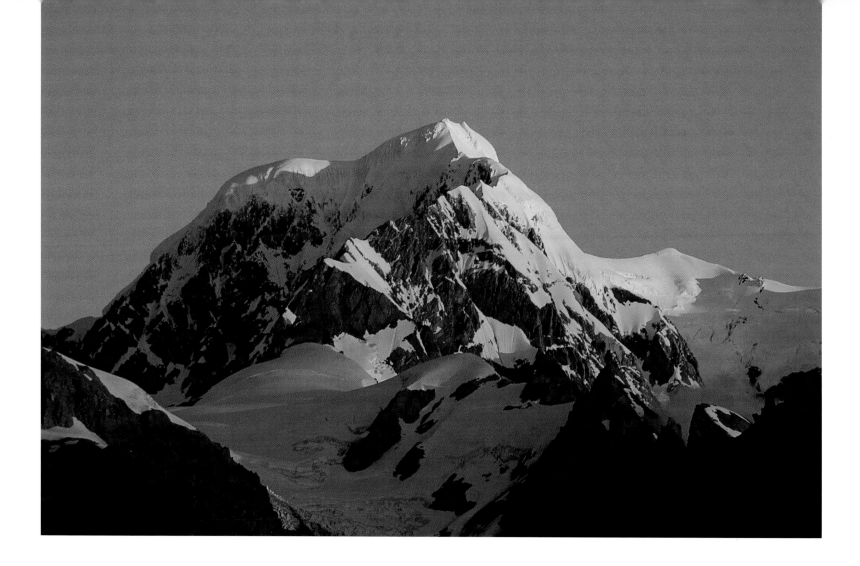

The pressure to shoot is especially great when working on location to a commission with a tight deadline. In this situation, a photographer pretty much has to take whatever photographic opportunities come along, which occasionally demonstrates how effectively necessity can be the mother of invention. It is quite amazing how a few images, taken under what one would consider to be hopeless lighting conditions, can turn out to be surprisingly good. So, if the mark of a good photographer is knowing when to leave the camera in the bag, one should also know when to take a chance, just in case something remarkable happens.

Understanding light and mood

If we seem to be dealing so much of the time with the 'wrong' lighting, then what is the 'right' lighting? And how do we go about grabbing it and making the best use of it? Understanding the nature of natural light, its many different forms and how it affects the landscape, lies at the heart of successful landscape photography. Crucially, the great majority of successful landscape images are lit with some kind of directional sunlight, even images taken during storms or in mist,

Mount Tasman, South Island, New Zealand

Directional sunlight helps to give form to this image.

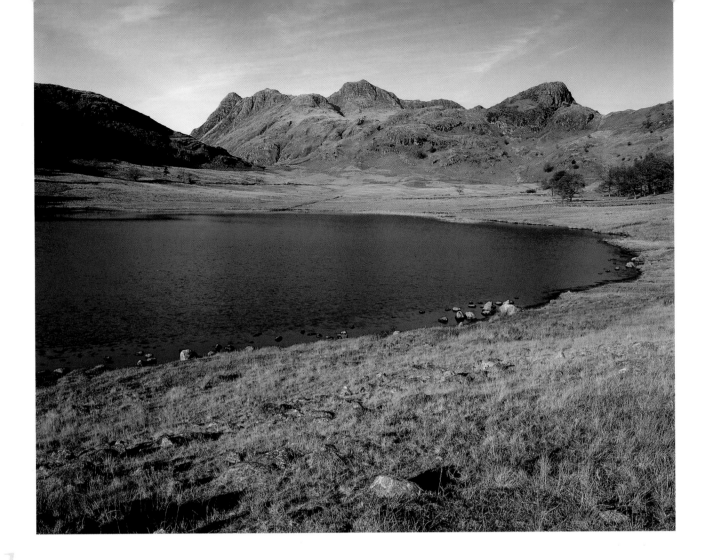

nb Blea Tarn (with the Langdale Pikes behind), Lake District National Park, UK

lending the subjects in the resultant image a sense of three-dimensionality: depth, shape and even movement. Images taken under a dull, grey sky, where the subject appears flat and formless, rarely generate stunning images – excepting those occasions where, for example, the subject itself is so strong it virtually leaps out of the image, and renders poor lighting quite secondary.

More commonly, successful images are lit by some kind of directional light, and you have to consider all the different ways in which that light can be delivered, how it generates particular moods, and how well or badly these elements suit a given subject.

The way the sunlight is delivered to a landscape, in terms of its filtration through the Earth's atmosphere and weather conditions, can be infinitely varied, ranging from the brilliantly clear high sun of a summer's afternoon, the stormy scene in which a constantly changing shaft of sunlight forces its way to the ground through fast-moving black clouds, to the veil of a gentle fog during an autumnal dawn. These, and the immense variations in between, deliver directional light that illuminates landscape subjects and generates the moods that one hopes to convey in the image.

To foresee the kinds of images you can achieve at a given photo shoot, it is first important to understand the relationship between different lighting situations and different landscapes and the moods that they convey. Advance planning is important here. Not only must you decide on your subjects, but also what final effects you want to achieve; what mood you want to convey. These decisions will affect the type of weather you head out in, and at what time of day. Of course, you don't always have the luxury of being able to wait for the ideal moment. When working to a client's deadline, the shoot has to happen regardless and you are at the behest of whatever conditions are thrown at you.

Nevertheless, when shooting for a client it is vital to consider the types of images required, in terms of both subject matter and mood, and then to use to best effect whatever lighting conditions come along. For the tourism market, for example, it is unlikely that images of storm-wracked skies and seas will impress the client. Generally, this market requires views lit with beautiful warm sunshine so, unsurprisingly, images shot under clear, summer sunlight are in greatest demand. In terms of moody landscape photography, they score poorly, but their feel-good factor serves its purpose for the tourism market.

The height of the sun

Even for tourism photography it is possible for the sun to be simply too high. Under most circumstances, a sun that is directly overhead produces landscape images that have little appeal; colours look washed out, the absence of shadows means the view loses all depth and the subjects within it any sense of shape. As the sun's angle to the ground decreases, so the images have greater impact – initially, simply for the picture-postcard views mentioned above, but, as the sun moves lower in the sky, stronger, longer shadows appear, followed by a warm glow that creates wonderfully atmospheric views. This glow often appears across a landscape in the final 30 minutes before sunset, and creates in images a feeling of comfort and safety. It is no coincidence that travel brochures are filled with images of loving couples or families admiring a view bathed in this light.

On a technical note, daylight film is balanced to give correct colours under the clear light that is typical of midday: a time that is relatively rich in high-energy blue light. In the final hour before sunset or the first hour after sunrise, the amount of blue light is greatly reduced – hence the warm red glow – signifying that the light's energy level is low, almost certainly below that for which normal daylight film is balanced. Since low energy light is red, the reddish glow we see in the view is accentuated in the final image, an effect which, because people usually find warmly lit images pleasing, is generally a bonus.

Beyond the warm glow of a very low sun are sunrise and sunset, dawn and dusk. These moments are wonderfully atmospheric. Many landscape photographers prefer dawn and dusk over sunrise and sunset in which

nb St Michael's Mount, near Penzance, Cornwall, UK

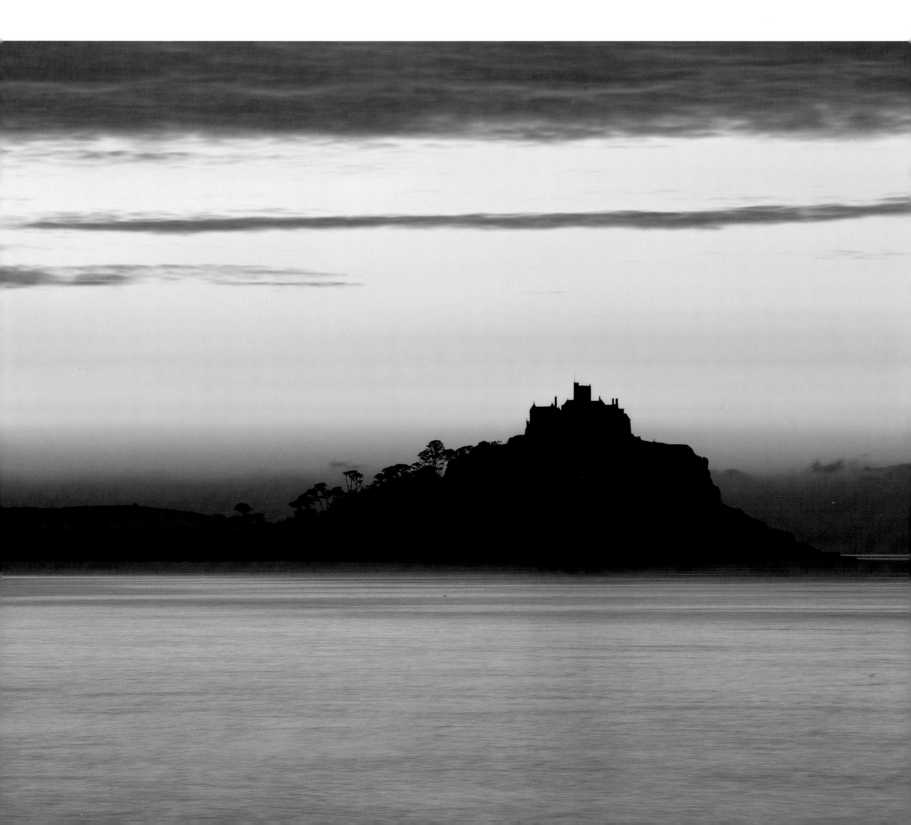

CW Ketatahi Hot Springs,
Tongariro National Park,
North Island, New Zealand

*Looking away from the sunset, which is over my right
shoulder, gives this image a subtle rose-coloured glow.*

the rising or falling sun often overwhelms any image you want to capture of the event, even though you may want to highlight some other aspect of the landscape. Far better to shoot at dawn or dusk when the lighting is more subtle and infinitely variable. This variability can itself cause problems for it is very difficult to predict a good dawn or dusk before it happens. As a result, it is common to waste time waiting for these shots, only to be disappointed at the very last minute.

Generally, a potentially great dawn or dusk landscape image begins with a natural or man-made feature that forms a strong silhouette. Finding one can be surprisingly difficult, and involves some advance research, initially to find a strong feature and then to work out the right viewpoint relative to where the dawn or dusk is expected to occur. You simply cannot do this in the half-hour preceding the event, unless it happens purely by chance, which it occasionally does.

Next you just have to wait for dawn or dusk to arrive and pray for perfect conditions: a glorious orange red glow on the horizon reaching high into the sky, reflecting beautifully off a few well-placed and slow-moving streaks of thin cloud, imperceptibly giving way to a fabulous violet high overhead and to black on the opposite horizon. The absence of cloud or dust in the air can mean a disappointing show because the firey glow stays quite low to the horizon. Conversely, too much thick cloud – even just a small patch of it – can also ruin an otherwise superb dawn or dusk by introducing a black smudge in the

middle of the red. Working in our favour, however, the technical nature of film ensures that the reds of dawn and dusk are accentuated in the final image, sometimes turning a mediocre show into a spectacular one.

Dawn occurs some time before sunrise, and dusk some time after sunset; the actual delay depends largely on latitude. In the tropics, the gap is often only about 15 minutes – barely time to nibble a sandwich – but in temperate latitudes you may have a wait of 45 minutes to an hour. If you are intent on sitting out the interim, how do you best fill the time? Well, a darned good book is useful, but it may also be worthwhile looking around to see what other unusual lighting effects there are in this crepuscular period. Try looking away from the dawn or dusk light for more subtle, beautiful lighting: a landscape gently lit away from direct sun with a slightly rosy glow in the bottom of the sky and in the landscape itself.

Filtration of sunlight

So, the angle of light is important, but what about the intensity? By this I mean the degree to which the sunlight is filtered by elements such as dust, cloud and mist before it reaches the ground. Clear, bright sunlight means strongly lit subjects, well-defined by sharp shadows, especially if the sun is at a low angle. Visibility is likely to be good, making long-distance landscape views possible.

A certain amount of cloud in the sky will add interest to a picture. A clear blue sky

31

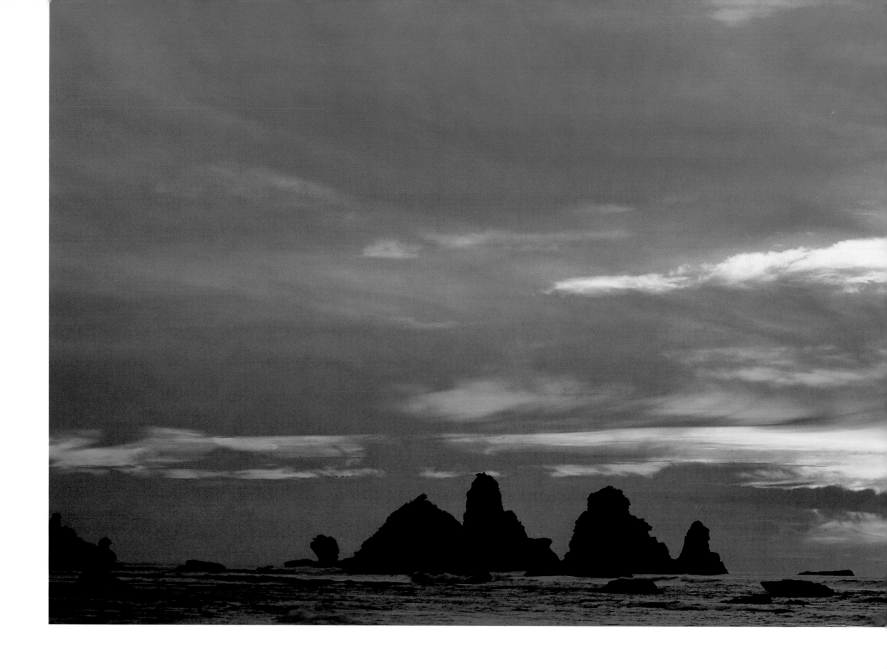

may emphasize the perfection of the day, but visually it is not very interesting. By contrast, fluffy white clouds add to the picture-postcard quality of an image, and a sheet of black cloud across the sky, lit by a low sun, adds drama to the landscape.

A little water vapour or dust in the air reduces the intensity of the sun, which may be of benefit when shooting views where large areas of dense shadow would otherwise be a problem. However, they will also make the sky hazy, reducing the intensity of a blue sky and limiting visibility, thus ruining long-distance views. This is especially a problem in summer; it is hard to beat a sunny winter's day for sheer clarity.

The right balance of dust or water vapour in the air can greatly enhance sunset and dusk periods. Clear air usually results in a sunset in which the sun is still very intense and barely yellow – let alone red – by the time it reaches the horizon, completely overwhelming any attempt to photograph it, and it can be followed by a disappointing show at dusk, with little colour above the horizon. A little dust or water vapour reduces the intensity of the setting sun, often creating a picturesque and clearly visible red ball as it drops below the horizon and, at the approach of dusk, fiery reds climb into the sky.

A veil of mist across the sun can generate some moody landscape images. Under these conditions it is usually impossible to shoot long-distance views unless you are able to climb above the mist, in which case some wonderful views across the top of it are possible. Generally, however, you will be down in the mist, concentrating on photographing landscape elements nearby. In this situation, detail is lost and you should concentrate on shape and form. Sunlight penetrating the mist increases the ethereal nature of the view, bringing out little cameos of detail here and there, and increasing the three-dimensional nature of objects such as trees and rocks that it illuminates. If the mist thickens into fog to such an extent that the sun cannot penetrate, it is possible to shoot eerie silhouettes, a subject we return to later.

Paparoa National Park, South Island, New Zealand

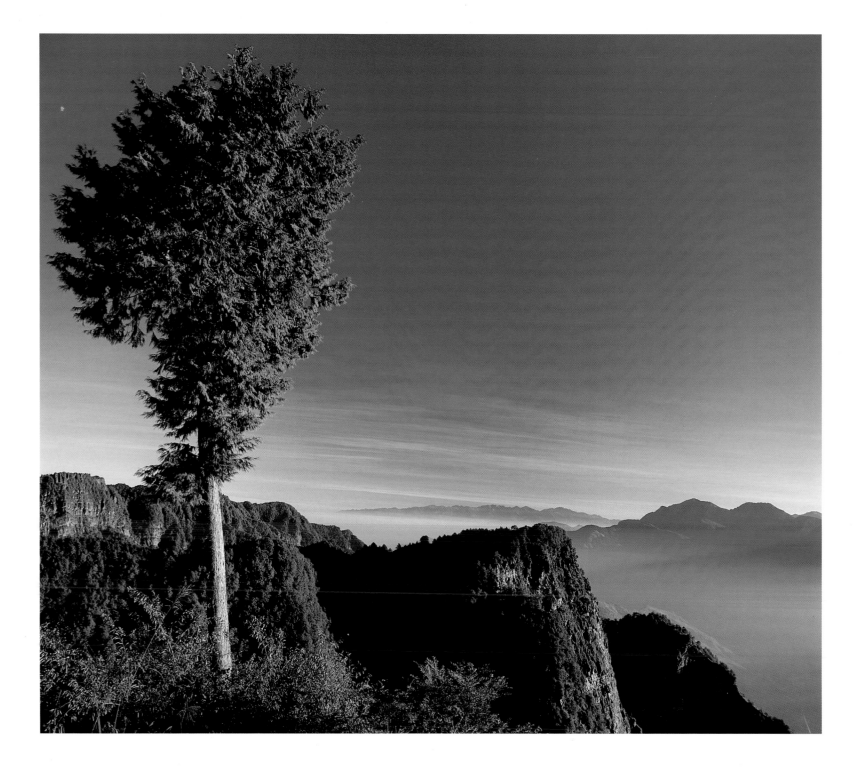

At this point it is worth making a technical note about the importance of using filters.

When shooting in clear sunlight, it is advisable to use a polarizing filter, especially when the sun is high. A standard in landscape photography, it intensifies colours, increases contrast, reduces reflections off water and wet vegetation, removes the typical excess blue light of bright sunny days, and decreases the negative effects of haze.

The polarizer's effectiveness can be varied by rotating it once mounted on the camera, particularly useful when the sun is really low. Under such conditions, a polarizer set to maximum may intensify already dark areas of shadow to such a degree that the resulting contrast range cannot be recorded on film. In this situation, the polarizer should be rotated to reduce the effect. It may even be necessary to remove the filter altogether. It is also inadvisable to use one when a view is lit by weak sunlight as the resulting colours can be a little muddy. In this situation, if an image needs warming up, add a light pink 81A or B filter.

Other useful filters are graduated neutral density filters. One half of the filter is dark, but transparent, and the other half is clear, making them useful in overcoming problems such as when one part of a view is much brighter than another. A common example is where a view is divided into a bright sky and poorly lit landscape beneath. Your eyes might be able to see the detail in both areas, but film, particularly transparency film, is not able to resolve details in such a wide range of light intensity. A graduated neutral density filter will darken a bright sky, reducing the difference in exposure so that it is closer to that of the land, thereby revealing the detail in both areas.

Sun-to-camera angle

Another consideration for photographing sunlit views is the angle of the sun to the camera. The classic shooting angle is with the sun directly behind the photographer, but this usually results in less interesting images, especially when the sun is high. Shadows become less visible, and elements in the landscape such as trees, rocks and hills lack three-dimensionality. Polarizing filters have only a minimal effect at this angle.

As the camera-to-sun angle increases, so do the shadows and the effectiveness of the polarizer. If the sun is side-on to the camera, shadows are stronger and provide plenty of relief and the polarizer works to maximum effect. But, as discussed, if the sun is too low to one side, it will work almost too well, creating large, inky black shadows. At this angle, it is important to shade the lens from the sun in order to reduce the risk of light leaking into the image which affects the colour and, worse, creates flare. Fitting a lens hood will help, but this can interfere with the manipulation of filters. If this is the case, shading the lens with a piece of card or a hand works well.

With further increases in angle, the camera is increasingly shooting into the light, which steadily reduces the level of

Alishan, Yushan National Park, Taiwan

With morning sunlight coming in side-on to the camera, a polarizing filter shows maximum effectiveness, producing an intense blue sky, rich greens in the vegetation and dense shadows.

detail in the view. This can be used to great effect to back-light features such as trees and rocks in the landscape. While some detail will be lost in the main body of the subject, its outline will be highlighted by a brightly lit 'halo' that can be quite stunning.

When the camera is shooting straight into the sun, the images produced will be silhouettes. At this point the landscape's outlines rather than the details become all-important. When the sun is high, silhouettes lack impact; everything turns to shades of grey. Only when the sun is reasonably low do the silhouettes begin to strengthen into solid, dramatic blacks. Inevitably, the lower the sun, the greater the risk of the sun flaring into the lens. A lens hood becomes vital to counteract this problem. If the sun is actually within the view, the camera's TTL metering can be overwhelmed and it may be necessary to overexpose the image up to two or three stops above the meter's reading, especially if the sunlight is bouncing off water. Keeping the aperture

small – at least f/11, but more likely f/16 or f/22 – will show the sun as a tight star in the final image, whereas a wide aperture will reproduce it as a diffuse white ball. Flare is a major problem for images that contain the sun – how much flare can vary according to the quality of the lens, and luck. The problem can be resolved by shooting when the sun is partially obscured by cloud or mist, thus reducing the intensity of the rays. A misty sunrise is an ideal time for this.

A polarizer is quite ineffective when shooting into the sun, and may actually deaden the attractive sparkle of sunlight reflecting off water, for example, so it is better to dispense with it. A graduated neutral density filter can be used to reduce the intensity of the sun, thereby bringing out some detail in the middle and foreground but, to be effective, the dark part of the filter has to be very dark, reducing the sun's exposure by as much as five or six stops, something that usually needs two filters.

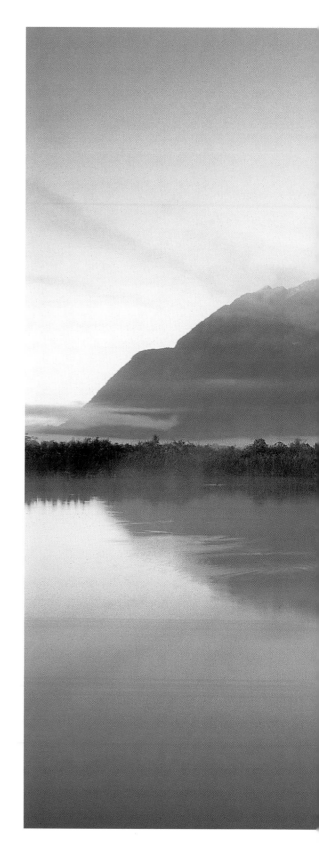

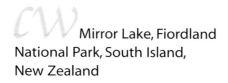 Mirror Lake, Fiordland National Park, South Island, New Zealand

A graduated neutral density filter helps to even out the contrasting tones in this image.

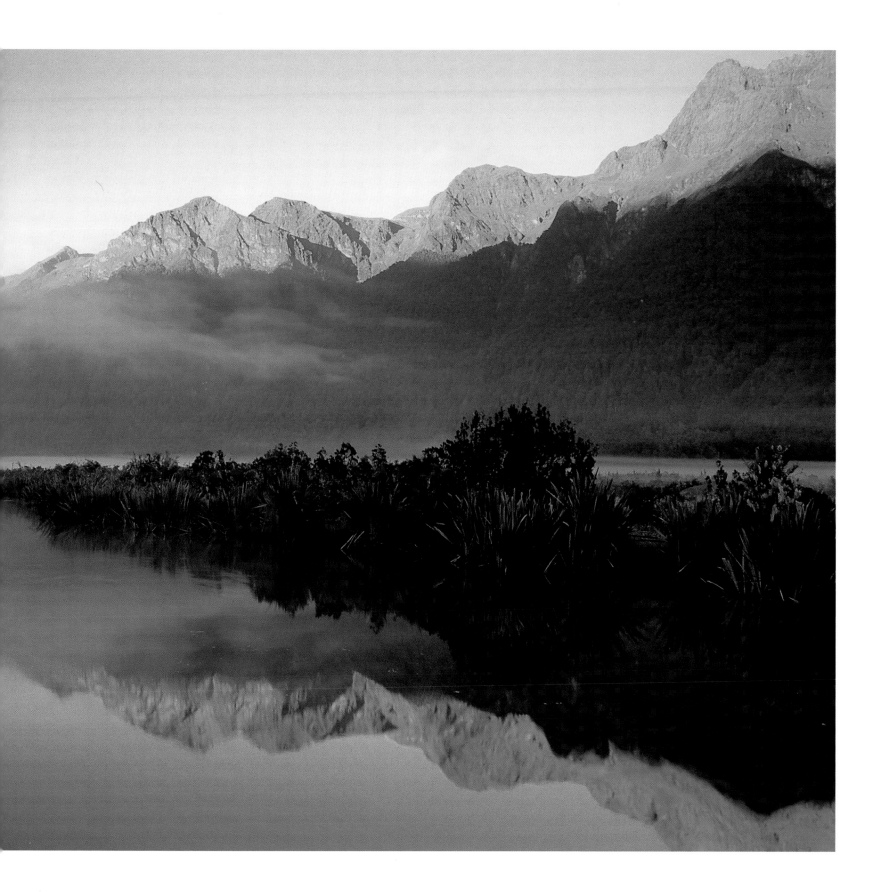

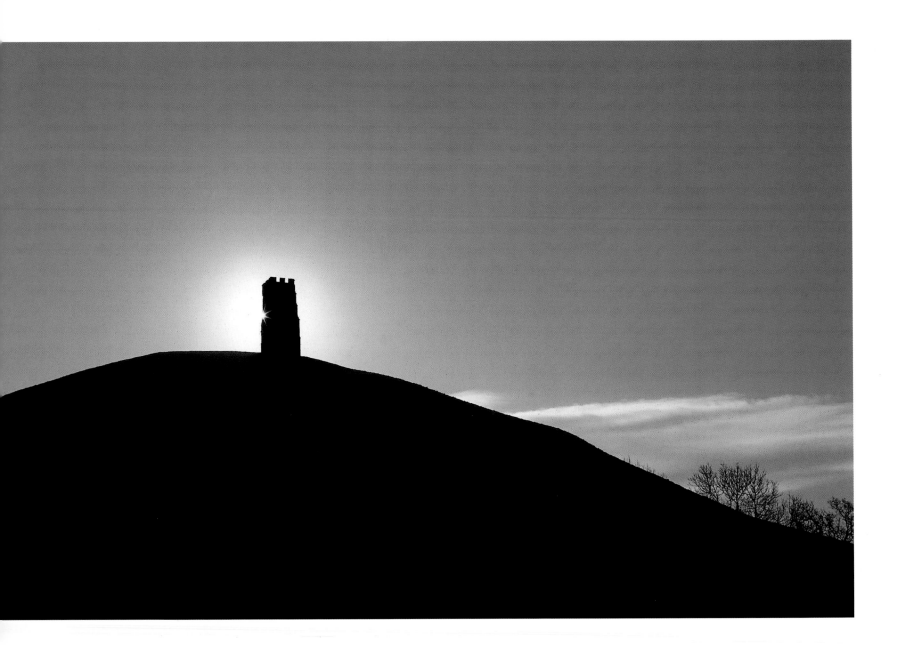

Flat lighting

We began this chapter by saying that the great majority of landscape images incorporate directional light of some kind, but there are a number of instances where it is a positive advantage to have no such illumination; when flat lighting conditions are preferable.

The most common situations for shooting without sunlight are when either the main subject is very strong and the lighting must be simplified to emphasize it, or where the introduction of light and shadow would serve to confuse the image, rather than highlight it. These are most likely to occur when shooting close-up landscapes or features such as rock formations or trees.

nb **Glastonbury Tor, Glastonbury, Somerset, UK**

The church tower on the summit of the Tor was perfectly aligned with the sun, creating a great silhouette, a beautiful starburst effect around the tower and minimal risk of flare in the lens.

nb Haldon Hills, near Exeter, Devon, UK

The soft lighting makes it easier than on a sunlit day to appreciate the beauty of this woodland.

Shooting inside a forest in either clear sunlight or bright overcast conditions can be problematic; the former due to the complex patterns of sunlit areas and shadow, the latter due to the rather dark, poorly lit trees and bluish cast on the green vegetation against the backdrop of bright white sky. Shooting in flat light enables the complexity of a forest view and the strong elements within it to be captured without these distractions. Also, if light levels are low, the amount of blue light will be reduced, producing stronger greens in the final image. Some great forest images can be taken during rain, when the greens are strong. Reflections coming off the wet leaves can be removed using a polarizer, one of the few situations in which a polarizer can be used successfully in cloudy conditions.

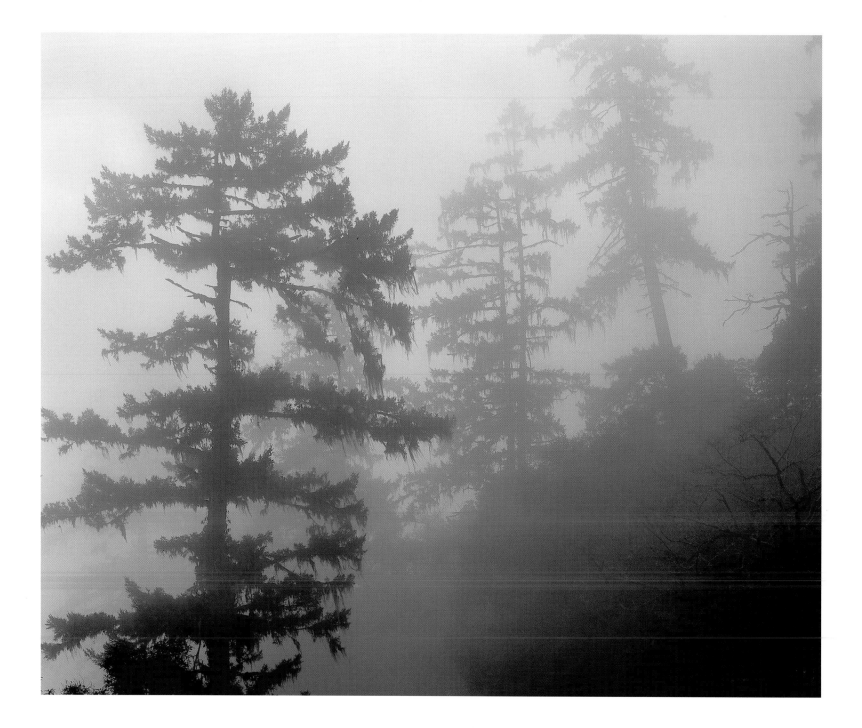

nb Taroko National Park,
Taiwan (*facing opposite*)

Fog can also be effective. Very different from landscapes covered with a thin mist through which sun can provide a delicate, ethereal light, images shot in thick fog convey an eerie, sombre, even threatening mood. In forest, fog creates a sense of the primeval. Over a calm stretch of water, fog brings to an image a brooding timeless silence.

Storms can produce dramatic images with little light. A narrow shaft of sunlight bursting through a stormy scene suggests a tumultuous world soon to restore to peaceful normality. Without the sunlight, an image can have as much drama, as long as it includes a truly strong subject to dominate the image, such as the wildness and awesome power of an intense storm, conveying the terror of being caught in the grip of nature's fury.

This chapter highlights just how essential it is to use the right lighting in landscape photography, and describes the wide range of lighting conditions that a landscape photographer may be confronted with and must use to good effect in different conditions. The photographs in the following chapters represent the application of these principles to a range of photographic situations, resulting in evocative images.

nb Lizard Peninsula, Cornwall, UK

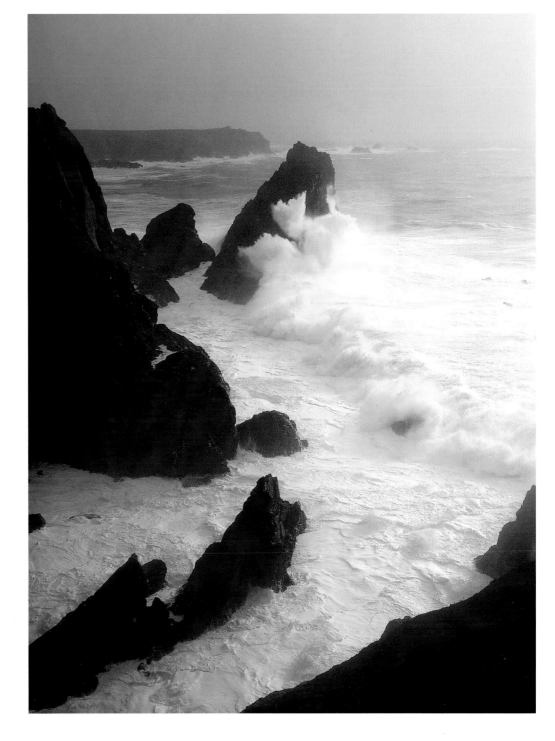

water

rivers

lakes

the coast

waterfalls

snow and ice

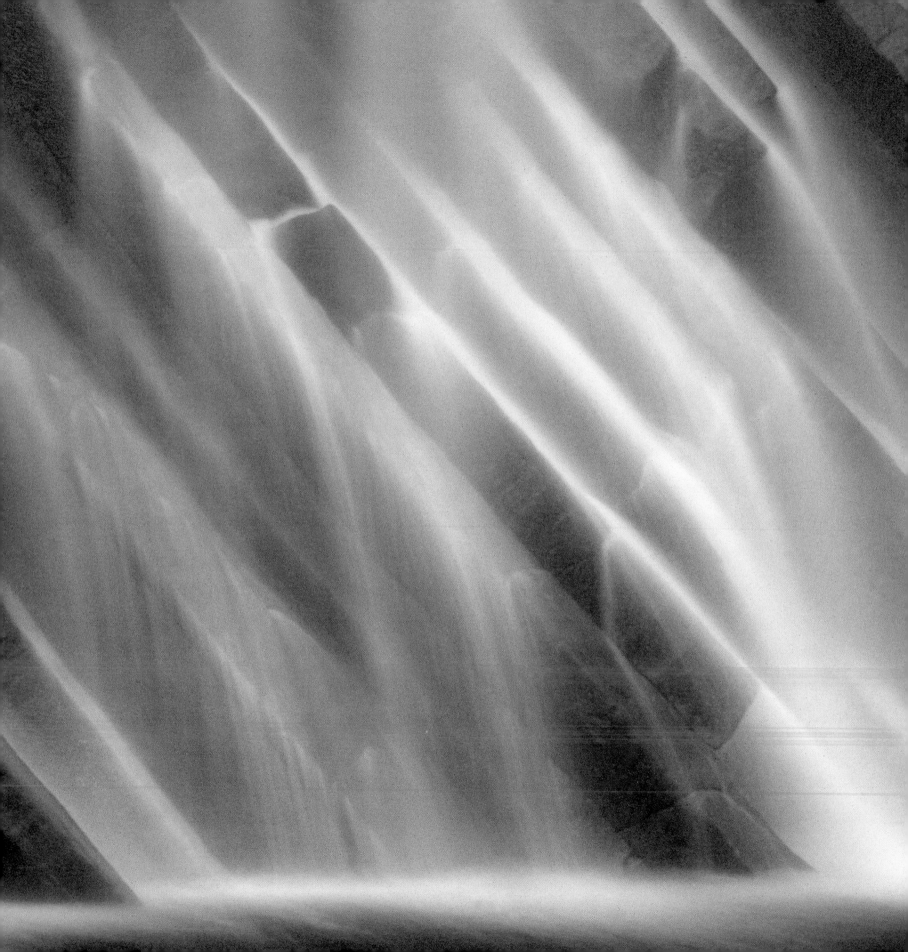

Water is the basis of life and, as such, is at the heart of every landscape, even the desert. Of course, it is not always visible, but when it is, it becomes almost impossible not to see it as a central feature, if not the defining element, of that landscape. How to photograph it naturally depends on the landscape in which it exists and the light that falls upon it, since by itself it is almost meaningless: its shape is mobile, and it has very little colour. It is defined by its environment.

When photographing water, inevitably one thinks more about the water's environment than about the water itself, the aim being to generate in the final images its mood or, rather, the mood that the water conveys in the mind of the viewer. This can vary, ranging from a sense of calm to one of wonder, excitement, agitation or fury, depending on whether the image depicts a flat, glassy lake, a powerful, but silkily flowing waterfall, a fast-running river or a massive storm crashing onto dramatic cliffs.

The choice of watery subject to photograph will be affected by a number of factors, not the least of which is the time of year and the prevailing weather, but also one's mood and inspiration. It may well be that to photograph a calm, placid lake is made difficult by feelings of agitation or tension. Such a mood might be better suited to heading off to a wild, windswept coast to do battle with the elements and generate some rugged surf- and salt-laden images. Of course, if you are being paid for a commission, you can't afford to indulge a mood! A professional photographer must be able to attune his or her mood to the job and focus on the subject in hand.

It is quite often possible to have a clear idea of the kind of images you want to capture before heading out to shoot. Indeed, having a mental image can be immensely important to making a decision where to go and, once there, the approach you must take. However, the combinations of water, landscape and light are virtually endless, which means that it is not always possible to predict what can be achieved until after you arrive. Unexpected weather or light conditions may necessitate a change in plan and the concept of the images you shoot. Even if conditions do turn out as expected, it is never certain that the final images will be just what you planned. Surprises are not infrequent which, combined with the endlessly variable combinations of water and landscape, ensure that the quest for the perfect aquatic landscape image is never-ending.

nb Maruo Waterfall, Kirishima-Yaku National Park, Kyushu, Japan

This wide estuary almost completely empties out at low tide, leaving just a small stream meandering through banks of mud towards the sea, about 5km (3mls.) away from the camera. While many people find the brown expanse ugly, I find it quite intriguing, partly because of the flocks of shore birds it attracts, but also for the variety of patterns that form across it, with patches of wet and dry mud, and standing and flowing water – such a contrast to the wholly different but equally beautiful sheet of shimmering blue water that covers it completely at high tide.

Then there's the river itself: a stream coming down from the hills in the distance, meandering lazily and, with its zigzag pattern, dynamically, across the mud. As can be seen in this shot, at sunset the whole scene comes alive with gold and purple, something that only works well when the setting sun is lined up with the meandering stream, enabling the brightest colours to be reflected in the water.

And in this picture, that was no chance alignment. Viewpoints along the Teign's shore that allow one to approach the stream closely and have a clear view to the west, are few and far between. Having found a suitable spot, I then had to wait about six months for a short period in October when the sun came down in just the right place – all the time crossing my fingers that I would get at least one calm, clear evening.

In fact I had several such evenings, and this is the result: a warm, tranquil, yet curiously dynamic image; a combination generated by the calm water and gentle contours of the land and the zigzagging alignment of the river and the fiery colour of the sky.

I was able to wait patiently for just the right sun position because this view is within easy walking distance of my home – literally at the other end of my road – as well as the fact that this shot was not constrained by a deadline.

nb Sunset over the estuary of the River Teign, Devon, UK

Canon T90 with an 80mm lens on a Uni-Loc tripod, Fujichrome Velvia, 1/15sec at f/16

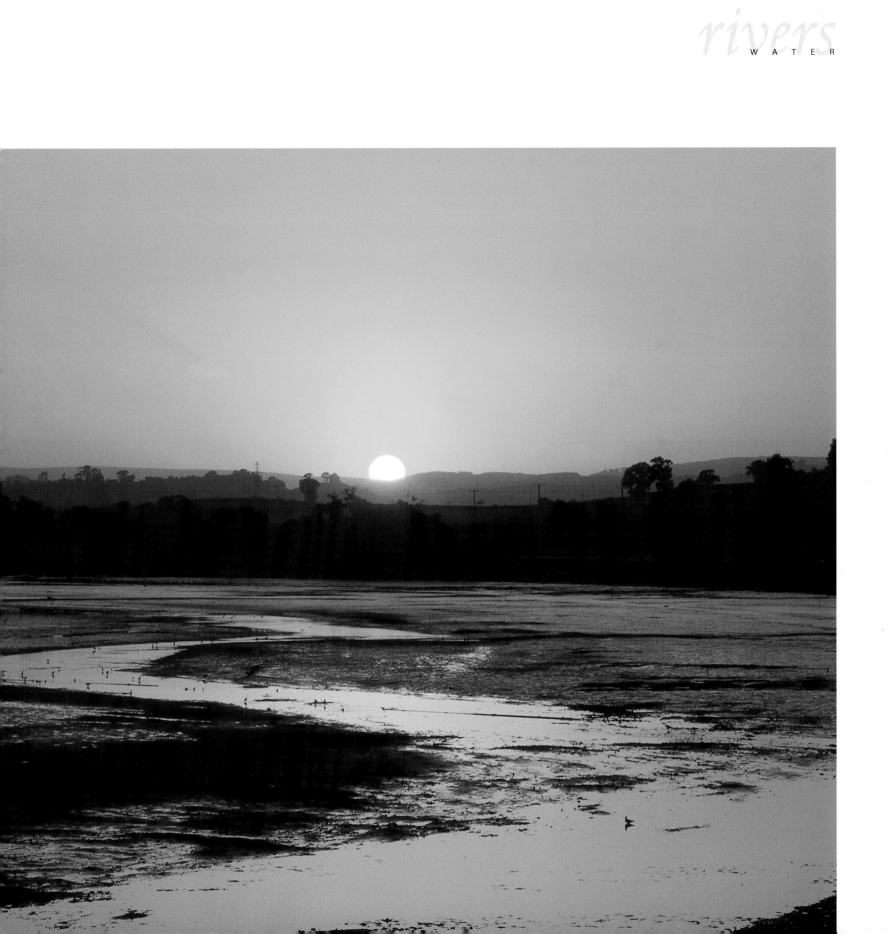

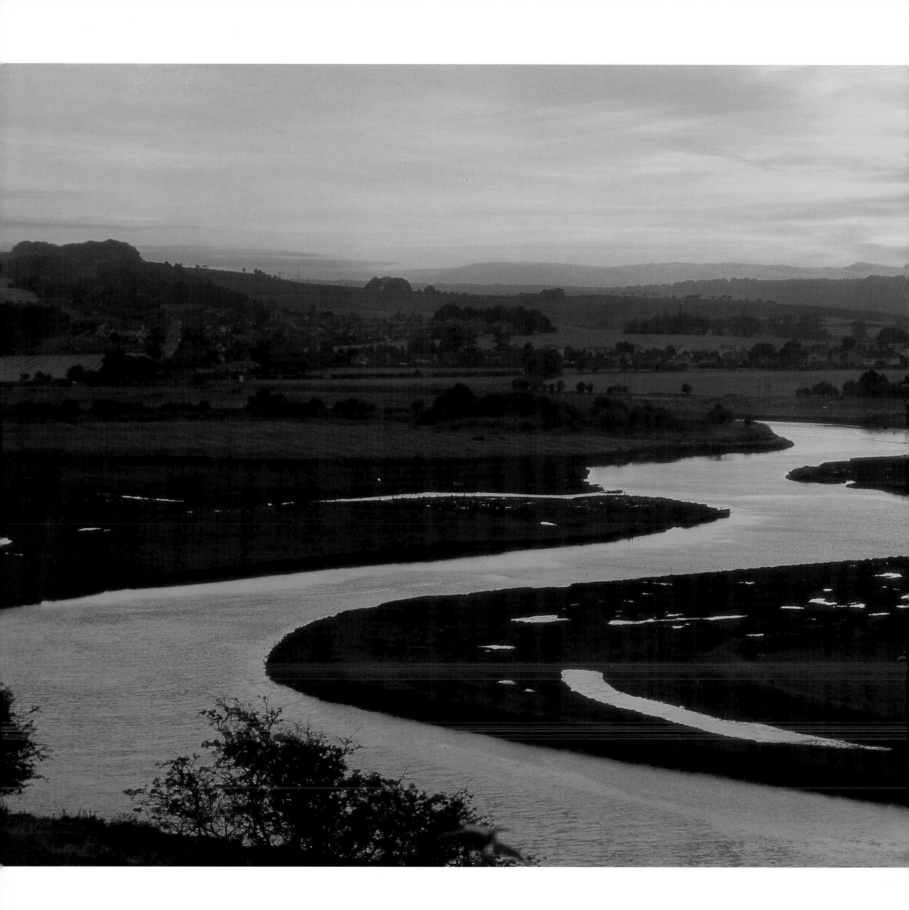

Much of my landscape photography is influenced by a passion for travel and desire to experience new adventures. For me, rivers represent the promise of a journey and, as such, often feature as a central theme in my image-making.

In this image, the Aln glimmers in the golden light of sunset, meandering from one Northumbrian village to the next on its way out towards the English coast and the North Sea. I shot this scene from the roadside, just outside my home town of Alnwick. For me, this image is a very personal one, and says something symbolic and deeply personal about my own journeys away from home into the uncertainties of the world beyond. It is that personal association with the subject that demonstrates how, in landscape photography, we interpret and select what we photograph not simply with our eyes, but also with our hearts and minds. One of my aims with landscape photography is to inspire the viewer to take their own journey, through the photograph.

Here, the river zigzags left to right, leading you from the bottom of the frame, through the image, and into the distant hills. To compress the space between bends in the river, and accentuate its serpentine features and add movement to the photograph, I needed a 300mm lens. With a standard or short telephoto lens, the effect would have been less pronounced. And by waiting until sunset and then exposing for the highlights, I have emphasized the river, enhancing this sense of an imaginary journey as the central theme of the image.

River Aln,
Northumberland, UK

Nikon F90X with a 300mm lens on a Manfrotto tripod, Fujichrome Velvia, 2 seconds at f/32

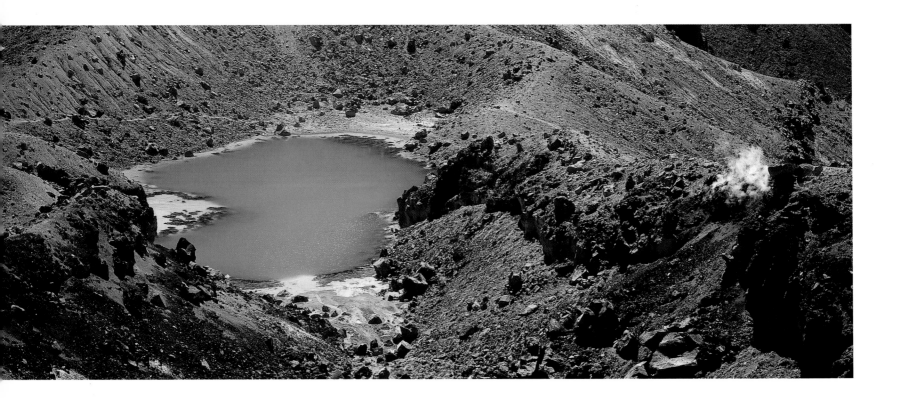

As a landscape photographer, I do a fair amount of trekking, often in remote parts of a country. There are times when I walk for hours without seeing anything worth getting my camera out for, and then there are times when – just occasionally – I'll come across something that makes the whole walk worthwhile. Dotted among the many mountain ranges of the world are small lakes and tarns. Rarely very impressive in size, discovering one can feel like finding a jewel amid a pile of dusty rubble. I have photographed many lakes, including some of the biggest in the world, but the lakes that enchant me most are these.

With this photograph, I wanted to share the experience I feel when stumbling across such gems. I was lucky enough to be in New Zealand shortly before this book was due for completion and, through prior research,

was aware of some water-filled explosion craters high up near the volcanic Mount Tongariro. Carrying 50lb (23kg) of equipment, I trekked for two days to reach them, and was not disappointed. Aptly named the Emerald Lakes, they sit like precious stones guarded by the antediluvian mountains.

To illustrate the isolation of these lakes, I used a panoramic format to provide the necessary width. The brilliant green of the water, caused by minerals which have leached from the adjoining thermal region, is accentuated by the bright, unimpeded overhead sunlight. A polarizing filter helped to saturate the colours and remove some reflections from the surface.

For me, this image really does give the impression of a gemstone, sparkling in its natural environment: the 'Jewel of the Tongariro'.

CW **Emerald Lakes, Tongariro National Park, North Island, New Zealand**

Hasselblad Xpan with a 45mm lens, plus polarizing and 81B/20CCG filters on a Manfrotto tripod, Fujichrome Velvia, 1/60sec at f/16

A clear example of the beautiful images that can be pulled out of a desperate situation, this view was shot on the final day of a job I undertook for a travel magazine. Given just three days one December to photograph the southern part of the Lake District in England, I knew that, given the phenomenal rainfall, even in summer, let alone the start of winter, I was probably heading for trouble.

The first two days turned out to be quite spectacular, the hills bathed in golden winter sunlight, allowing me to snap away at the spectacular views. But then the clouds rolled in and, by dawn of the third day, a steady rain was falling. I had seen this view of Grasmere (a lake closely associated with the early nineteenth-century poet William Wordsworth), the evening before, and had decided then that it would make a nice morning view. Well, in sunlight, it might. Despite the appalling weather, I headed over to the spot anyway, and disconsolately drifted up and down the shore racking my brain for a way to recover the situation. Slowly, my eyes came to focus on the dead branches offshore which, when viewed from a certain angle, connected with a line of three rocks pointing from the shore out into the lake. Combined with a misty, distant shore and a surprisingly bright ethereal glow in the sky, I suddenly had a workable image. Using a warming filter to remove the blue cast that I felt certain would appear on the film, I ended up with a very calm, gentle image of sky and lake merging into one, a view enlivened by the rocks and dead tree, and given depth by the half-hidden far shore.

I am very fond of this image, partly because it shows so well that even in appalling weather you should not necessarily give up. Still, I am well aware that this is very much a photographer's photograph; its simple beauty appealing to a sense of the aesthetic. Commercially, it is a failure. Inevitably, it was not used by the travel magazine and no other magazine or photo library has been bold enough to chance its usage – proof that artistic atmospheric images and good commercial images are not necessarily one and the same.

nb Grasmere, Lake District National Park, Cumbria, UK

Mamiya RZ67 with a 65mm lens and 81B warming filter on a Manfrotto tripod, Fujichrome Velvia, 1 second at f/16

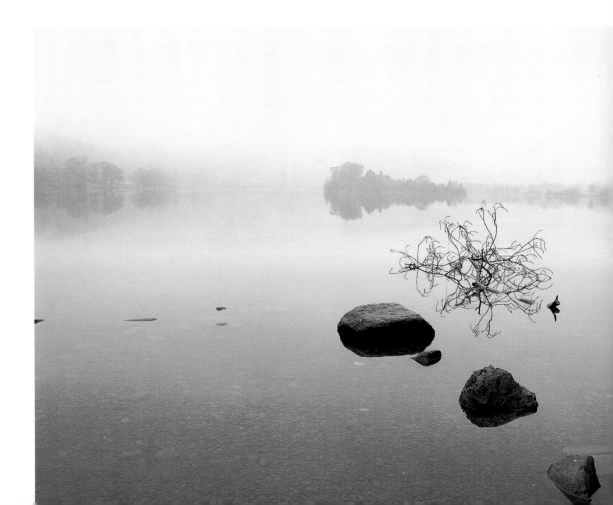

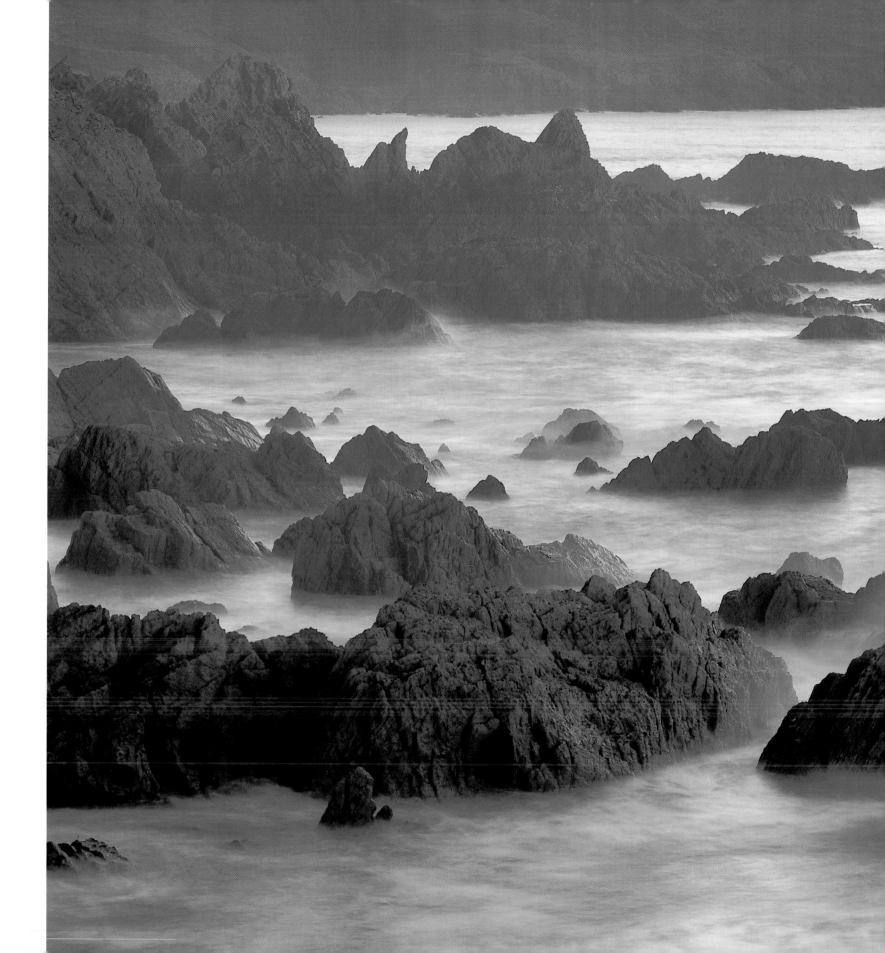

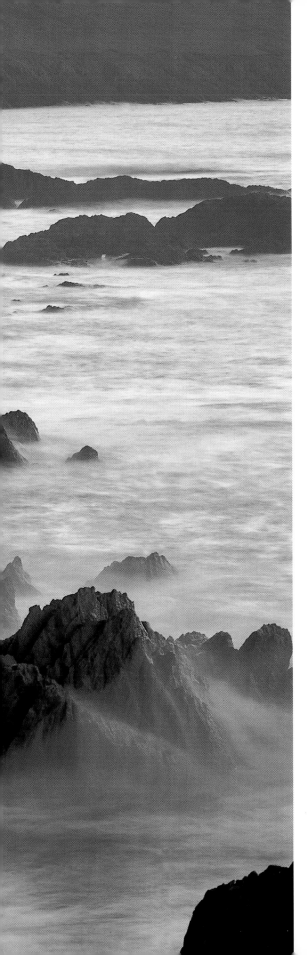

Over the past few years, I have been slowly building up a library of images of the southwest coast of England. Being a long peninsula, there is an awful lot of it – a large proportion very wild and stunningly beautiful. Deciding where to go is often extremely difficult, simply because of the immense range of possibilities. In the end, the choice is often determined by wind direction and force, as well as the likelihood of sunlight and cloud.

On this particular occasion, I had decided to explore a stretch of cliffs along Devon's north coast which were new to me. Exposed to the westerly storms that pound this coastline through the winter, the shoreline was a mass of jagged, eroded rocks that stretched out into the sea well beyond the cliffs, revealing a landscape gradually being ripped apart by the elements.

Looking for good vantage points, I was fortunate to discover that the cliffs here were very low, allowing me easy access to viewpoints that were only just above the shore – a welcome contrast to the inaccessibility of the higher, more dramatic cliffs further west in Cornwall. Exploring along the cliffs, I found a number of points that gave me views not only out to sea, but also along the shore, allowing shots across rows of half-submerged rocks, washed by the incoming waves.

My first series of pictures was taken shortly before sunset, showing rocks and water lit by warm, low sunlight, the waves pin-sharp due to the fast shutter speed. My favourites, however, were a number of pictures taken about an hour later, just as day turned into dusk, as shown here. The indirect light – the result of the sun being below the horizon – has given an overall blue cast, while the four-second exposure means that the sea appears calmer than it really was, the moderate surf reduced to a gentle mist. The result is an image in which the calming effect of the blue mist is at odds with the restless jaggedness of the rocks, creating a tension that I find compelling, and which seems wholly appropriate for an image of ocean waves dashing themselves against the shore.

nb Bull Point, north Devon coast, UK

Mamiya RZ67 with a 250mm lens on a Manfrotto tripod, Fujichrome Provia 100, 4 seconds at f/16

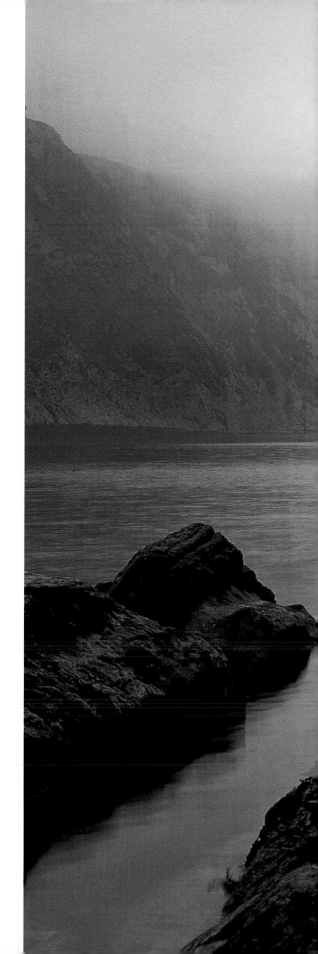

This image, taken near Lulworth on the Dorset coast in southwest England, defines what landscape photography means to me, and demonstrates what I always try to achieve with my landscape images.

Directly behind where I stood to take this shot is the Durdle Door rock arch, a famous and often photographed, ancient rock formation. Indeed, on the very morning I took this picture, there were three other photographers out taking pictures of Durdle Door from much the same angle as each other. And herein lies my point. Sometimes, because we focus too much on the obvious, we miss the beauty that surrounds us.

Great landscape photography for me, aside from commercial necessity, is about capturing the scenes that others don't see. It is about discovering and then interpreting for the viewer – through the medium of film (or pixel) – the untold story of that scene or location. In so doing, you create in the viewer's mind a sense of the extraordinary that, if only for a whisper of a moment, intensifies their experience of life.

This particular morning, frustrated by the assemblage of other photographers on the beach, I decided to investigate some other, less well-beaten trails. To reach this particular spot I had to climb a steep set of steps to the left of the rock arch and descend down the other side. I was rewarded with solitude and this view. Its sheer beauty took my breath away and I sat just looking for some time before I picked up my camera.

Perhaps, more than any other photograph I have taken, this image defines my perception of how life should be lived, each day a step forward from the surety of the known towards, with delightful anticipation, mysteries and adventures yet to be discovered and experienced. In this image, the seaweed-covered boulders in the foreground represent solidity and provide the platform from which the viewer's eye is led towards the horizon, shrouded in low sea mist. The mist establishes a sense of mystery by concealing what lies beyond, while a wide-angle lens provides added depth and generates a feeling of space. The diagonal lines created by the cliffs on either side add dynamism to the image, and the warm glow of early morning light cast by the rising sun and accentuated by an 81B filter, together with the still water, provides calm.

The ethereal feeling of this image is common in much of my landscape work and, while not always commercially successful, I could happily spend my life seeking out and photographing moments like this.

Lulworth Cove, Dorset, UK

Bronica ETRSi with a 60mm lens and 81B filter on a Manfrotto tripod, Fujichrome Velvia, 3 seconds at f/32

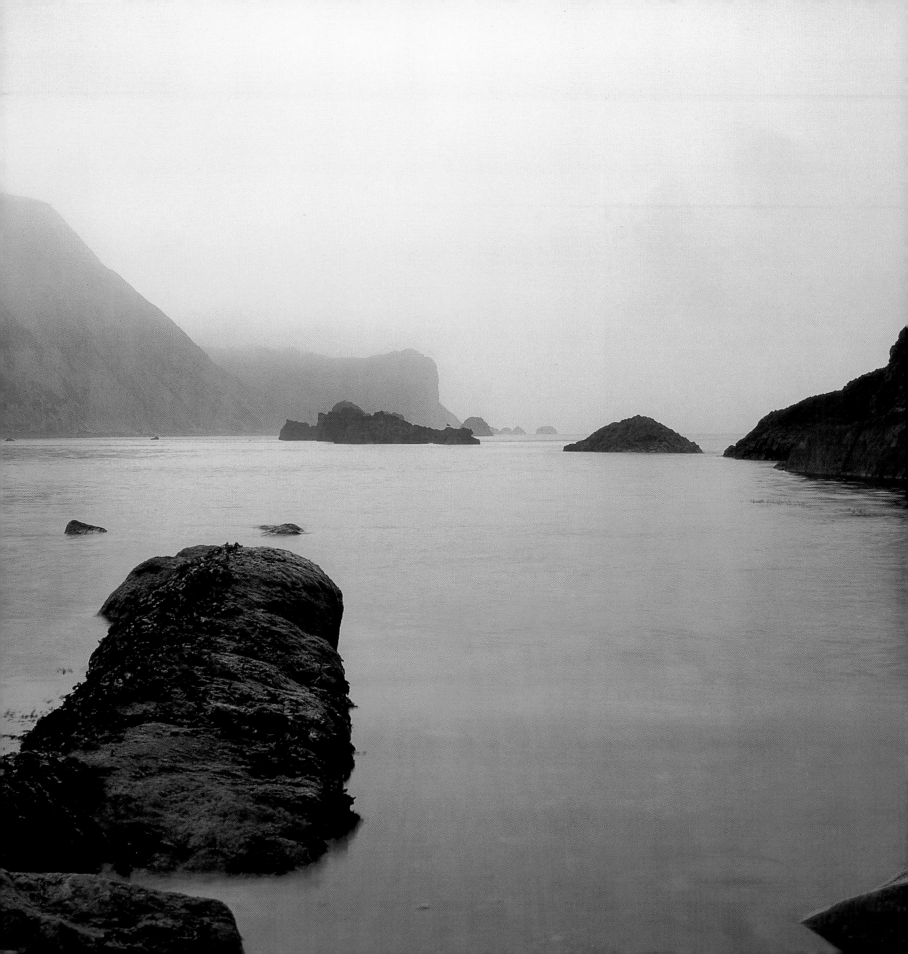

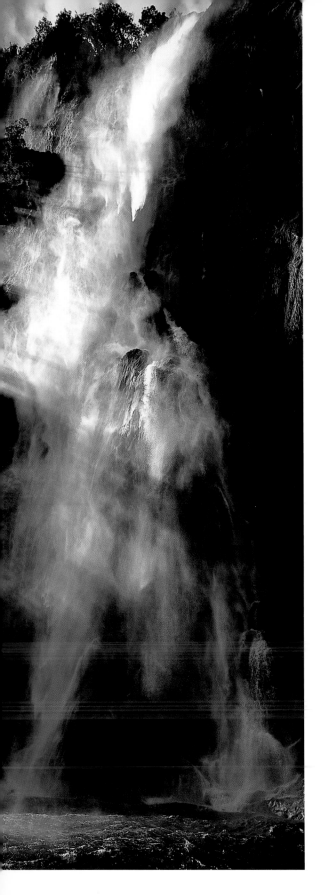

cw Stirling Falls, Milford Sound, Fiordland National Park, South Island, New Zealand

Hasselblad Xpan with a 45mm lens, handheld, Fujichrome Provia 100F, 1/30sec at f/4.5

nb Pearl Shoals Falls, Jiuzhaigou Nature Reserve, northern Sichuan province, China (*facing opposite*)

Mamiya RB67 with a 50mm lens and a polarizing filter on a Manfrotto tripod, Fujichrome Velvia, 2 seconds at f/22

When I first considered the subject of waterfalls for this book, I had a clear idea of the image I wanted to portray. While I wonder in awe at the overall size of falls such as Niagara in North America and Victoria in Zimbabwe, I am impressed more by the majesty of the high, narrow falls found in countries such as Venezuela and New Zealand. Watching the seemingly endless play of water as it tumbles over lichen-covered rocks has a fascination for me that cannot be matched.

To capture the image I wanted meant using a panoramic format to emphasize space and a sense of height in the frame. I went to Aira Force in the English Lake District and fired off a few rolls of film. The results, while pleasing, did not quite match the image I had in mind. However, on a recent visit to Milford Sound in New Zealand, on a boat trip on the sound itself, I found what I was looking for as we sailed past Stirling Falls.

From a mighty peak, it plunges hundreds of metres down the course of the rocks before splashing violently into the green waters of the sound. I watched in fascination, switching between a view of the whole scene to clearly visible tiny droplets of water.

This is one of only a few images in the book that I have taken without a tripod. The swaying movement of the boat meant that it was necessary to handhold the camera, but this complicated the shot because I wanted to use a slow shutter speed to blur the motion of the water as it fell. In the end, balancing between creative endeavour and technical viability, I set the shutter at 1/30th of a second and exposed for the middle of the falls to capture the brilliant shafts of light that add to the mood of the scene.

When I look at this photograph I see three pictures in one: the top third as the water breaks the edge of the cliff face, the middle third where the shafts of sunlight pick out the zillion droplets of water as the falls shatter on the jagged rocks, and the final third as the dying falls disappear, ghost-like, into their watery grave.

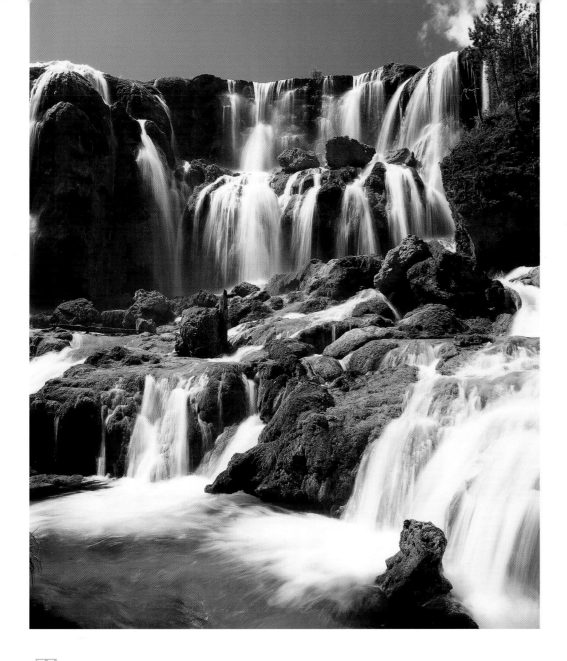

Small wonder, then, that I seem to be perpetually on the hunt for the 'perfect' waterfall photograph. I doubt that I shall ever achieve that goal, but the fascination does ensure that I seek out waterfalls wherever I go, intent on rising to the challenge of capturing something of their atmosphere on film.

This photograph of Pearl Shoals Falls is one of my all-time favourites: a spectacular waterfall in a remote nature reserve in southwestern China. Consisting of two deep, densely forested valleys surrounded by snow-capped mountains, the reserve is famous for its achingly beautiful waterfalls and crystal clear lakes. Pearl Shoals Falls is the biggest and grandest of all the falls, a 100m (109yd) wide band of water cascading over a vertical cliff, surrounded by conifer forest and dense stands of rhododendrons.

During the one visit I have made to this reserve, while shooting for a book on the wildlife and landscape of China, I was treated to three days of torrential rain before the sun finally broke through, and I was able to rush out to spend a day grabbing some of the shots I had already lined up. When it came to Pearl Shoals, although I photographed a number of views, it was not possible in any of them to back far enough away to fit the entire waterfall into the frame. I eventually concentrated on just one corner, producing this great image, the long exposure ensuring that the water came out as sensuous, and yet simultaneously energetic, the silken sheets bouncing and weaving their way down over the rocks.

*T*here is something truly magical about a waterfall, the sparkling water cascading over a cliff, dancing downwards from rock to rock and finally crashing into a pool at its foot. They evoke, in my mind at least, all kinds of moods and thoughts, which will often depend very much on a fall's shape and the way the water pours down it, whether it be a single vertical leap down a cliff, a sinuous ribbon weaving among rocks on a steady downhill slope, or a wall of water tumbling

chaotically down a chasm. Inevitably, the weather plays a major part too, the presence of sunshine adding a sparkle or, with any luck, a rainbow, while rainfall will dramatically affect a waterfall's mood. A delicate, sensuous ribbon of water in fine weather may turn into an angry, foaming monster after a heavy downpour. The possible variations on this theme are almost infinite and I never tire of their thought-provoking, ever-changing beauty.

I confess straightaway, I have little
experience of photographing on snow.
A large portion of my adult life has been
spent in the tropics, and even now that I am
back in Britain I live in the far southwest, an
area that sees little snow. However, I am
partly saved by having Dartmoor National
Park relatively nearby, an area of rolling hilly
moorland that will catch just about any
snow that does happen to be flying around
in this part of the world. Even here, however,
you have to move fast to catch the best of
the snow – if not before it melts, then before
the sledgers and snowman-builders move
in to ruin the perfection.

On this particular occasion, the arrival
of a depression from the Atlantic coincided
with unusually cold northerly winds,
causing Dartmoor, in one night, to receive
what was considered locally to be quite a
heavy fall of snow. Early in the morning,
I headed for the highest part of the moor,
not long after the snow ploughs had been
through, and set to work photographing
some of the lovely snow sculptures and

drifts that had formed around the hilltop
rock outcrops.

On the summit of Haytor, one of
Dartmoor's highest peaks, I was able to
take a series of shots that revealed the
way the bitterly cold northerly wind had
frozen and sculpted the snow into shapes
around many of the rocks, their form
highlighted by the angle of the low sun.
The particular image shown here, though
quite simple in many ways, is very graphic,
the presence of the cold wind indicated
by the wind-blown shape in the snow.
The blue cast heightens the feeling of the
cold, something that I was aware would
occur before I pressed the shutter, but
which I deliberately decided not to
remove with a warming filter.

Although this snow looked set to stay
for some time, a day later the wind switched
back to its more usual westerly, the
temperature shot up and immediately the
snow disappeared. By moving fast I had
caught the best of the white stuff, at least
for that winter.

nb Haytor, Dartmoor National
Park, Devon, UK

**Mamiya RZ67 with a 50mm lens on a Manfrotto
tripod, Fujichrome Provia 100, 1/30sec at f/16**

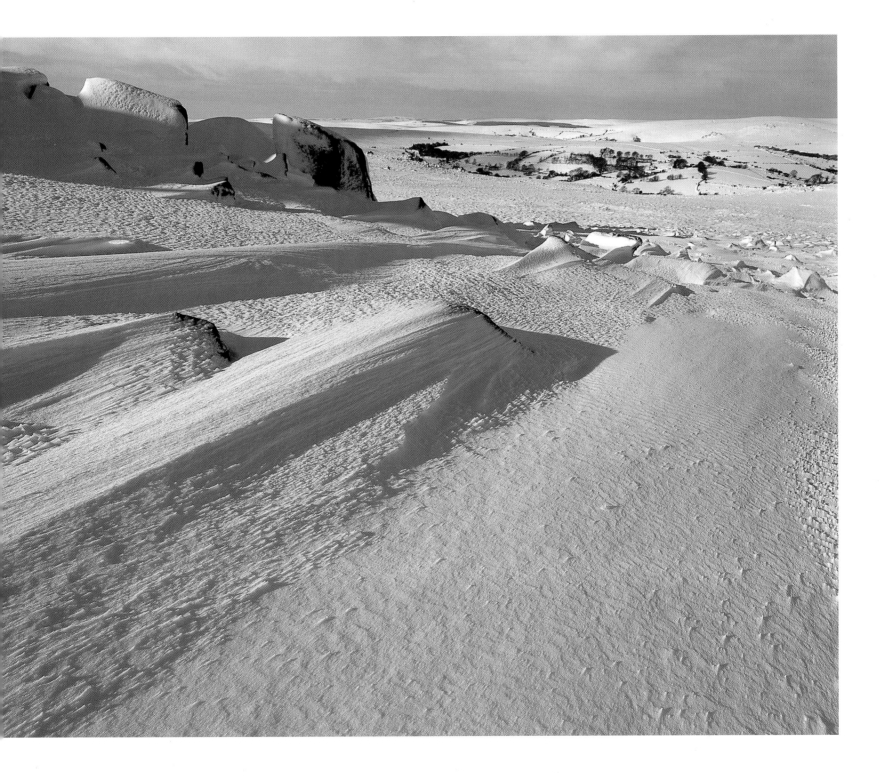

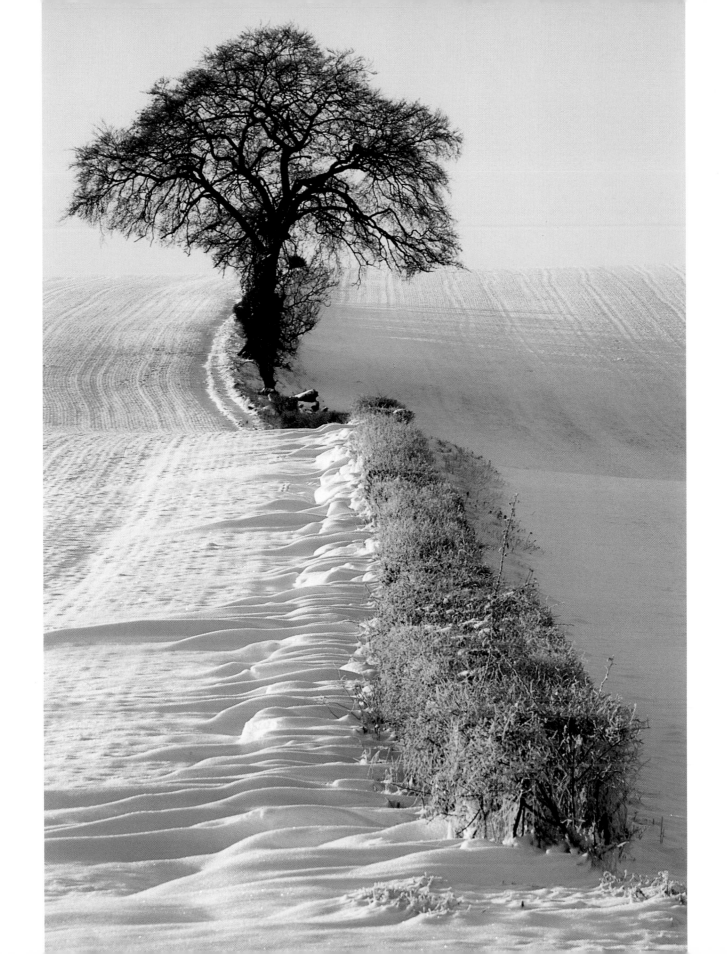

There is a popular misconception in landscape photography that you must travel to distant, exotic locations to capture great pictures. Of course, this isn't so. This image was taken just half a mile from my home in Hertfordshire, England, just after Christmas. The scene reminded me of a Christmas many years ago when, as a six-year-old child, I received a wooden sledge as a present. It had been a white Christmas that year and I rushed straight out with my new toy and headed for the nearby hills. I didn't come home all day.

What I liked about this scene was the perceived journey from the foreground up to the crest of the hill – a jaunt reminiscent of the one I had taken all those years ago. I set my tripod up on the roadside and used the hedge to lead the eye up the slope and into the picture space. The early morning light helped to create a sense of depth, throwing shadows across the folds of snowdrift and highlighting the furrows, which forces the eye to move through the frame. I deliberately used a low angle to emphasize the incline and used the tree to add interest to an otherwise plain sky.

Exposing for snow scenes can be tricky, particularly in bright sunlight. The high level of reflected light always confuses the exposure meter. For this image, I took a light reading from the ground to the left of the hedge with a 1˚ spot meter and opened up two stops. I also bracketed one-third of a stop either side of the reading.

I liked the resultant image instantly. When choosing an image for this section of the book, I looked at various options – including many more dramatic and abstract images taken on ancient glaciers in far-flung countries. However, of all the potential images, I felt that this photograph demonstrated best the philosophy behind this book: that photography can and should be a form of personal expression.

CW Lilley Bottom, Hitchin, Hertfordshire, UK

Nikon F90X with a 35mm lens on a Manfrotto tripod, Fujichrome Velvia, 1/10sec at f/16

landscape

mountain views

valleys

cliffs

seashores

*e*ndlessly varied, from the gentle undulations of England's Cotswolds to the massive peaks of the Himalayas of Nepal and Tibet; from the shifting forms of the Arctic icecap to the vast, flat expanse of the Australian deserts, our planet's geological make-up provides endless permutations of pattern, shape, highlight and shadow, in addition to flora, fauna, seasons and weather.

Of course, shooting a range of beautiful views on film in a way that captures the essence of a scene and its mood at a particular moment is not always an easy task. To start with, there is the sheer scale of the view before you. It is easy for the eyes to pan the scene, taking it all in with a single scan, but to grab it all in a single frame can be a challenge. The temptation is to reach for a wide-angle lens and, often, this is a good solution. However, wide-angle lenses reduce the scale of the scene, so that anything other than a mountain range of Himalayan proportions risks winding up looking surprisingly flat and unimpressive in the final image. For this reason, it is often better to use the telephoto to concentrate on just a few sections of a view that, rather than show the entire mountain, valley or precipice, instead captures the essence of the whole.

This does not mean that you should ignore the wide-angle lens; just that it should be used with care to avoid the belittling effect. Wide-angles can be used to great effect, enhancing diagonals and thus generating dynamic images that give the landscape a feeling of restlessness, especially important in high alpine scenes where sharp mountain outlines and jagged outcrops are the norm.

Overall, the aim of photographing landscapes should be to capture the mood and beauty of the location. Selecting the right viewpoint, lenses and light to suit the mood are at the heart of shooting successful atmospheric images of such environments.

nb Mountain outlines of the northern part of Sichuan province, China

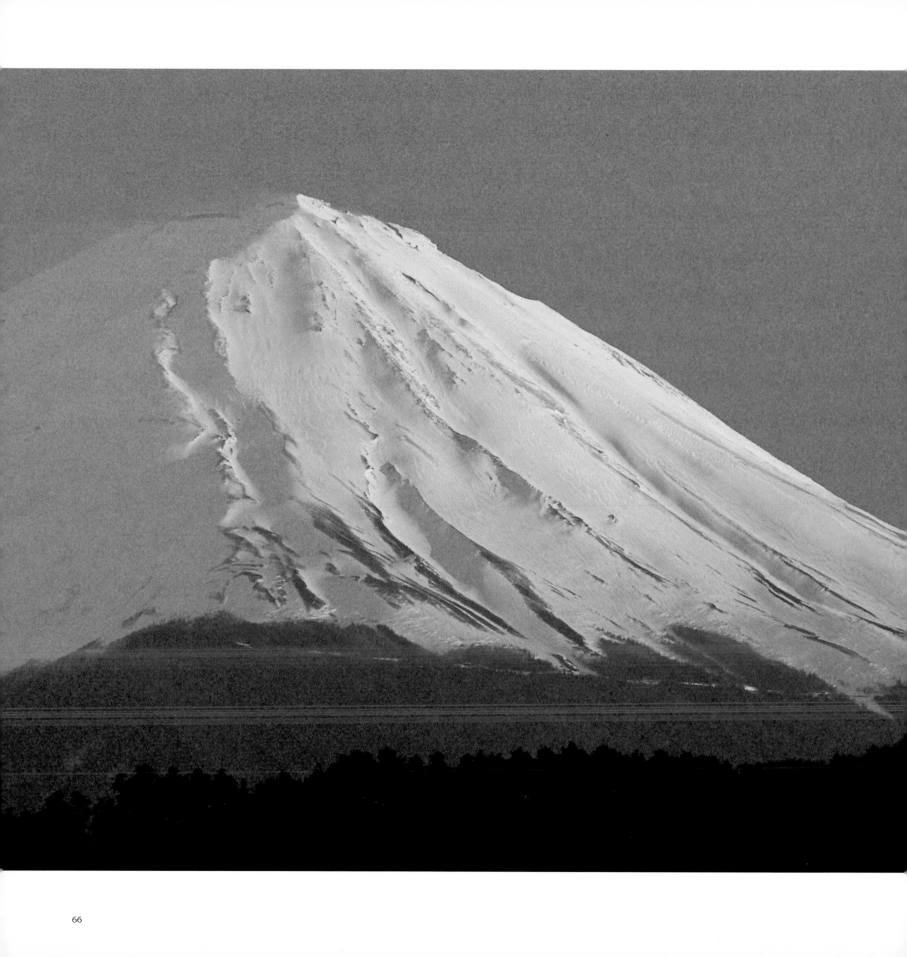

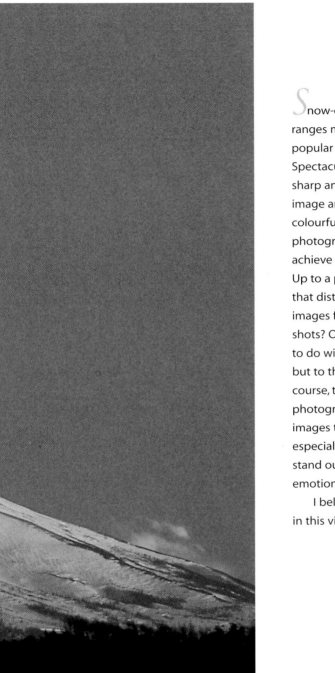

Snow-capped mountains or mountain ranges must constitute one of the most popular themes in landscape photography. Spectacular, endlessly varied, with lots of sharp angular lines to add dynamism to an image and, in the right light, fabulously colourful – when it comes to mountain photography, it seems almost impossible to achieve anything other than superb images. Up to a point this is true, but what is it that distinguishes the best mountain images from all the other perfectly good shots? Often the difference is not so much to do with camera technique as such, but to the mood an image conveys. Of course, this is true with much landscape photography but in the case of mountain images the effect of mood seems to be especially important. The best images stand out because of some indefinible emotional quality.

I believe that such a quality is apparent in this view of Mount Fuji. The quintessential mountain, a volcano with stunningly beautiful, curving slopes that are almost symmetrical on either side of the summit – Mount Fuji must rate as one of the world's most photographed mountains. It might seem difficult to photograph it in an original way but, to me, all that matters is that this image captures the beauty of the great mountain. The fact that it does so by showing only a part, illustrates how the essential beauty of the whole can often be better conveyed by revealing only a single aspect. Seen here in spring, with the upper slopes still draped in a blanket of fresh snow, the last glow of dusk catches Mount Fuji at its best, highlighting its strong, graceful contours. By concentrating on the upper western slopes, the most is made of the dusk light, warm hues playing on the snow, and the light's low angle picking out the contours of mountain and snow. The sweeping slopes are both dynamic and graceful, the overall scene one of strength and calm.

nb Mount Fuji, Japan

Canon T90 with a 125mm lens and polarizing filter on a Manfrotto tripod, Fujichrome Provia 100, 1/15sec at f/11

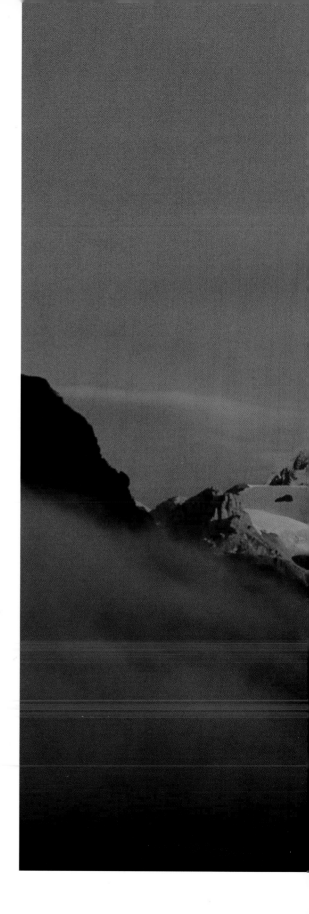

*T*he day before I took this picture of Mount Tasman, I had been flown in by helicopter, traversing its slopes on crampons. I'd had a thrilling tour around and above its peak while the hike had given me a close-up view. Both experiences were enchanting, but it wasn't until I viewed the mountain from the valley floor that I appreciated its true presence.

Communities living in close proximity to great mountains believe these granite giants to have mystical powers and consider them to be sacred places. Living within their shadow, even for a short while, it is easy to understand why. It is this sense of power, mysticism and life force that I try to portray when photographing mountain scenes. This was achieved here by using the composition of the triangular shapes created by the mountain peaks and, by compressing the space between the surrounding ranges, the photograph takes on a more intensely dramatic, graphic statement.

Perhaps because I had walked along its slopes, I also felt an unusual sense of calm in the mountain's presence. I tried to reflect this feeling by balancing the lenticular form of the cloud on the right of the frame with the strong pyramid shape of the peak. By doing so, I have allowed neither shape to overpower the other, creating a sense of balance without compromising the dynamic nature of the image. This balance is enhanced by the placement of the horizon. Its central position in the frame lends equal weight to the mountains in the foreground and the cloud formations above.

Having successfully climbed a mountain, I believe you achieve a certain amity with it, an enhanced bond and respect for each other's existence, born from sharing a moment in time. Similarly, you recognize that this bond exists only until you meet again, at which time, unpredictably, the temperament of the mountain can change your relationship forever. It is an uneasy, yet peaceful union.

 Mount Tasman, Fox Glacier, South Island, New Zealand

Nikon F5 with a 300mm lens and 81B filter on a Manfrotto tripod, Fujichrome Velvia, 1/6sec at f/11

*T*he main focus of this book is to challenge the photographer to capture with the camera what he or she sees in nature. Ultimately, how an image appears on film depends on the choices we make when composing the shot. I first photographed this valley scene using the standard 35mm camera format. However, despite repositioning the camera several times and changing lenses more than once, I couldn't get comfortable with the image I saw in the viewfinder. Whatever I tried, it simply didn't tally with what I was seeing in my mind.

Stepping back from the tripod, I reviewed the scene and decided to switch to a panoramic format. Instantly, the wider area of the image gave me what had been missing: space. By confining the elemental components within a square frame, I had done the photographic equivalent of fixing blinkers on a horse. What my mind saw was the wide expanse of the valley floor offset by the long stretch of mountain peaks above. My initial choice of camera, then, had literally chopped the ends off the picture, creating a disturbing sense of unbalance. In this image, the elongated format has provided the space for the picture to 'breathe'.

For me, this is a very relaxing image. The trees in the foreground are bathed in the radiant glow of the early evening sun, set off against the cool blue shadows of the mountains. The horizon line, psychologically soothing, leads the eye across the picture space, further emphasizing the trees and giving weight to the valley walls.

This image is another illustration of how cameras – however technically advanced – can limit our imagination if we allow them to control our actions. By understanding photographic composition and making our cameras work for us, we can create far more compelling images.

CW Fox Glacier Valley, Westland/Tai Poutini National Park, South Island, New Zealand

Hasselblad Xpan with a 45mm lens and 81B and graduated neutral density 0.3 filters on a Manfrotto tripod, Fujichrome Velvia, 1/12sec at f/11

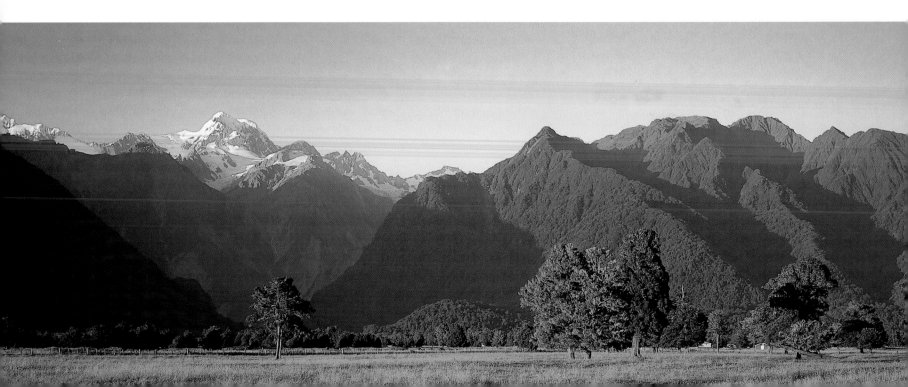

*I*t may seem obvious to say that a valley is, by definition, the space between two or more hills or mountains. It is, therefore, an essential part of hilly or mountainous scenery. So, if to photograph a valley you also have to photograph the hills or mountains, at what point does a valley image become a mountain or hill image?

I had not really thought about this until I came to sift through images for this chapter, when I realized that many of the images that I had thought to be valley views were actually mountain views. The pictures described the surrounding mountains far better than the valley enclosed somewhere in their midst. Subsequent efforts to shoot valleys served only to drive this home, and I became perplexed by the question of just what constitutes a valley image.

Then I thought about this picture – a view of Edale, one of the most well-known valleys in the Peak District National Park in the Midlands, England. One of a series of shots I took of this valley on a clear day in February, it is very simple, both in concept and execution, but it captures the feeling of a valley very effectively, without showing either the valley floor or running the risk of becoming a mountain image. The sloping green hillside is the dominant part of the image, and provides the feeling of a mountainside dropping down into a valley. The distant barren hill, lightly dusted with fresh snow, establishes the context of a valley enclosed by rugged hills, but it does so without dominating the image, ensuring that the main focus remains with the valley.

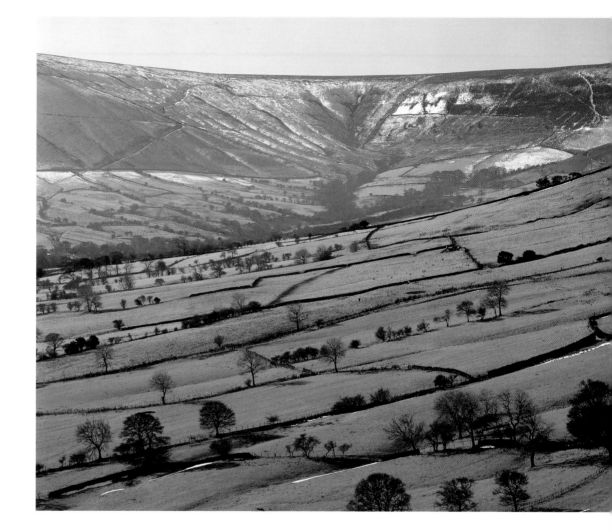

The sense that this is a valley surrounded by wild hills is emphasized by the contrast between the rather homely patchwork of farm fields that cover the sloping valley floor, and the desolate, snow-covered hill in the distance. And where the sunlit greenery adds a little warmth to the valley, the snow increases the sense of desolation on the hill.

nb Edale, Peak District National Park, Derbyshire, UK

Mamiya RZ67 with a 250mm lens and polarizing filter on a Manfrotto tripod, Fujichrome Velvia, 1/15sec at f/16

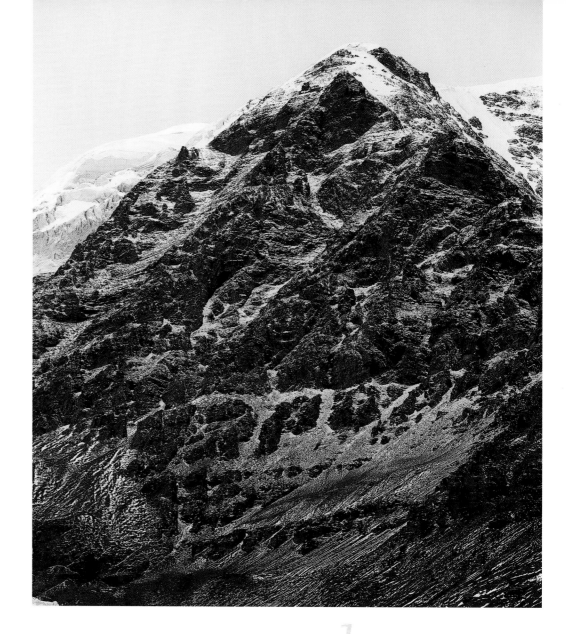

When I was in the process of deciding which image of cliffs to include, my initial impulse was to show sea cliffs, particularly some of those around the British coastline. But the more I thought about it, the more I felt that this was too obvious a route, and that I needed something more unusual. Obviously, a cliff image should be spectacular and, therefore, probably a rugged and daunting place. To achieve this, not only is the size of the cliff important, but also the lighting and the camera's perspective.

This led me to think about mountain cliff faces, and soon I thought of this image of Mount Nojin Gangsang, a 7,191m (23,515ft) mountain in southern Tibet. I came across this mountain while driving from Tibet's capital, Lhasa, towards the Nepalese border, its huge grey walls forming the northern flank of the Karo La Pass, which the road crosses on its way south. My jeep broke down right at the top of the pass, and while my Tibetan driver and his mate coaxed it back to life, I wandered off in search of likely images. The light was appalling, with thick grey clouds clinging to the mountain tops, but the gloom added to the grandeur of the towering mountain overhead, glaciers streaming down the less vertical slopes, coming to a halt in huge ice walls a few hundred metres above.

The mountain's south face was a near-vertical cliff on which snow could barely settle, soaring up from just above the pass directly to the summit, a height of nearly 3,000m (10,000ft). This is the view shown here. The poor light adds to the glowering character of this mighty cliff, the glaciers

around the summit apparently on the brink of tipping over the cliff's edge, their soft white upper surfaces merging almost seamlessly with the stormy sky.

For me, this is the mother of all cliffs, a place that, combined with the threatening weather, symbolizes the wild and ferocious landscape of Tibet. And yes, my Tibetan companions did get the jeep going again (though it broke down many more times before I finally reached Nepal).

nb Mount Nojin Gangsang, Tibet

Mamiya RB67 with a 110mm lens on a Manfrotto tripod, Fujichrome Velvia, 1/30sec at f/5.6

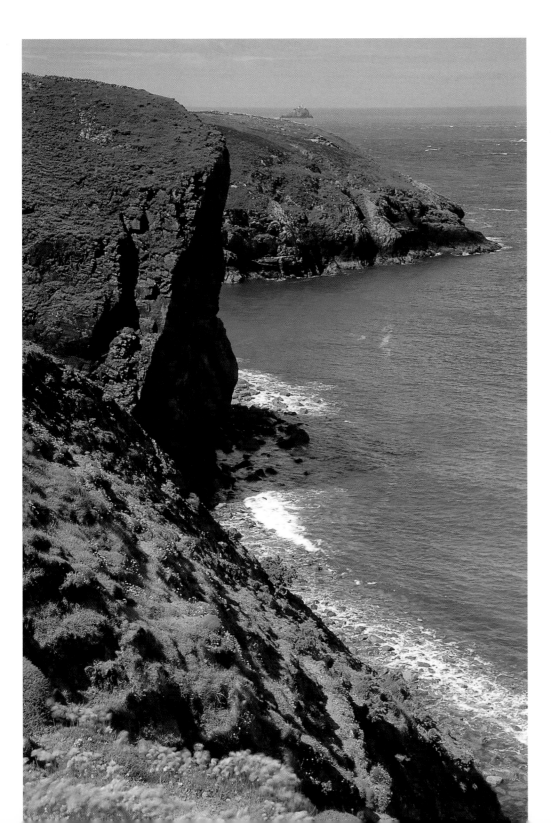

CW Skomer Island, off the
Pembrokeshire coast, Wales, UK

**Nikon F90X with a 50mm lens on a Manfrotto
tripod, Fujichrome Velvia, 1/50sec at f/16**

*F*or me, seashores symbolize the unity
of our planet's elements. Cliffs, on the other
hand, seem to form a barrier to that union, and
it is interesting how rarely I photograph them.
They are not my favourite landscape subject!

Whenever I talk about nature
photography, I espouse the theory that, to
create great photographs, you must first feel
an affinity towards your subject, whether it
is a mountain, a bear, an eagle or a cliff.
Without a genuine rapport between the
photographer and the subject an image
will, on the whole, appear lifeless and flat.

It is this sense of discord that I wanted to
portray with this picture. The photograph
works, not because I am sympathetic with
the cliffs but because I am in tune with the
symbolic nature of the cliffs as I see them.
Compositionally, I have made extensive use
of angles to depict feelings of strength
(upward-pointing triangles) and instability
(inverted triangles), denoting the powerful
nature of the cliff as a barrier, and my unease
with the implications for the world as I view it.

The point here is that to create an
aesthetically pleasing, evocative image, you
must first consider the effect of a landscape
on your emotions. Only then should you
compose the photograph, to show not
simply the scene in front of you, but what
you feel in your heart and mind.

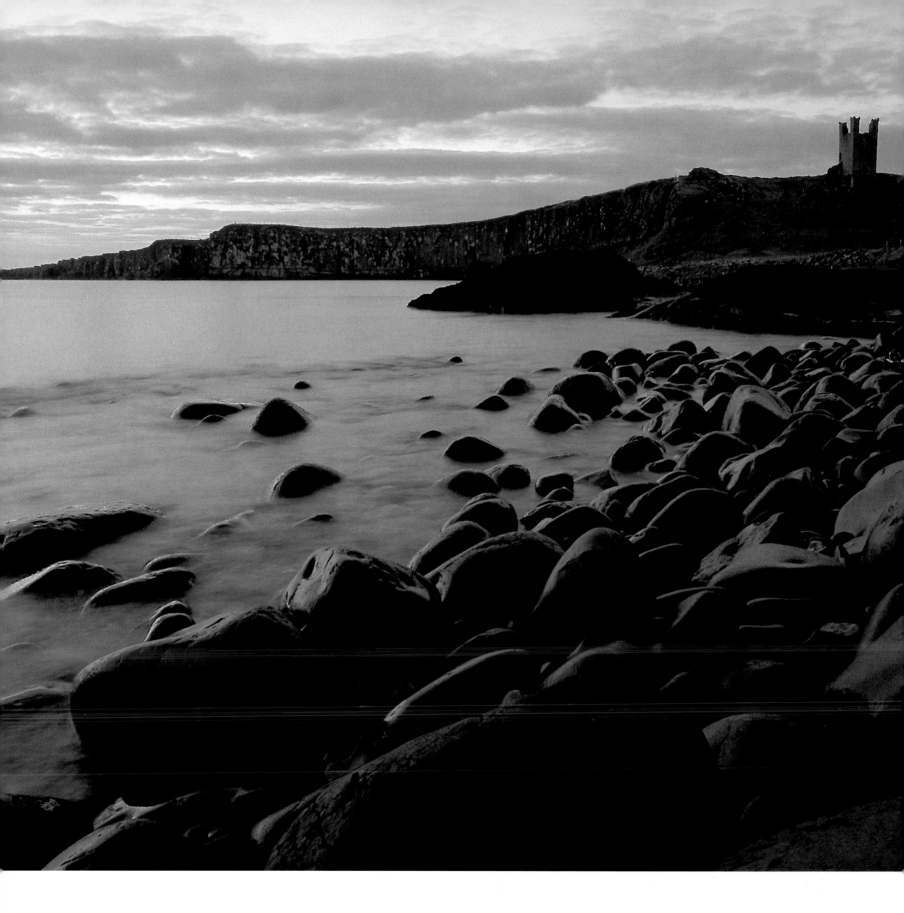

I consider our planet to be a dynamic whole, without boundaries, where diverse yet complementary features form into one. An example of this interaction is the seashore, where tidal waters blur the margin between land and sea. It was this relationship between elements that I wanted to explore when shooting this picture.

The boulders in the foreground of this scene are not always visible. Frequently, they are hidden beneath the violent surf and rolling waves of the North Sea. On this morning, however, the water was calm and the tide was out. The encroachment of rock and sea on each other's territory portrayed perfectly the image I had in my mind.

My primary aim was to blur the movement of the sea as it played across the stones to create a feeling of the ethereal and to obscure the boundary between solid and liquid states. With my camera on a tripod, I set a slow shutter speed to create this effect, which also allowed me to gain maximum depth of field from the small aperture. The perceived diagonal line helps to draw our eye into the frame and adds energy to the image.

The word seashore joins two nouns to make one. Similarly, in this photograph, the combination of two worlds – sea and earth – has created one.

CW Dunstanburgh,
Northumberland, UK

Nikon F90X with a 24mm lens on a Manfrotto tripod, Fujichrome Velvia, 3 seconds at f/22

nb Mangrove at Subic Bay, Philippines

Canon EOS5 with a 24mm lens and polarizing filter, handheld, Fujichrome Provia 100, 1/60sec at f/11

*Y*ears of exposure to glossy travel guides have created the impression that the term 'seashore' is synonymous with an endless stretch of golden sand, fringed at the very least by a few picturesque rocks, preferably by swaying palm trees. Yet this kind of seashore is the exception to the rule, and for this reason I have opted to use an image of a much overlooked, but absolutely vital tropical seashore habitat: the mangrove. Mangroves consist of a select group of tree species that tolerate tidal salt water, and are fantastically important in protecting low-lying shores from storm erosion, helping to build new land. They also protect nursery areas for the fry and larvae of a huge range of marine animals, on which vast fisheries depend.

They can also be incredibly difficult to photograph, largely because their dense stands not only make it awkward to get a seaward view – usually the most interesting angle – but also because they create a rather unphotogenic featureless block of green.

This image is one of the best I have obtained of a mangrove tree, taken in a sheltered part of Subic Bay on the west coast of the Philippines. It was once a huge American naval base and is now a partly protected rainforest. When I found this tree, I was exploring some of the forest right down to the shoreline, looking out for populations of the endangered Philippine mallard which roost in these mangroves.

On the way back to my jeep, I spotted this lone mangrove tree, separated from the main mangrove forest and not only perfectly placed in the shallows, but also owner of a fine set of pneumatophores, the spikes that literally allow the tree's roots to breathe while still under water, and one of the mangrove's characteristic survival features. I paddled into the shallows to line up the perfect angle, making sure to use both a wide-angle lens and a narrow aperture to bring the entire picture into focus, from the nearest pneumatophore to the distant forest. It was a perfect mangrove view. A few minutes later, the morning was made still more perfect by the sight of a pair of black-tip reef sharks swimming past, just a few metres from shore.

trees

solitary trees

dense stands

young trees

ancient trees

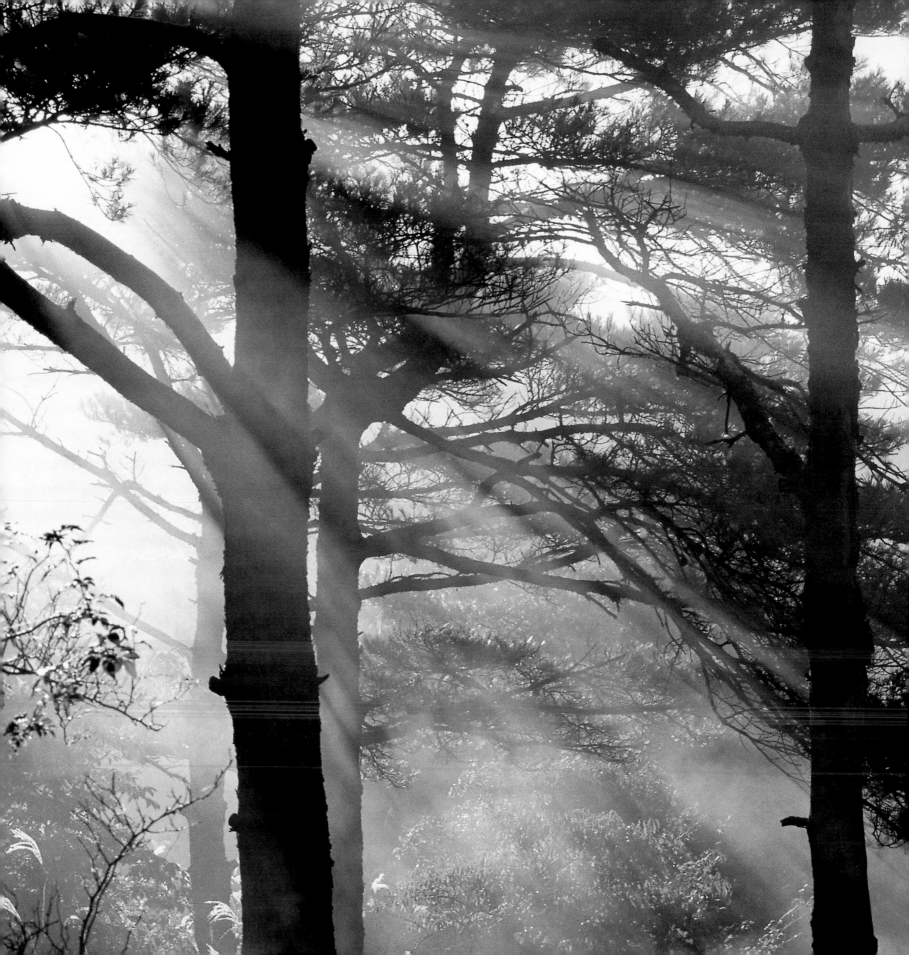

*P*hotographing trees can be one of the hardest subjects for the landscape photographer and yet one of the most crucial elements. Inevitably, trees feature somewhere in a great many landscape images, and when shown in the mid- or background, they serve to provide texture, colour and scale – as well as, on occasion, shape – to the overall view.

In the foreground, trees inevitably become the main feature of the image, offering the opportunity to generate some dramatic shots that say a lot both about the trees and their environment.

When photographing a lone tree, the shape of its outline makes a huge impact on the mood of the image. A tall, straight tree with a thick trunk suggests permanence and strength and produces an image that exudes a sense of calm and reassurance. A tree sculpted by the wind into a leaning position indicates the harsh, wild environment in which it exists, the diagonals in the image emphasizing a sense of dynamism or agitation. The mood of the image is also influenced by the angle from which the tree is viewed, the angle of the sun and the nature of the sky. To photograph a tree in its environment with the right shape, the right angle and the right light is absolutely crucial to telling the story of the tree and its landscape.

Photographing dense stands of trees is a different story altogether. How do you photograph a forest? Stand well away from its edge and you risk getting a uniform block of vegetation. Once inside the forest, more often than not it is difficult to, literally, see the wood for the trees. One solution is to focus on fragments of the forest; little cameos that give the idea of a vast forest without necessarily showing a great deal.

Sunlight, grey clouds, rain, and wind all have a major influence on what techniques can be used to photograph a forest and, therefore, the types of image you can achieve. The aim is always to grab images that really convey the atmosphere of the forest, the lushness, vitality and beauty of dense vegetation, whether it be tropical rainforest or Arctic taiga.

Every image should have a strong central feature, something to draw the viewer's eye into it, such as a striking tree or group of trunks, saplings reaching upwards, or leaves that are a dramatically different colour from the surrounding greenery. Without a strong central focal point, an image will simply come out as a tangle of disorganized vegetation. However, finding the perfect cameos in a vast forest is a daunting task, and raises the awkward question of whether, in the quest to convey the feeling of the forest, you actually end up highlighting the atypical rather than the representative. It is a question that may have no definitive answer, but is one that, when working in a forest, the photographer must try to balance with producing images that tell a story.

nb Ebino Kogen, Kirishima-Yaku National Park, Kyushu, Japan

My interest in nature is aligned to an appreciation of the teachings of an ancient Chinese philosopher named Tao Te-Ching. One of the central themes of Tao's teachings is the belief that in amidst the chaos of modern life, we should seek simplicity and, in nature, there is no better example than the tree. Within the tangle of roots, branches, twigs and leaves there is a very simple form.

With tree photography, I strive to capture this sense of simplicity. My aim is to eliminate the clutter and accentuate the elementary lines, form or pattern, thereby enabling the viewer to focus on what is important without distraction.

The classic solitary tree image shown here, rendered as a silhouette by the setting sun, is a perfect example of this approach. The simplicity of the image is as much about what you don't see, as by what you do. For example, the foreground was a recently ploughed field that detracted from the principal element. Underexposing this area to match the tonality of the tree has removed this distraction. Similarly, by allowing the setting sun to drop below the horizon rather than become the focus of the image, the tones are more subtle and balanced, leaving just a discreet range of tones to create interest.

The hedge helps to break the harsh line of the horizon that would otherwise conflict with the softer outline of the tree, and brings clarity of form that helps to unify the whole picture.

CW Solitary oak tree, Lee Valley, UK

Nikon F90X with a 300mm lens and 81B filter on a Manfrotto tripod, Fujichrome Velvia, 1 second at f/11

*T*here is something very majestic about a mature oak standing alone in a field, such a common sight throughout Britain's agricultural countryside. They give an impression of strength and permanence, their huge branches and gnarled bark expressing a durability that contrasts with our human frailty.

On this occasion I was driving through the Staffordshire countryside in England at dawn, a bitterly cold but perfectly clear morning at the start of winter. I was looking for images that would put over the feeling of this countryside and, in particular, the kinds of trees already established here, as the area was included in plans to create a vast new forest – the first to be planted in lowland, agricultural England in almost a thousand years. I was keen to find a subject that would make a strong silhouette against the dawn, a task that can be surprisingly difficult to manage on the hoof, without having spotted a subject in advance. I drove along winding country lanes, my frustration intensifying as the day became brighter and brighter when, finally, just as the sun was breaking the horizon, I came upon this lone tree standing in the middle of a field. Fortunately, not only was it close to an open gate, but there was space to park the car – a rare treat on such narrow country lanes. I grabbed my camera kit, raced into the field and stumbled across the newly ploughed surface, walking back and forth for several minutes within the tree's shadow until I had the sun in just the right place: perfectly silhouetting the tree, with a gorgeous starburst breaking around the trunk. Within a few minutes it was all over; the sun was climbing, making the silhouette less enticing and the orange glow of daybreak fading into the clear light of morning.

For me, this image is both a dramatic view of sunrise and a classic shot of an English oak tree; the silhouette revealing its strong, rounded shape, so characteristic of an oak growing in wide open space.

nb Lone oak, Needwood, Staffordshire, UK

Canon T90 with a 35mm lens on a Manfrotto tripod, Fujichrome Provia 100, 1/60sec at f/16

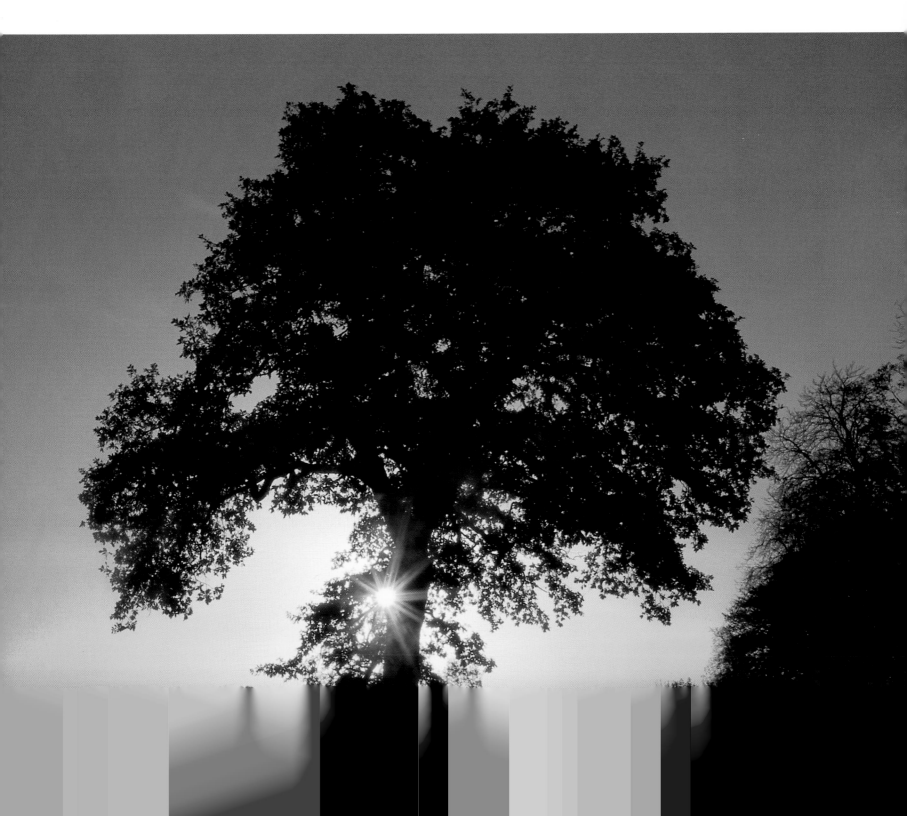

*P*hotographing a tropical rainforest when right in the midst of it can be one of the toughest assignments imaginable. All around is a dense, tangled wall of green, completely devoid of a single strong element so vital to a successful photograph. Hunting out those few possible places – usually some small clearing where a tree has recently collapsed, or along a river bank – can be a tiring, thankless task. There have been many times when I have hiked through tropical rainforest looking for those quintessential images, only to return to base hours later with just a handful of mediocre shots. And when I do manage to capture something dramatic, ironically it is almost by definition something that is the exception to the rule – a view containing some striking feature rather than the usual featureless tangle of forest.

Even rarer, then, is the image that manages to achieve two goals: contain a single dynamic element, and capture something of the density and tangle of the rainforest. This image manages just that. The single large tree catching a shaft of late afternoon sun, which has somehow managed to penetrate the forest canopy,

provides the all-important strong element, while the tree's acute angle adds a dynamic feeling that enhances the interest in the picture. All around, the forest crowds in, vines hanging from both the main tree and others around it, young saplings forcing their way skywards, and the leaves of a rattan framing part of the left-hand side of the image.

Best of all, I did not have to explore remote forest for hours on end to find it. A two-minute walk from my hotel room and I was out in primary rainforest, and within a few more minutes I had stumbled upon this image. I found it as a result of beating my way off the path towards a tree that looked rather interesting some distance away. That tree, so I discovered, was quite unphotogenic but, turning around, I was presented with this view.

Despite the sunlight, the depth of field required to make this image work meant using a slow shutter speed and a tripod. The shutter speed was slowed further by a polarizing filter; a vital addition to remove the vast amount of reflection bouncing off the leaves and the inevitable blue cast of indirect sunlight washing over the greenery.

nb El Nido, Palawan, Philippines

Canon EOS5 with a 28–70mm lens and polarizing filter on a Uni-Loc tripod, Fujichrome Provia 100, 1/15sec at f/11

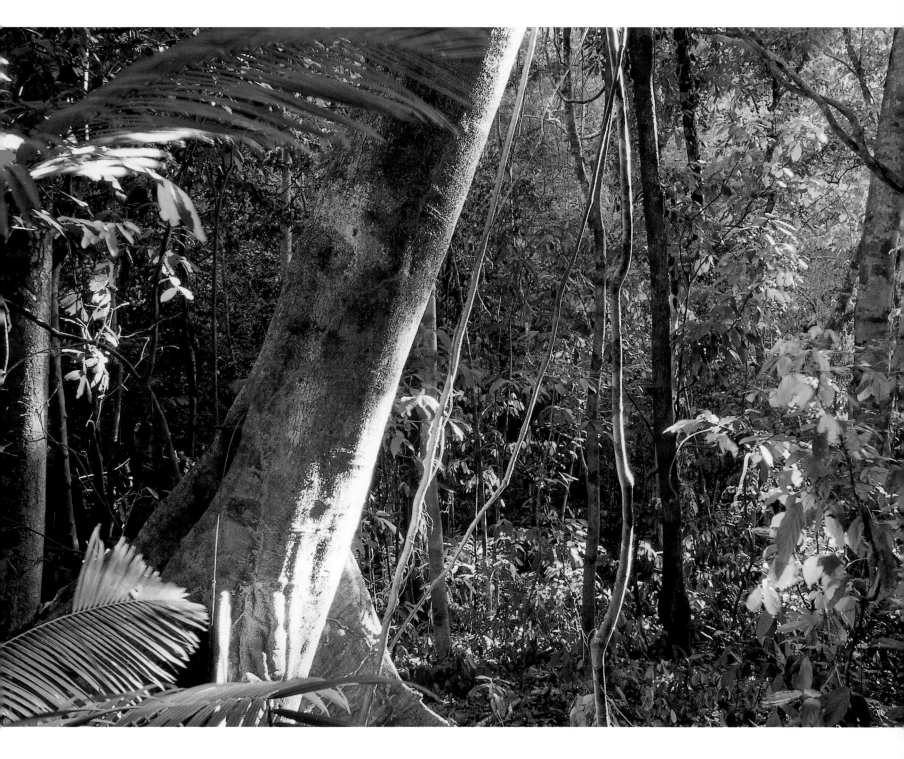

There is something humbling about forests. Photographing the antiquated sequoias of North America, the ancient kauri and giant red cedars of Australia's rainforests or – as in this case – the towering tree ferns of New Zealand's Whakarewarewa Forest is a great privilege. Technically, tree ferns are not trees, but like their ancient counterparts described above, the trees seem to grant protection, their fronds lending shelter from the outside world – so long as we return their hospitality and ensure our presence leaves no trace once we depart.

I have often felt this sense of guardianship when tramping through a forest or in dense woodland and, on occasion, been thankful for it, too. This was one such day. As the rain fell on the world outside, the broad fronds of these elderly tree ferns kept everything within their elongated reach dry, including me. It was this sense of protection that I wanted to portray in the photograph. To accentuate the height of the tree ferns, I lay on my back and positioned the camera low to the ground, pointing the lens up towards the extended branches. I composed the shot so as to give prominence to the circular pattern of the fronds, symbolizing a tree's life energy. Then, as the sun played hide-and-seek between the fast-moving rain clouds, I waited until the conditions and the light were just right, providing enough back-lighting to render detail in the leaves and accentuate the radial pattern of the umbrella-like fronds.

Photographing into the light in this way can be tricky, trying to find the balance between bright sky and deeply shadowed interior. I used a 1° spot meter and took a reading from a mid-tone green. I then bracketed a half-stop either side. To compensate for the blue tone cast by the dark shadows, I added an 81B/20CG filter, which adds extra punch to the green leaves.

For me, what makes this photograph stand out, is the visual energy created by the pattern of the tree fern fronds, giving what might otherwise be a static image, movement and life.

Whakarewarewa Forest, Rotorua, North Island, New Zealand

Nikon F5 with a 28mm lens and 81B/20CCG filter on a Manfrotto tripod, Fujichrome Velvia, 1/25sec at f/8

nb Changbaishan Nature
Reserve, Jilin province, China

**Mamiya RB67 with a 110mm lens and polarizing
filter on a Manfrotto tripod, Fujichrome Velvia,
8 seconds at f/11**

*E*xploring a forest, it is all too easy to be
mesmerized by the massive, fully grown trees
and to completely overlook the delicate
seedlings struggling upwards from the forest
floor. So, it is important to look downwards
from time to time and, at least occasionally,
rise to the challenge of capturing a seedling
or two on film. It is surprisingly difficult.

Where a seedling's thin stems and tiny
leaves are visible to the eye in the three-
dimensional world, in the flat two-
dimensional universe of a photograph they
often disappear into the background
vegetation. For me, a successful image of a
seedling is one that clearly shows not only
the young tree, but also its environment,
while at the same time ensuring that it
stands out against its background.

This picture, showing a young Siberian
spruce seedling growing out of the base of
an ancient tree – probably its parent – fulfills
both needs. Not only is the seedling itself
clearly visible, but its position at the base of
the old tree says volumes about its forest
environment and the role the young tree
will one day play in replacing its progenitor.

I stumbled upon this image when
wandering in the spruce forest of
Changbaishan Nature Reserve, one of
China's most important protected areas,
abutting the border with North Korea.
Stormy grey skies made my original plan to
photograph mountain and lake views quite
impossible, so I contented myself with
collecting images within the forest. This one
formed the final part of a sequence of shots
I took in an area where the forest floor was
carpeted with emerald green ferns. The light
was appalling but, despite this, I used a
polarizer to clean up reflections coming off
the wet leaves and to strengthen the greens
just a little bit more. Fortunately, despite the
worsening weather, there was little wind
within the forest, making a long exposure
feasible. However, shortly after I completed
this shot the heavens opened, and I was
forced to beat a soggy retreat to my
guesthouse, and all further photography
at Changbaishan was washed out.

CW Westland/Tai Poutini National Park, South Island, New Zealand

Nikon F5 with a 105mm macro lens and 81B/20CCG filter on a Manfrotto tripod, Fujichrome Velvia, 1/60sec at f/8

*T*ravelling the globe, I have had the opportunity to spend time with some of the world's indigenous tribes, cultivating a fascination and respect for their cultures – in particular, their art. While many of their long-held values and rituals have disappeared as a result of exposure to western culture, the art has remained and, today, is making increasing gains in influence and international acclaim.

For this image, I drew inspiration from the highly respected Maori carvers whose work has a distinctive style, not just in their use of visual elements but also in their approach to their material. The stylized spirals and organic forms of their designs are based on the curling young fronds of New Zealand's copious tree ferns.

Hiking through the forest around Lake Matheson on the South Island, I noticed the sunlight falling invitingly on this particular frond. Setting the camera on my tripod I used a 105mm macro lens to accentuate the detail on the stem, using the open leaves in the background to give the image a context. When photographing an image such as this, it is crucial to keep the film plane parallel to the subject, and finding the exact positioning of the camera can be time-consuming – and body contorting!

The true subject in this photograph is not the young frond itself but its shape. The spiral design reflects a universal pattern, that of the journey of life, death and rebirth.

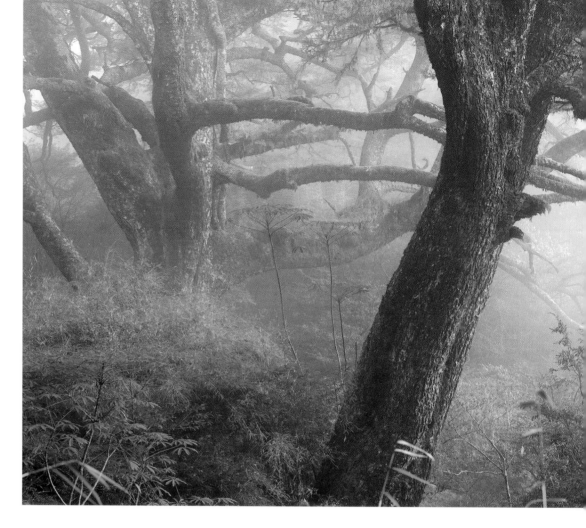

Yushan National Park,
Taiwan

**Mamiya RB67 with a 110mm lens and 81A
warming filter on a Manfrotto tripod, Fujichrome
Velvia, 3 seconds at f/11**

There is something primeval about ancient trees enveloped in fog. It is hard to deny the eeriness which perhaps stirs deeply buried, but lingering memories, of our ancestors' cave-dwelling origins. The ghostly views can make my skin creep and, while the range of potential photographs is usually limited, I love the opportunity to explore the possibilities for highlighting shape against light, often in an almost monochromatic environment.

Some of the most beautiful ancient forest I have discovered anywhere is in the mountains of Taiwan. Despite its appalling international conservation reputation, the island has some important national parks,

set in stunning mountain scenery, much of it cloaked by 2,000-year-old coniferous forests. Some of the best is in Yushan National Park on the island's highest mountain, the 3,952m (12,923ft) Mount Yushan, where much of the ancient coniferous forest lies in a band ranging between 2,000–3,000m (6,500–9,800ft) in altitude.

While much of the park is off-limits and without footpaths, an area at 2,600m (8,500ft) on the the park's western fringes is quite accessible. On this particular morning, I was exploring a trail in an area that works its way around a saddle known as Tatachia. Much of the route was across grassland in clear sunlight, but fog lingered in a few forested

areas, and it was in one of these that I came across this group of old Chinese hemlocks.

Heavy, gnarled and draped in moss, these trees, with their blanket of morning fog, are timeless. In this pocket of fog, the light was quite poor, necessitating a slow shutter speed and a warming filter to remove the likely blue cast. A light breeze rustled the surrounding bamboo, forcing me to wait for the occasional calm moment to press the shutter. Despite this, I had to work quickly as I was afraid the fog would lift at any time. I was right. I had barely finished when the fog suddenly pulled away, and although the trees remained impressive, the sense of mystery was gone.

Nature has a habit of making something ugly seem beautiful. I spotted this old tree during a trip to the Lake District in England, and was instantly amused by the way the folds of bark had seemingly slipped down around the foot of the trunk. Affectionately, I named it 'Nora Batty' after a character in a British television comedy, renowned for her wrinkled stockings. I love this tree; standing in isolation, as if cast out like an ugly duckling, it has a personality all of its own which I wanted to capture on film. I spent four hours isolating the elements that gave it its form and deciding on the best composition.

Often, when we think of ancient trees, we envisage towering giants like the sequoias of North America or the oaks of Britain. Here, however, I had a different perspective: age depicted not by size, but by texture and form. Focusing on this, I chose a short telephoto lens to isolate the bottom portion of the trunk from its environment and help blur the background.

The light was coming from the right-hand side and throwing the left-hand side of the trunk into dark shadow, which was not ideal. To alleviate this, I used a large gold reflector to throw light back onto the trunk, accentuating the line, form and texture of the bark that gives the picture its depth and shape.

For me, 'Nora Batty' is a reminder that looking beyond the obvious often reveals the hidden beauty of nature.

CW Lake District National Park, Cumbria, UK

Nikon F5 with a 100mm lens, 81B/20CCG filter on a Manfrotto tripod, plus a reflector, Fujichrome Velvia, 1/30sec at f/11

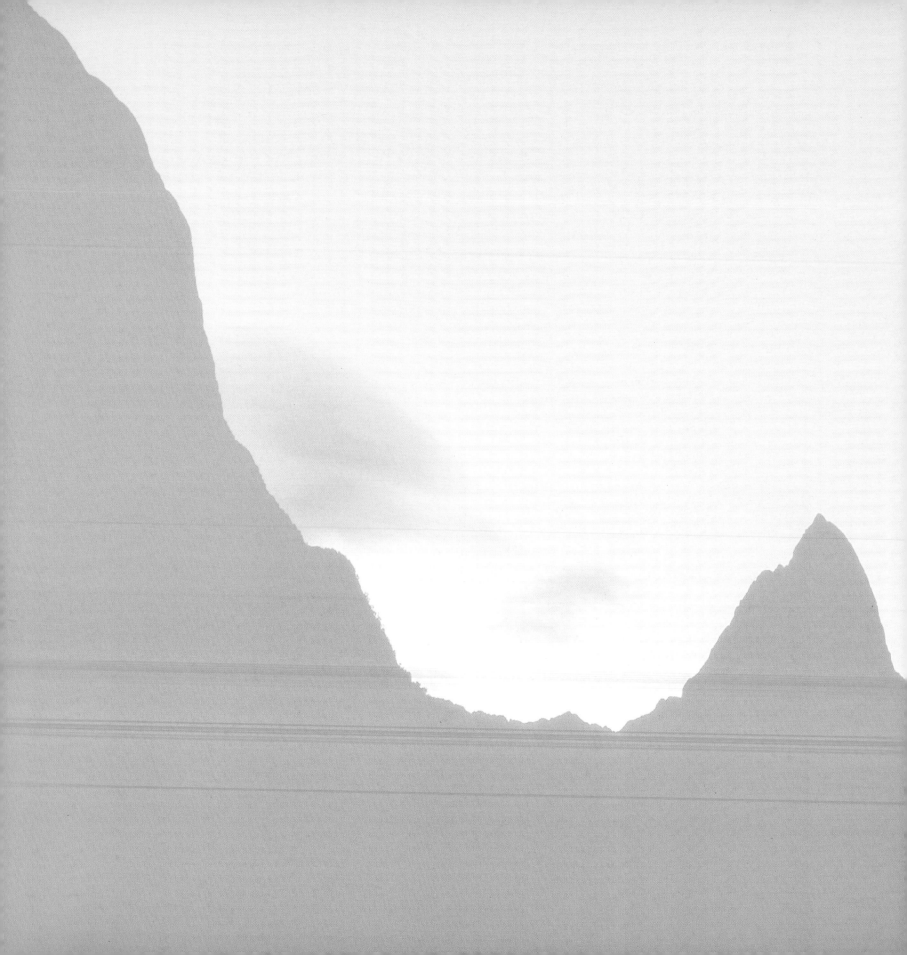

sky

dusk

dawn

night skies

stormy skies

sunshine

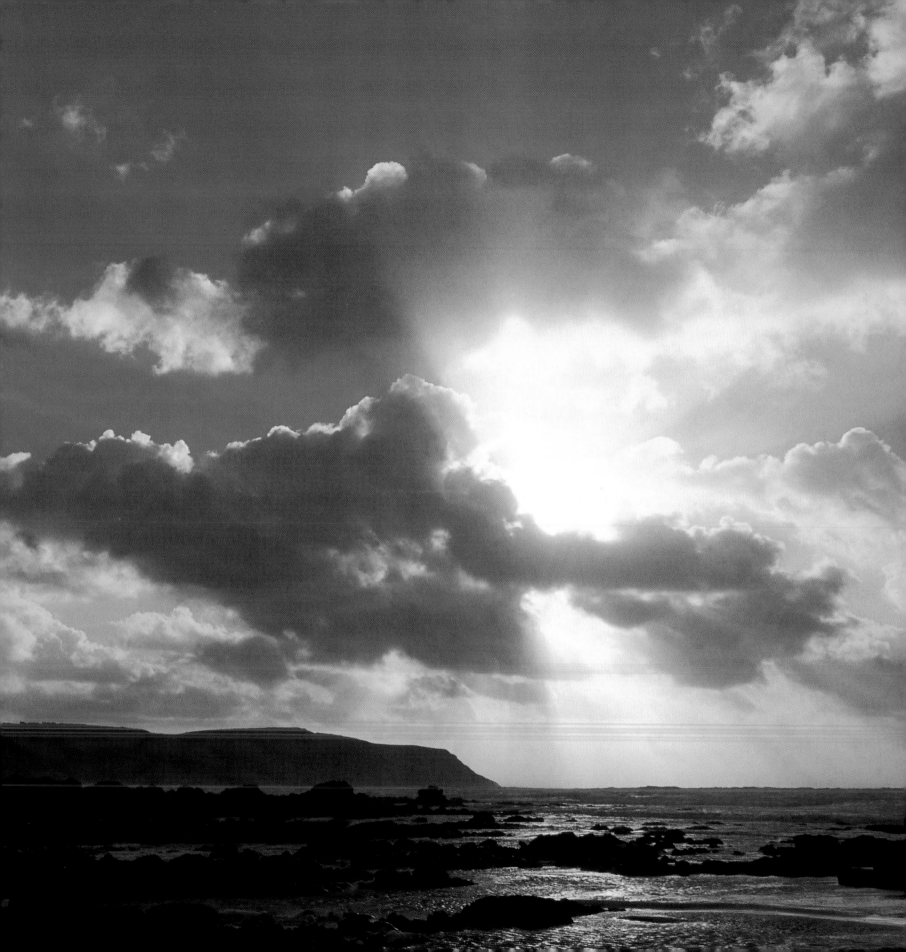

While sky is usually an important element in the majority of landscape images, it is normally present in a supporting role to the main subject, providing background colour, helping to establish a mood, or simply filling the remainder of the frame. It is not often itself the principal subject of an image. This is a shame, because the sky can be fantastically beautiful. It is endlessly varied, composed of a host of colours, and filled with a vast range of different cloud types and shapes.

It is the sky's variety that makes it one of the greatest sources of atmosphere for many landscape images. When the mood in an image is calm and soothing or wild and angry, for example, it is often because of what is in the sky in terms of light, colour and cloud. There is little point shooting a calm, soothing scene when the sky is full of angry scudding clouds, and just as pointless to attempt to convey the feeling of a storm on a calm, clear evening.

So, inevitably, landscape photography is closely tied to the mood of the sky. One does not, however, often set out on a photo shoot specifically to collect sky images: you just grab interesting views as they appear, usually while shooting another subject, snatching occasional sky shots as and when engaging colours, cloud formations or perhaps rainbows appear. The one exception to this is at night, when photographing stars. The long exposure times ensure that your work concentrates on that and nothing else.

Perhaps the most important times of day for sky photography are at dawn and dusk. A clear sky or, better still, one with a thin smattering of clouds, can offer spectacular colours, lending a calming, angry or inspiring mood to an image, becoming a beautiful piece of art in itself. Even in this situation, the sky is usually there as a backdrop to a landscape feature, but during a particularly superb dawn or dusk, it is worth concentrating on the sky alone.

Whenever you photograph a landscape you constantly have to think about the sky – its colour, the type of clouds, and how quickly the patterns change. Even when it is not the main subject of an image, you should always keep an eye out for occasional striking patterns and colours that justify a photograph.

Widemouth Bay, Cornwall, UK

*T*he word photography means 'painting with light' and, as my photography has developed, I have become increasingly aware of how many aspects of painting also apply to photography. I have learned a lot about composition and design from studying books on watercolour painting, and my image-making has improved as a result.

The key difference between the two art forms is that while artists start with a blank canvas and add colour and line to create an image, photographers start with a full canvas and isolate the desired subjects, removing any unnecessary clutter. While the methodology may be different, the results can be remarkably similar and I have seen paintings that on first sight could pass as photographs, and vice versa.

As I sat and watched dusk settle over this small lake in the Okefenokee National Wildlife Refuge, it was the texture of the sky that immediately grabbed my attention. The rolling folds of cloud appeared like brush strokes in an enchanting watercolour, and I was fascinated by their form.

With the camera on a tripod, I composed the image to give prominence to the sky, selecting a vertical format to reduce the element of land and accentuate the perpendicular trunk of the dead tree that creates a sense of height, leading the eye upwards through the image.

For the exposure, I took a reading with a spot meter from a mid-tone section of the sky. The contrast in tones between the clouds and their reflection in the still waters of the lake was quite pronounced. Because I wanted to include some detail in the reflection, I used a graduated neutral density filter to even out the tones.

The primary subject in this image is not the landscape nor, truthfully, is it the sky. What I was essentially photographing was the texture of the clouds, using the remaining elements to convey a sense of place. Taking the lead from my artist cousins, this image illustrates how the tool of our trade is not simply a camera, but the basic elements of design.

Okefenokee National Wildlife Refuge, Georgia, USA

Nikon F5 with a 50mm lens and graduated neutral desnity filter (0.6) on a Manfrotto tripod, Fujichrome Velvia, 1/2sec at f/22

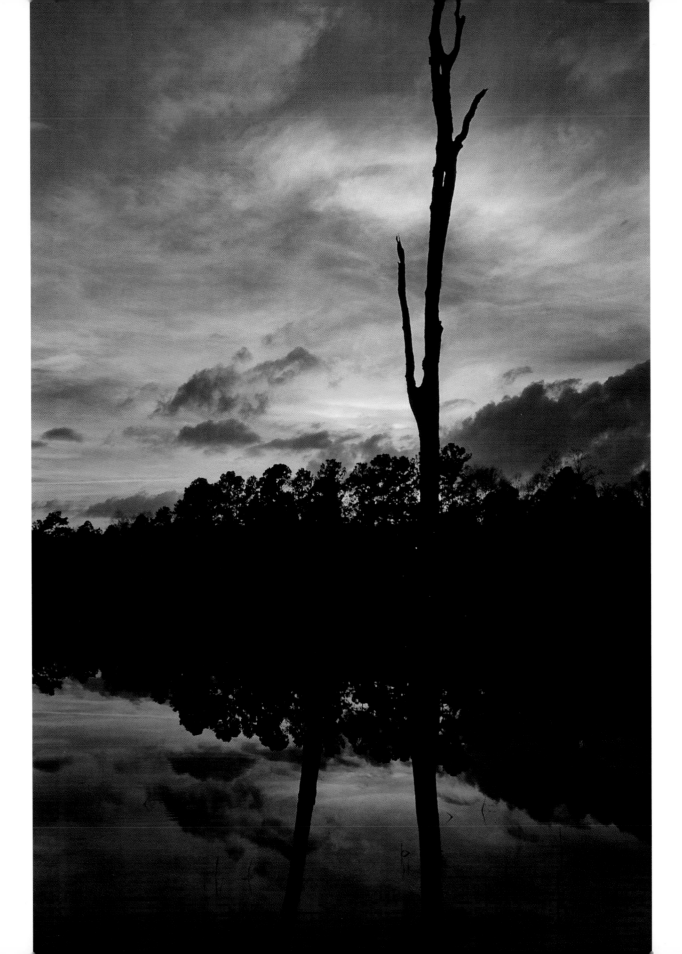

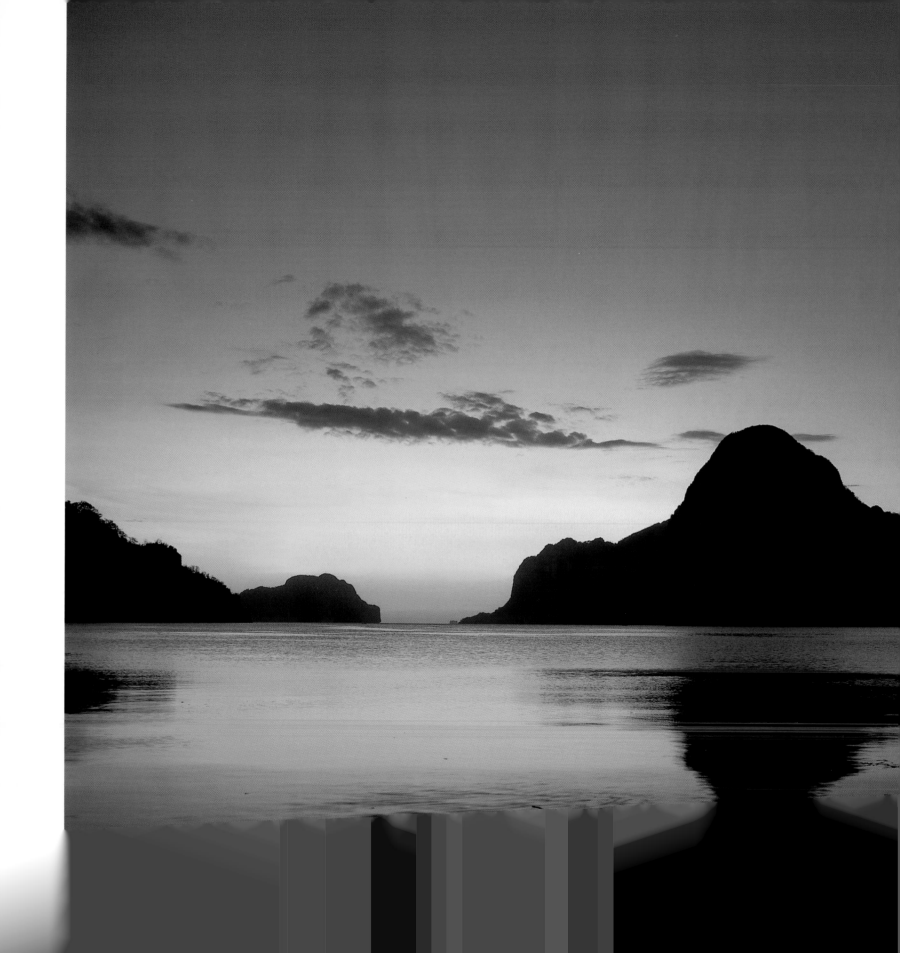

The dusk sky can be one of the world's most beautiful sights. The graduation of oranges and reds near the horizon, rising into violet and then darkness towards the east is a soothing antidote to the busy hours of the day. I am always astonished at how many people gaze in wonderment as the sun sets, but then turn around and walk away the moment it slips below the horizon. As far as I am concerned, the sunset is just the warm-up to the often far lovelier show that is dusk, the final burst of colour and light that follows a little later, just before night sets in.

Despite years of practice, I still find it difficult to predict a great dusk. Obviously you need clear weather, but really clear weather usually results in a dusk with few colours in the sky. What is required is just the right amount of dust and/or water vapour in the air to generate good dusk colours. A smattering of clouds to reflect the colours helps, too, although cloud that is too dense or low will ruin the effect. And then there is the wind. A calm dusk image depends on the absence of wind; moving clouds, blurred as a consequence of the inevitably slow shutter speed results in a dynamic, agitated image that is anything but calming.

In the image shown here, all the right elements have come together; the sense of calm is heightened by an almost perfect reflection of the island's silhouette in the flat, tranquil sea. The view was photographed at El Nido, a remote location in the west of the Philippines that is becoming increasingly famous for its beautiful bay and string of offshore islands. I went there as part of a project to record the country's protected areas, of which El Nido is one. I stumbled upon this view on my first afternoon in the area and, realizing that the island would make a great sunset and dusk silhouette I made a date to go back there that evening. I photographed the view from right on the shoreline, starting from just before sunset and finishing after dark, all the time having to retreat before the rising tide. It was a perfect dusk, making it very simple, and a joy to shoot. The hardest part was getting there.

nb Cadlao Island, one of the Bacuit archipelago, El Nido, Palawan, Philippines

Mamiya RZ67 with a 65mm lens on a Uni-Loc tripod, Fujichrome Velvia, 4 seconds at f/5.6

nb Penang, Malaysia

Mamiya RB67 with a 65mm lens on a Manfrotto tripod, Fujichrome Provia 100, 1/30sec at f/8

There is little, if any, difference between the quality of light at dusk and dawn, although the latter is, perhaps, less prone to the effects of air pollution and dust, and more likely to be affected by mist or vapour. And despite folk tales warning that a red sky in the morning is a shepherd's warning, a warm glow at dawn can herald a wonderful day, just as much as a red glow at dusk can round one off. A fiery dawn, however – as with this image – usually does forewarn of approaching storms.

All the problems of predicting a good dusk, as well as the factors that ought to contribute to a great one, apply to dawn, with the added difficulty of having to drag yourself out of bed in time, irrespective of whether you end up with a great show. Many are the times I have crawled from sleep to a superb dawn viewpoint, only to be disappointed. But, many are the times, too, when I have missed great dawns because I could not pull myself out of bed. Those occasions when I have matched my level of wakefulness with great dawns have proved to be truly memorable experiences.

So it was with this image: a glowing dawn on the island of Penang, off Malaysia's west coast. My original plan to shoot views of Penang at dawn did not really come off. Instead, the sky itself became the spectacle of the morning, the dawn and sunrise light creating a kaleidoscope of colour and pattern overhead. The swirling clouds suggest turmoil in the heavens which, coupled with the vivid, warm colours, result in an agitated, dynamic image. If it transmits a feeling of impending doom, then that is just about right. Later that day, a storm of torrential rain broke, which lasted off and on for the next three days.

Sometimes, there are no deep, hidden meanings to a photograph; times when pre-visualization and planning go out the window, and you act on instinct. I had woken early to visit a nearby lake renowned for its reflective properties, expecting a calm, still and clear morning. When I saw the dawn canopy, however, I quickly grabbed my camera and tripod and, half-dressed and unshaven, headed for the door.

The brilliant red clouds edged by dark, sooty grey was, quite literally, like a fire in the sky. I could almost feel the heat from the colour alone. Compositionally, I framed an area of sky where the clouds had gathered in earnest and used the silhouette of the tree to add a sense of place. I took a meter reading from a section of clear sky out of frame and opened up half rather than a whole stop knowing this would marginally underexpose the sky, so saturating the colour of the clouds. The main problem with photographing skies like this is the amount of time you have before the scene changes. Once I'd set the camera on the tripod and composed the shot, I barely had time to fire off a half-dozen frames before the light changed and the view dissipated.

Over the years, I have witnessed many of Mother Nature's spontaneous exhibitions.

Sometimes, when you're working, it is easy to get caught up in the pressures of the job and miss the splendour of what you are doing. Other times, however, in the early light of day, you get a chance to just sit back and enjoy the show.

CW Fox Glacier, Westland/Tai Poutini National Park, South Island, New Zealand

Nikon F5 with a 200mm lens on a Manfrotto tripod, Fujichrome Velvia, 1/12sec at f/8

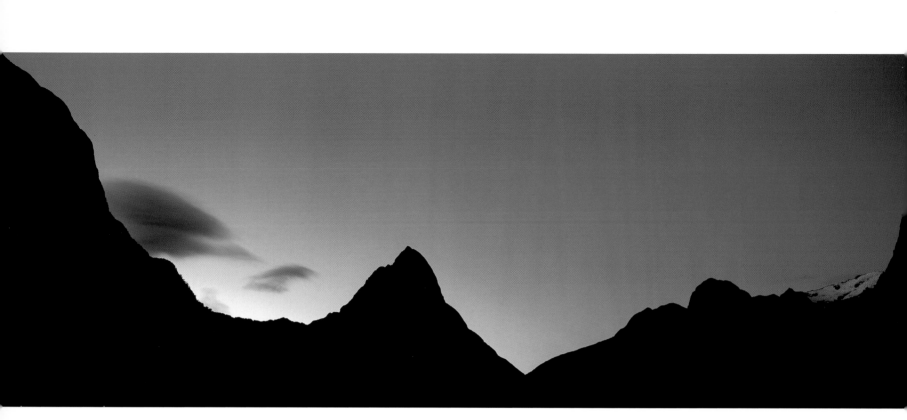

Often, when photographing the sky at night, it is easier to focus on the objects in the sky rather than the sky itself. The moon, stars and planets, bolts of lightning, all capture the imagination because of their vibrancy or the patterns they create against the dark backdrop of the heavens.

With this image, I wanted to focus solely on the sky and make it the principal subject of the photograph. The timing of this shot was crucial, as I wanted to capture the multiple layers of colour as the sun fell away beyond the horizon. Importantly, I wanted to arrest the deep blue hue that, for me, so epitomizes the night sky.

I used the panoramic format to establish and emphasize a sense of space. To heighten the sensation of the abstruse power of space, I composed the mountain peaks in such a way that they add a mystical intensity to the picture, placing the pyramid-like form of Mitre Peak, in New Zealand's Fiordland National Park, in the centre of the frame.

Throughout this book, there are images that make use of triangular shapes and diagonal lines to portray mysticism, movement and strength. Perhaps the strongest rendition of a triangle is in silhouette, as shown here. The silhouette helps to focus attention on the light in the sky, which was my aim when composing the photograph.

Some photographers will tell you the only rules of landscape photography are 'f/8 and be there'. Finding where 'there' is, however, is not simply a matter of luck. The image you see here is identical to

Milford Sound, Fiordland National Park, South Island, New Zealand

Hasselblad Xpan with a 90mm lens on a Manfrotto tripod, Fujichrome Velvia, 3 seconds at f/5.6

the image I perceived in my mind when I considered the shot for this book, which emphasizes my point that we can have better control over our photography when we are clear in our mind's eye what it is we want to achieve.

A star-filled night sky is one of nature's great shows, but it is one that all too often is dimmed by air pollution and city lights. In the countryside, to see this free light show all we have to do is look up. To photograph it is quite a challenge. An obvious but often overlooked fact is that the show is constantly on the move, slowly arching across the sky. Slow shutter speeds will not help the brightness of the stars on-film, but they generate an image that shows the stars tracking their way across the sky.

The stars' brightness in the final image depends largely on the lens aperture used. The trouble is, how big an aperture do you need? It all depends on the clarity of the air and how much light interference there is from either the moon or artificial light. It is almost impossible to suggest a rule, except that the wider the aperture, the better.

Manmade light pollution is, perhaps, one of the biggest hurdles to successful starlight photography and, in crowded England at least, it can be surprisingly difficult to find night views that are completely free of it. The image shown here was taken during a trip to Snowdonia National Park in Wales. Out in the mountains, the sky was completely free of light, and the air beautifully clear

(though also bitterly cold), so I was able to obtain this image across one of the mountain ranges. The one-hour exposure shows the stars moving quite some distance in their arc, while the stars' individual intensities comes out clearly both in the brightness of their tracks and in their different colours, something impossible to grasp with the naked eye. For me, this is a dynamic and revealing image of the night sky.

 Snowdonia National Park, Wales, UK

Mamiya 645 with an 80mm lens on a Uni-Loc tripod, Fujichrome Provia 100F, one hour at f/5.6

Stormy skies are among the toughest of landscape subjects to photograph since, by its very nature, catching the subject in an interesting light will be in part down to luck and to an ability to catch fleeting moments. The adage that 'if you've seen it, you've missed it', is wholly apt.

There are several kinds of storm, in which the light will vary greatly, thus affecting the chances of grabbing some interesting shots. The height of a winter storm is likely to provide few, if any, opportunities for good stormy sky images since, in my experience, under these conditions, everything becomes a sodden, uniform grey. Success here depends on catching conditions either before the storm arrives or shortly after the worst has passed, times when visibility is likely to be reasonable and the cloud is at least partly broken.

Short, sharp showers often provide the best opportunities, the frequent breaks in the cloud allowing shafts of dramatic sunlight to break through, while a low sun shining under a bank of storm clouds can result in some beautiful inky black skies. If a strong wind is blowing the showers through at speed, so much the better as a period of just a few hours should provide a range of interesting lighting possibilities. The main difficulty is being able to shoot quickly enough to grab short-lived ideal moments.

The image shown here belongs to the first category of stormy sky images; the build-up to a massive winter storm. One winter morning, I watched the storm gradually building, a veil drawing across what little sun there was, and the cloud slowly thickening and darkening. I headed up onto some hills close to my home, prepared my camera and waited for them to shift around the sun until they generated an interesting cloud formation and a large enough break to allow some sunlight through. I managed to fire off a few frames before the cloud closed in for the last time, and we were into a dull greyness that slid slowly towards the approaching storm.

At the time this photograph was taken the wind was still quite light, which is reflected in the clouds; while a little angular, they are not the ragged speeding clouds indicative of a strong wind. The cloud-filtered, just-visible sun provides the dramatic light that makes this image possible, highlighting the shapes of individual clouds, and emphasizing the many layers of cloud that make up this developing storm. The final image, which preceded the storm, forebodes the rains and raging winds that were soon to follow.

nb Stormy sky, south Devon, UK

Mamiya 645 with a 55mm lens and ND3 graduated neutral density filter, handheld, Fujichrome Provia 100F, 1/60sec at f/5.6

As a child, I watched and listened to thunderstorms from my bedroom window, and would think of mighty battles between vast, unseen armies being fought among the clouds. The crashing of thunder was the sound of charging stallions, and lightning the spark of steel against steel as the swords of brave warriors clashed in mortal combat.

The weather on this particular day in the Highlands was typically Scottish: unpredictable and ever-changing. The morning began gloriously, the rising sun casting a warm glow over the lochs around Glengarry. As the day wore on, however, storm clouds began to settle in and brief blinks of sunlight were interspersed with flurries of rain, sleet and snow. I made my way towards the Kyle of Lochalsh where, sitting in the car park peering through the rain at Eilean Donan Castle, I recalled those long-ago thoughts and images of battle that occupied my young imagination.

With this picture, I wanted to create an overwhelming sense of battle: of fiery skirmishes and bloody feuds. As I waited for the sun to set, the storm intensified – not the most compelling weather for photography. Finally, however, during a brief lull, I got the conditions I wanted, and I ventured from the car with camera, tripod and umbrella. This is a dark, intense image, full of foreboding. The bleak stone walls of the castle and bridge enhance the sombre mood. The thunderous storm clouds in the upper left-hand quarter of the picture intensify the sense of battle, while the setting sun, casting its fiery glow over the hills in the background, speaks to me of bloodshed. The whole image is embellished by the reflection in the murky waters surrounding the building.

While this picture is commercially unviable (it has never before been published), it is one of my personal favourites. Its gloominess makes it unappealing to postcard and calendar publishers but, for me, it is this aspect that gives the picture its identity and life.

Eilean Donan Castle, Kyle of Lochalsh, Scotland, UK

Nikon F90X with a 35mm lens on a Manfrotto tripod, Fujichrome Velvia, 6 seconds at f/22

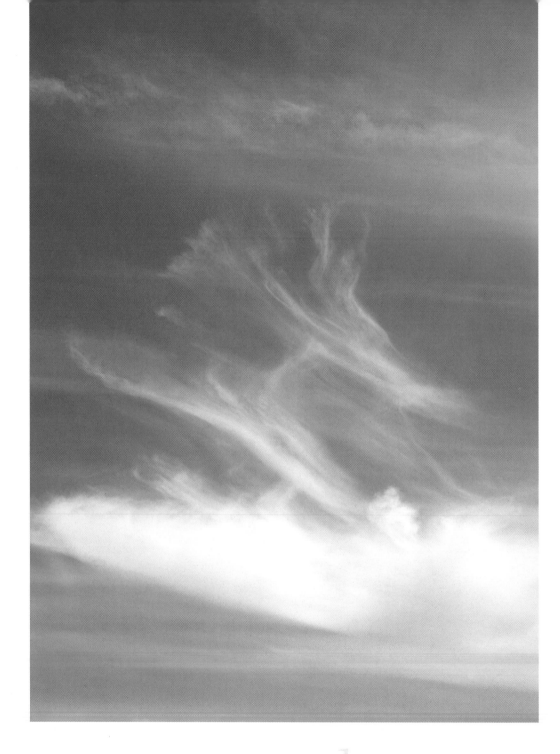

When I was young, I played a game called 'cloud angels'. Lying on a hillside on a sunny day, I watched clouds form and reform overhead, creating imaginary pictures in my mind. Galloping horses became fiery dragons, and then mermaids and leaping dolphins as wispy clouds melted across the sky.

While thinking about this section, I reflected on the game that so enchanted me when I was young. Taking just my camera and my tripod, I retraced those youthful steps to a nearby hill. Once there, I simply sat and watched the sky, waiting for the images to form.

I was uncertain what I would find, so used my versatile 24–120mm zoom lens to enable me to make an exact crop. The blue of a midday sky is a mid-tone, and I metered from a clear section to give me an accurate exposure value. Finally, I set the focus on infinity and waited.

As I got back into the hang of the game, I began to compose images with the low-lying cloud formations; some obvious, others less so. As the cloud patterns changed, I spotted the image shown here immediately. Framing purposefully, I pressed the shutter and headed for home.

'Cloud angels' is not an exact science. The images we see are unique and personal; often similar, but sometimes very different and, like a novel, the visualization is left to the reader. The image I saw in these clouds may not be the same image that you see. Whether it is or whether it isn't, I guess we will never know.

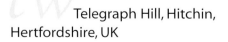

cw Telegraph Hill, Hitchin, Hertfordshire, UK

Nikon F5 with a 70mm lens on a Manfrotto tripod, Fujichrome Velvia, 1/60sec at f/16

nb Mortehoe, north Devon, UK (*facing opposite*)

Mamiya 645 with an 80mm lens and polarizing filter, handheld, Fujichrome Provia 100F, 1/125sec at f/8

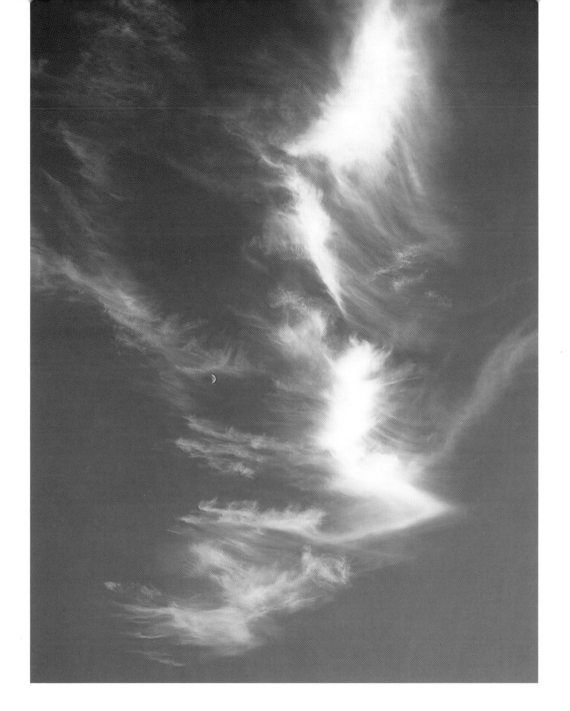

and for good reason; these are the conditions that tourism photography demands in order to show off local attractions in, quite literally, the best light.

But for the landscape photographer intent on catching moody, dramatic, evocative images, are picture-postcard conditions appropriate? Many landscape photographers, during summer at least, habitually shoot very early or very late in the day; specifically to obtain atmospheric images that avoid the quality of light so typical of a summer's day.

However, that summery, sunlit blue sky is, in itself, a mood and should not be wholly overlooked. Sometimes, you can come up with something quite interesting – often an image resulting from unusual cloud patterns in the sky. Such is the case with this image: an intriguing cloud pattern, high overhead on a summer's afternoon, complete with a crescent moon in the clouds.

I was actually taking a well-earned break from work, enjoying a camping holiday with my son, so photography was pretty low on the list of priorities, though I still had a camera with me, 'just in case'. I was in the middle of cooking when, for some reason, I looked up and spotted this cloud pattern. I was taken by its sharp angles and delicate flecks, so abandoned the food, grabbed the camera and fired off a string of frames.

The resultant image is not dramatically lit but, for me, is attractive for the overall composition of the white clouds within the frame and the blue background. The angles of many of the clouds are quite dynamic, balanced by the grace of the swirling wisps trailing off the edges.

What a contrast an image of a sunny summer sky is compared to one depicting the anger and gloom of winter's stormy clouds. Just to see the deep blue expanse flecked with cotton-wool whites, is a cheering sight, full of the promise of summer sunshine.

Such a sky could hardly be simpler to photograph, and yet therein lies the challenge. If it is that easy, then anyone can do it – so how do you make your images stand out? Beautiful views photographed under blue summer skies are often considered to be 'picture-postcard' perfect,

close-up

abstract patterns

rock formations

streams and rivers

forest

leaves

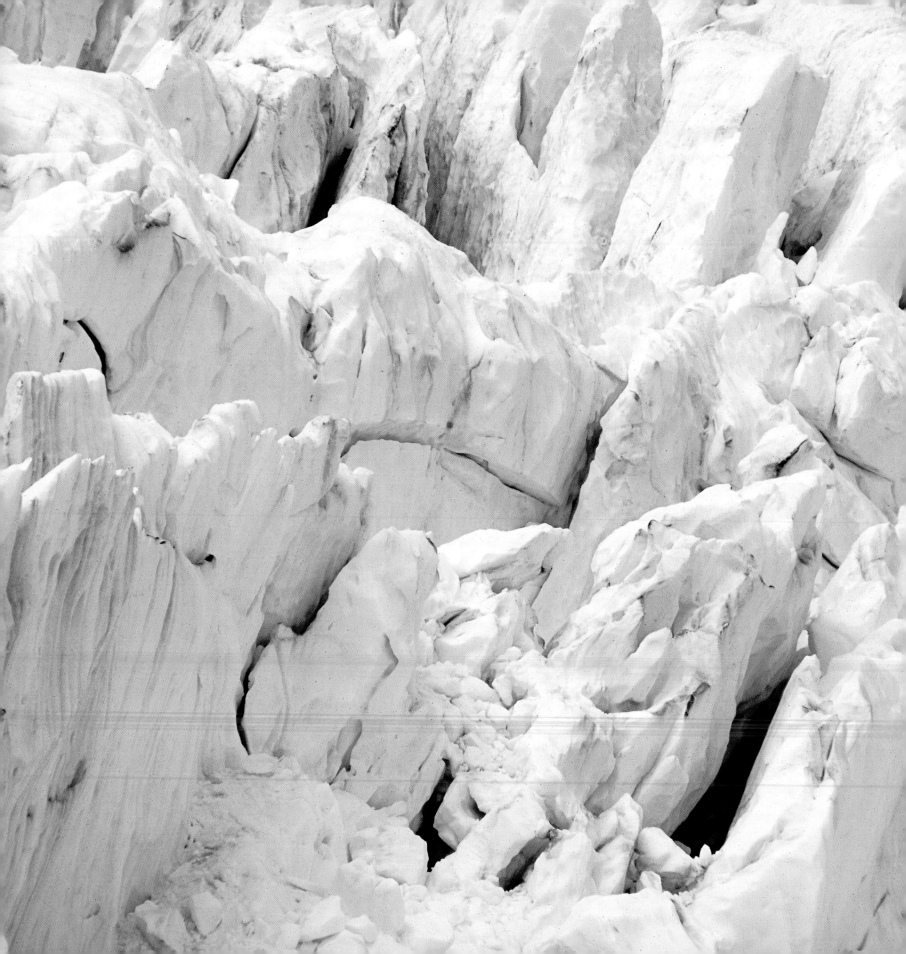

losing in tight on a subject to photograph only a single small component generates a very special kind of landscape image. No longer are you trying to convey a comprehensive view of an environment, but instead some fragment that is either simply pleasing or in some way suggests the landscape as a whole beyond the confines of the viewfinder. Many close-up landscape images hopefully achieve both. A close-up of water rushing around rocks is both an aesthetically pleasing image, and one that gives a sense of the wild mountain stream where it was taken. A detail shot of a dense stand of trees may produce an abstract pattern, but it also conveys the feeling of an immense forest.

It is not easy to spot the miniature within the wider, grander landscape, as your mind and eyes are more often filled with the complexity of the larger scale of the scene. To penetrate the landscape and see just the details, you need to shut out the wider view, and develop a kind of tunnel vision that can scan the overall view, section by section, in search of the interesting close-ups. Sometimes, technology comes to the rescue here; a telephoto lens proves very useful when scouring for those unexpected compositions and juxtapositions, elements that are often lost in their surroundings, but which jump right out at you when isolated by a viewfinder.

It is worth making a conscious effort to search out these miniature landscapes when the larger view is uninteresting or difficult to make into a meaningful image, or when the light is not good and it is better to make images that eliminate sky. Many of the most artistic landscape images, ones that work well in an exhibition, are of landscapes in close-up, images that range from simple cameos to the wholly abstract.

Fox Glacier, Westland National Park, South Island, New Zealand

Nature can produce some stunning, diverse, abstract patterns, but spotting them in the landscape can be a difficult process. They generally do not exist as major elements in the landscape, but as small ones that can be easily overlooked in the overall view, and which need to be isolated from their surroundings to produce a good image. They can occur almost anywhere, from the interplay of light on rolling hillsides, the differing colours of tightly packed trees, to minute crystals of ice. You simply have to develop a sharp eye to pick out the details.

Achieving this can be very much a matter of luck, however. A practised eye is definitely a major asset. One thing I have found through experience, is that I almost never find the best abstract patterns when I am specifically looking for them. I usually stumble across them while shooting other subjects, although I generally have a tiny part of my mind attuned to the possibility.

Such was the case with this image. One December day, I was out walking around the base of Mount Snowdon, the highest mountain in Wales, trying to photograph it and its reflection in Llyn Llydaw lake. Close to the lake's shore, I walked through an area in shadow where a small marsh, untouched by the sun's weak rays, still lay frozen. The ice had started to melt and fractured into an interesting wave-like pattern which, coupled with the air bubbles that lay trapped around clumps of grass caught in the ice, produced a very pleasing effect.

Deciding which part of the marsh to photograph and how close in to bring the camera took quite some time, and I ended up shooting several different views, of which this image is my favourite. The darkness of the image, a result of under-exposing by one stop, accentuates the white patterns in the ice. The clusters of bubbles break up the uniformity of the wave-like lines. The diagonal nature of the pattern makes the image quite dynamic, while I find the overall monochromatic grey-blue cast soothing.

nb Cracked ice, Snowdonia National Park, Wales, UK

Mamiya 645 with an 80mm lens on a Uni-Loc tripod, Fujichrome Provia 100F, 1 second at f/11

In my early days as a landscape photographer, I only selected images that conformed to a certain sense of realism. I photographed the patterns that nature laid out in front of me in a literal manner. However, as time has passed, spent out in the field studying nature and understanding my craft, I have learnt to rely more on my own interpretations and sense of the aesthetic to create images. In so doing, my pictures have become more abstract in their design, as I have challenged my natural assumptions with new relationships and distinct ways of seeing. Ultimately, this makes the art of photography so much more interesting.

When I first witnessed the geothermal region of Rotorua in New Zealand, I was drawn by the myriad kaleidoscope colours, the patterns and shapes formed by the mineral pools and terraces of encrusted silicates, dripping like stalactites. A well-marked footpath, interspersed with boardwalks, allowed a panoramic view of this sulphuric world. Swapping my wide-angle lens for a 400mm telephoto, I began to turn away from the landscape itself to concentrate on the patterns that formed the landscape.

The compositional elements of this image are very strong. The mix of complementary colours – orange and blue – makes each hue vibrate intensely (a phenomenon first exploited by the French impressionist painters), while the meandering line of white sediment leads the eye naturally through the picture.

I used a small aperture to maintain detail throughout, from the small layers of crust in the foreground to the tiny bubbles in the background.

The resultant image shows how the arrangement of colours, patterns and shapes can be set free from conventional representations of the world and takes photography into a more surreal form of art. Exploring the abstract encourages you to use photography to convey personal vision more than concrete reality.

CW Wai-O-Tapu, Rotorua, North Island, New Zealand

Nikon F5 with a 400mm lens on a Manfrotto tripod, Fujichrome Velvia, 1/25sec at f/22

*A*s we can tell the life story of a tree from the concentric rings of its trunk, we similarly get an understanding of the history of metamorphic rock from the layers of turbulence made visible by the patterns across its surface. For me, it is these patterns that give rock formations a sense of life; they turn an inanimate mass into an active form.

I was first drawn to this image by the near perfect line of vertical layers. As I stood and looked at the pattern of creases, they drew my gaze up the sheer rock wall, emphasizing the height of the cliff face. Vertical lines convey a sense of strength, motion and upward growth. When composing the photograph, cropping in tightly with a short telephoto lens, I used this pattern to recreate the optical effect.

The scene is soothing, predominantly because of the gently trickling water in the stream at the foot of the cliff wall. This provided me with the all-important horizon line that gives the picture both a relaxing orientation and a sense of place. I deliberately positioned the horizon line just below the centre of the picture to give weight to the principal subject, the rock formation above.

I included the spherical rock in the foreground to provide further balance and create an additional sense of energy. The power of circles and spheres is contained within their own circumference, and naturally draw the eye to them. The strong pattern of lines provides the necessary balance, and our eye travels easily back and forth between the two elements, creating a visual energy.

What I like most about this image is the dynamism of the three key elements working together. It is their interaction that animates the image and turns what would otherwise be a flat, static scene into one full of life.

 Franz Joseph Glacier, Westland/Tai Poutini National Park, South Island, New Zealand

Nikon F5 with a 100mm lens on a Manfrotto tripod, Fujichrome Provia 100F, 1/12sec at f/16

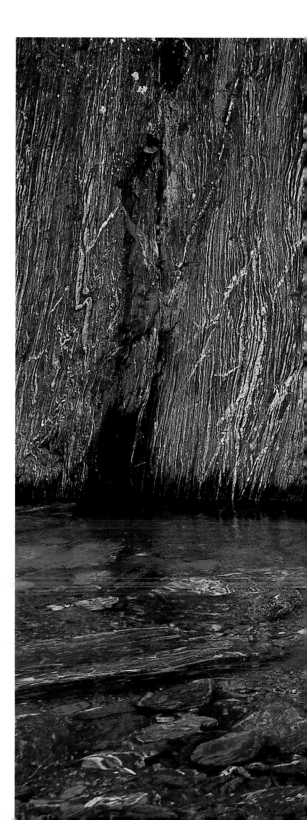

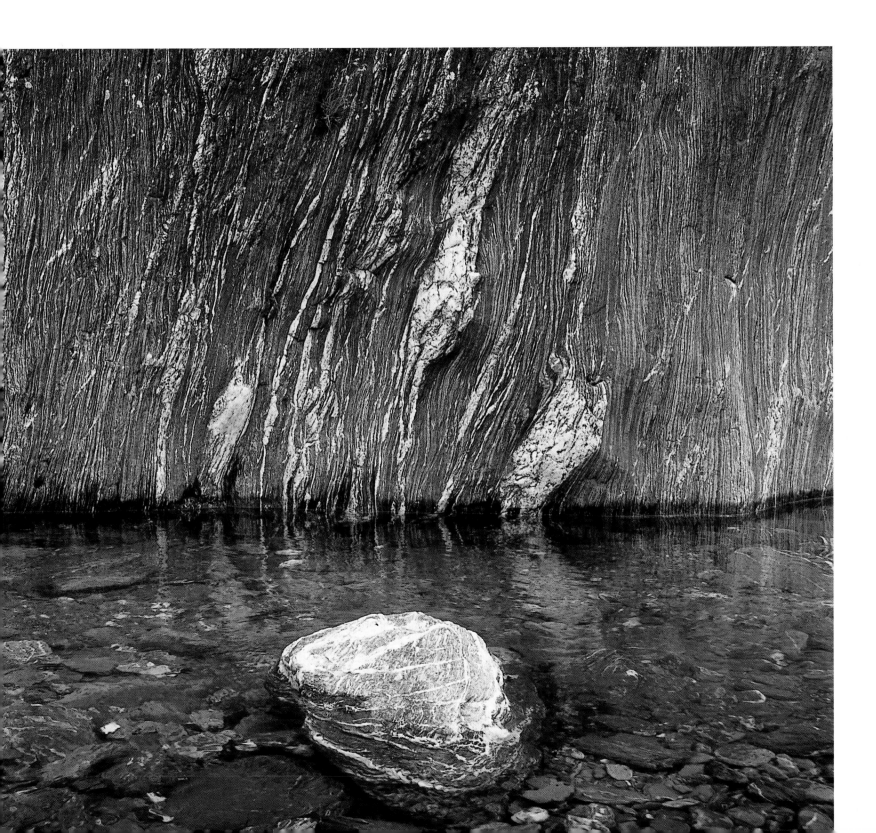

As with ice and water, rock formations can be a source of endless variation in pattern and colour. Close-up views of certain rocks can provide great abstract images, while stepping back gives a wider view of the overall shape and structure of a rock formation, without losing its patterns and colours and, at the same time, suggesting a much vaster landscape beyond the confines of the frame of the image

Depending on the kind of rock and lighting, this kind of image may convey either a sense of antiquity, permanence or frailty. The latter is definitely the case with this image. The soft, sandy cliffs of the Isle of Wight, off the south coast of England, are renowned for their amazing range of colours, and for the fact that they are eroding and collapsing at an alarming rate. At Alum Bay, close to the island's most westerly tip, these factors combine to produce some truly remarkable coastal cliffs. Each jagged 'tooth' of the crumbling cliff is streaked with different-coloured sand. From the narrow, close-up view, there is little clue to suggest whether this is temperate Britain or some rugged, arid desert in North Africa or America.

This was a view that I stumbled upon quite by chance. I was actually on holiday with my family – a time when I generally don't do much photography. However, after coming down onto the beach at Alum Bay, I was so taken by the angles and colours of this harshly lit, rugged, massively eroding cliff, that I simply could not resist reaching for my camera and grabbing a few shots of this miniature British 'desert'. The result is a dramatic arid landscape image, one in which scale is almost impossible to grasp. While the camera never lies, it can be misleading.

nb Alum Bay, Isle of Wight, UK

Canon EOS5 with a 24mm lens and a polarizing filter, handheld, Fujichrome Provia 100, 1/60sec at f/8

For me, fast-moving water is not only a dynamic force. Caught in the right way, it can simultaneously be very soothing, at least in a two-dimensional image, free from the thunderous noise of the water itself.

Such is the case with this photograph: a close-up of one small part of a stream rushing down the steep slopes of volcanic mountains in northern Taiwan. Photographed with a very slow shutter speed, the power of the water rushing downhill is transformed into a gently curvaceous, silken sheet. The viewer is drawn into the image by the group of rocks and the flow of the water, which leads the eye in a gently zigzagging route through the picture. The dark, wet sheen on the rocks contrasts strongly with the white and reddish water, the red resulting from dissolved volcanic salts. A steady rain made it hard to use the camera, but was responsible for the dark lustre on the rocks, from which random reflections were eliminated with a polarizing filter.

This image was the last in a series in which I homed in progressively closer to the stream. The first shots I took were wide-angle and took in not just the water but a big chunk of the surrounding forest, too, including some large tree ferns and dense tangles of trees. The second series focused mostly on the river, but also some fringing vegetation, its rich green colour contrasting beautifully with the water. The third series included the image shown here.

This picture, as with the others in this series, worked extremely well because of the dim, rain-soaked light. It is doubtful whether they would have been as successful in sunshine, in part due to the difficulty I would have had using a sufficiently slow shutter speed to achieve the right amount of blur in the water.

For me, this image has a gentle, sensual yet very powerful quality, that of a rushing mountain stream in a remote and wild place. Interestingly, however – and despite the fact that the river was surrounded by dense forest – this site was only a few hundred metres from the first buildings of Taipei, Taiwan's capital city. It is a mark of the abrupt way in which this huge city ends at the base of its encompassing mountains, and of the truism that one does not always have to venture far to find wild and beautiful places.

nb Yangmingshan National Park, Taiwan

Canon T90 with a 125mm lens and polarizing filter on a Manfrotto tripod, Fujichrome Velvia, 4 seconds at f/16

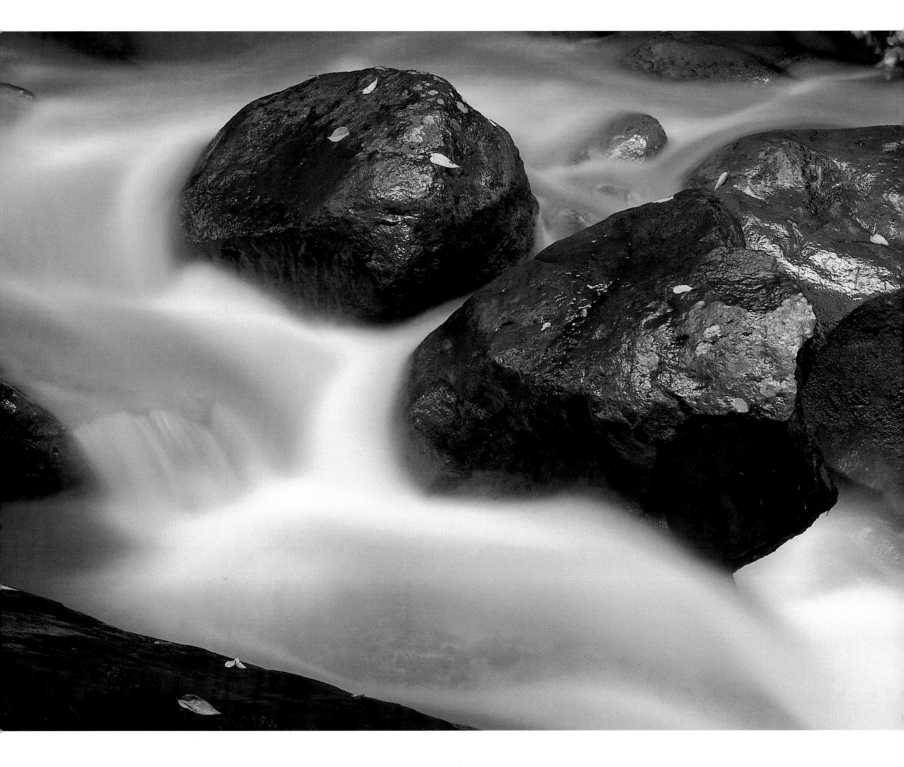

Yosemite National Park is one of the world's most dramatic examples of glacial sculpturing. From the monoliths of El Capitan and Half Dome in the centre of the park, to the ancient and majestic giant sequoias in the south, Yosemite has inspired some of the world's greatest photographers, arguably the most famous of which is Ansel Adams. So popular is this spectacular landscape with both professional and amateur photographers alike, it is difficult to conceive a shot that has yet to be taken of it.

On first arrival at Yosemite, it is impossible not to look upwards. The peaks of the Sierra Nevada range, the free-flowing waterfalls, the giant redwoods – as high as they are ancient – tower over you and command attention. It is these features that receive the most interest from visiting photographers. However, on a recent visit to the park, I wanted to take some images that offered a different perspective of the landscape.

My aim was to look afresh at Yosemite by breaking it down into its elements in order to reveal, close-up, something of the essence of the place. Hiking along Northside Drive, I spotted this scene of fall-coloured leaves reflected in the Merced River. To me, it is striking for the way it captures so much of the essence of the Yosemite landscape – the trees, rocks, water and colour – in so small a space.

This first morning, a strong breeze caused a ripple on the water's surface that agitated the otherwise perfect reflection, spoiling the overall effect. The following day, however, the breeze had softened and I returned to find this undisturbed, mirror-like image. Its success relies on the composition. I set my tripod on the bank and, looking through the viewfinder, played around with various angles and focal lengths. I was attempting to capture an image that would enhance for the viewer the perspective that there is as much to the Yosemite landscape at ground level as there is higher up. This is achieved by the picture space with the emphasis on the reflections in the lower portion. To reflect the energy that creates and continues to shape the Yosemite landscape, I used the angle of the silhouetted tree trunks and their reflection to add dynamism to the image.

The water itself sets the mood of the picture, its stillness reflecting the magical spell that Yosemite casts over you, and the warm glow that it leaves with you when you spend time in its presence.

CW Merced River, Yosemite National Park, California, USA

Nikon F90X with a 60mm lens and 81B filter on a Manfrotto tripod, Fujichrome Velvia, 1/30sec at f/8

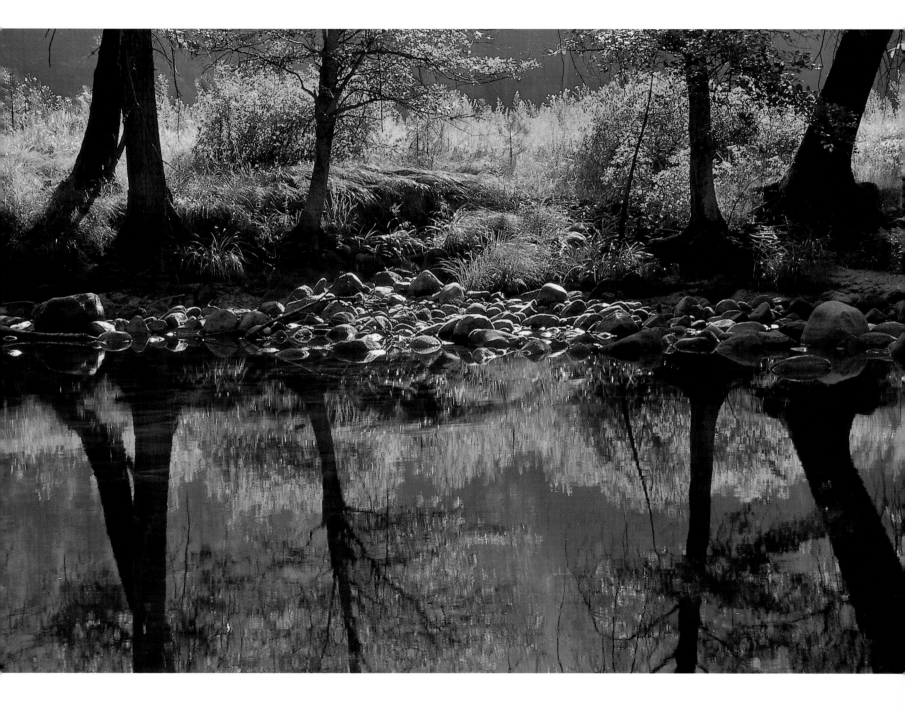

*B*eneath the protective canopy of the forest exists a miniature universe where countless creatures and organisms follow nature's cycle of birth, life and death in the same space and time. Study the forest closely and you witness many examples of this harmonious coexistence.

One autumn afternoon, I was photographing in woodlands near Ullswater in the English Lake District, when I was reminded of this juxtaposition of life and death. A dead leaf fell from a branch above and drifted slowly down on the slight breeze before coming to rest, caught in the moss-covered bark of the tree that had just ceased to be its life support.

What captured my attention most about this image was the vibrancy of the red leaf against the background of green moss. In compositional terms, red and green are opposing, but complementary, colours. Viewed together they have an unusual optical effect, each hue vibrating more intensely.

The light on this particular day was coming from the right-hand side, throwing much of the leaf into shadow. To alleviate this problem, I used a gold reflector to throw light back on to the leaf's surface and enhance the vivid red, thus creating the sense of depth the flat lighting had extinguished.

To isolate the scene from its natural surroundings, I cropped closely using a 105mm macro lens, stopping right down

to f/32 to ensure the background detail that was important to the story remained in focus.

Soon after I shot this image, a gust of wind blew the leaf free and it disappeared among its similarly fallen comrades on the forest floor. Back home, viewing the transparency on my light box, I was reminded that in nature all that exists is life and death – and that a single cycle is just a transient moment in time.

CW Lake District National Park, Cumbria, UK

Nikon F5 with a 105mm macro lens and 81B/20CCG filter on a Manfrotto tripod, plus a reflector, Fujichrome Velvia, 1/4sec at f/32

nb Wulingshan Nature Reserve, Hebei province, China

Mamiya RB67 with a 50mm lens and polarizing filter on a Manfrotto tripod, Fujichrome Velvia, 1/15sec at f/11

time to grab some photographs of the forest before sunset. I halted my car on a narrow track, just where a footpath led off through dense forest down a steep hill. I grabbed my camera gear and plunged down the slope in search of anything that might save the day. I was in such a hurry that I did not notice until almost too late just how steep it was, and I soon found myself slithering downwards out of control. I finally came to rest, lying on my back, clutching the base of a sapling, and looking up at this superb view.

I scrambled to my feet and set up the tripod. Once everything was ready, I found it quite difficult to hit upon an exposure that ensured both sufficient depth of field to have the nearby trunks and the distant leaves in focus, while having a shutter speed fast enough to freeze the fluttering leaves. As this image shows, thankfully, I was ultimately successful.

I love this photograph, not simply because it saved what was otherwise a bad day, but because even as an image of just a tiny fragment of forest it really captures the essence of an autumnal temperate forest, and not just Wulingshan, but almost any in the northern hemisphere.

*P*hotographing a forest from within can be quite a challenge as you are simply too enclosed among the trees to get a meaningful image. Yet, photographing a forest as a distant view, perhaps from a hillside above and beyond the forest edge, can result in disappointing, featureless images.

A solution I commonly employ in fine weather, is to shoot directly upwards from the forest floor, although this can be difficult to achieve because of obstructions to the view, such as vines or branches.

The image shown here represents an occasion where everything came together perfectly. The blue sky, the brightly sunlit white birch trunks and the golden leaves of autumn all make for a stunning shot. As with many of my favourite images, it almost didn't happen, and it was a view that I came across just in the knick of time.

Arriving at the reserve mid-afternoon, later than anticipated (I had been arrested for driving through an area closed to foreigners!), I was left with precious little

For the world's temperate regions, autumn represents nature's final glorious fling before the gloom of winter sets in, a time when the forests turn fiery gold before the leaves sadly fall to the ground. The forests of North America are famous for spectacular swathes of orange and red leaves, the result of a diversity of maple species, whereas in Europe the colours are generally a less vibrant, but still beautiful, series of golden yellows and russets, mainly from beech, birch and oak trees.

Around my home in the southwest of England, the colours generally peak at the end of October or early November, so I often make a number of visits to the area's forests at this time. Whether I get any reasonable photographs depends heavily on the weather; sunshine greatly enhances the beauty of the trees, whereas rain and gales rapidly strip the fragile leaves from their branches.

I found this view in one of my favourite local forests, on the edge of Dartmoor National Park, lining the valley and banks of the River Teign. The forest colours were at their peak and the weather at its finest.

And, even though this is a close-up landscape image, it does not cross the line into being a macro image of very few leaves. Instead, the image really captures the feel of an autumnal forest. It highlights the golden colour of the beech leaves, but also places them in their environmental context: on a mature tree, standing on the bank of a river and surrounded by a forest liberally clothed in autumn gold.

Strictly speaking, this view should have been photographed with the camera on a tripod in order to maximize depth of field and thus bring the entire view into focus. However, with the foreground leaves only just accessible right on the edge of the riverbank, and less than a metre in front of the lens, I found it easier to risk hand-holding the camera. Using the widest angle lens I had, plus the minimum shutter speed I thought would be fast enough to overcome camera shake and freeze fluttering leaves, I was able to bring almost the whole of the view into focus, an important ingredient in successfully showing the foreground leaves in their forest environment.

nb River Teign, Dartmoor National Park, Devon, UK

Mamiya 645 with a 35mm lens, handheld, Fujichrome Provia 100F, 1/60sec at f/8

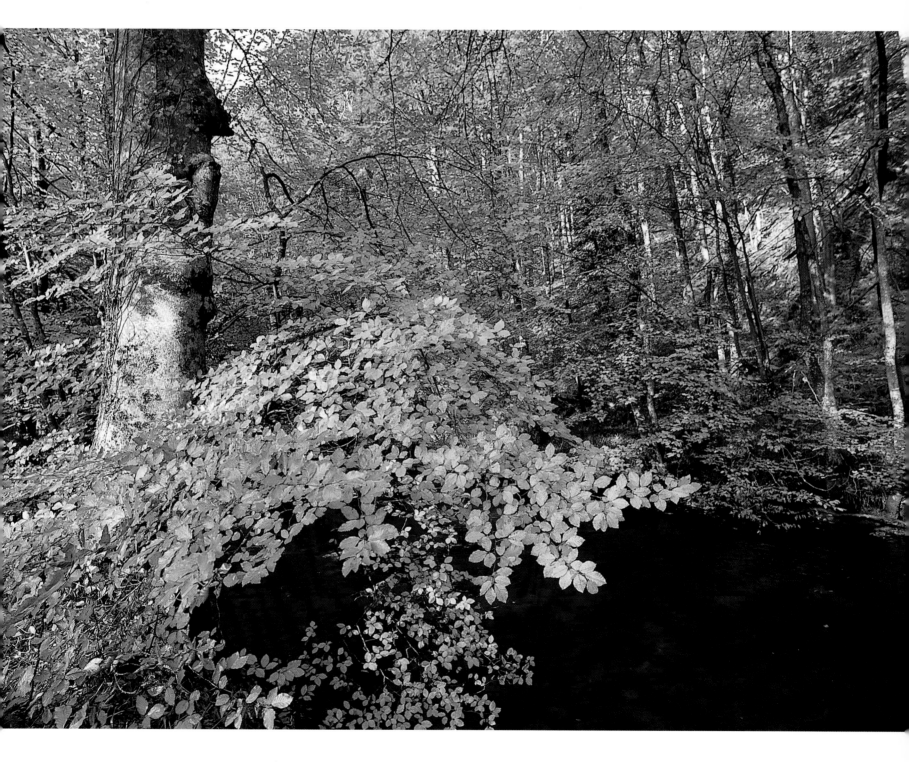

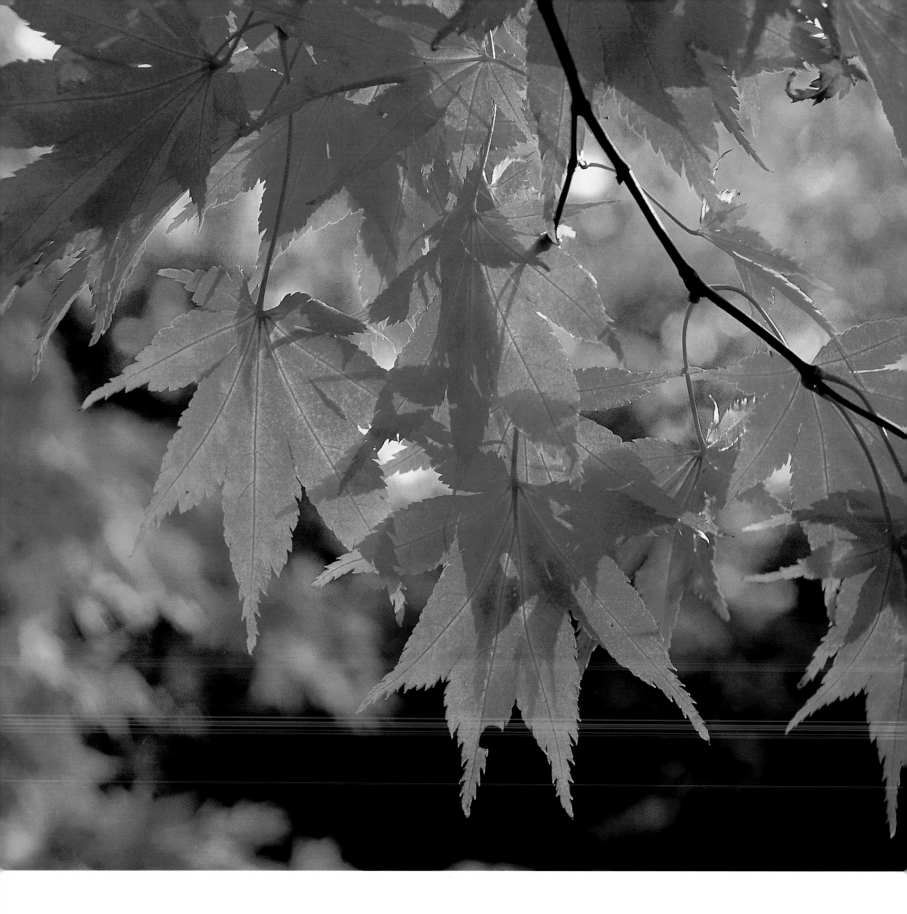

*A*s the winter approaches, our deciduous forests and woodlands come alive in a cloak of multicoloured foliage. Spring yellows, the colour of the sun, awaken feelings of warmth, life and abundance; summer greens, the universal symbol of life on earth, evoke feelings of hope and wonder; while dramatic autumn reds uplift and excite us.

I focused on the vibrant red of these Japanese maple leaves in autumn to give prominence to the subject. Red is an aggressive colour that stands out against other colours, making objects appear larger than life. Red captivates the eye and holds the gaze, which is the effect I wanted to create with this image.

Leaves also epitomize nature: its sense of strength, permanence and mysticism. The multi-angled polygonal shapes of the maple leaves are a graphic representation of these attributes, while the tightly cropped composition creates a tension in the image, reflecting the life within it.

When we open our minds and look closely at the patterns of nature, we begin to appreciate the intricacy and fragility of life. Leaves, like many elements of the landscape, are often viewed simply as part of the whole. Yet, isolated from their surroundings, they reveal their complexity, an understanding of which, as human beings, we should translate into our own lives and the part we play in nature.

CW Westonbirt Arboretum, Gloucestershire, UK

Nikon F5 with a 120mm lens on a Manfrotto tripod, Fujichrome Velvia, 1/30sec at f/5.6

humankind

historic structures

recreation

conservation

destruction

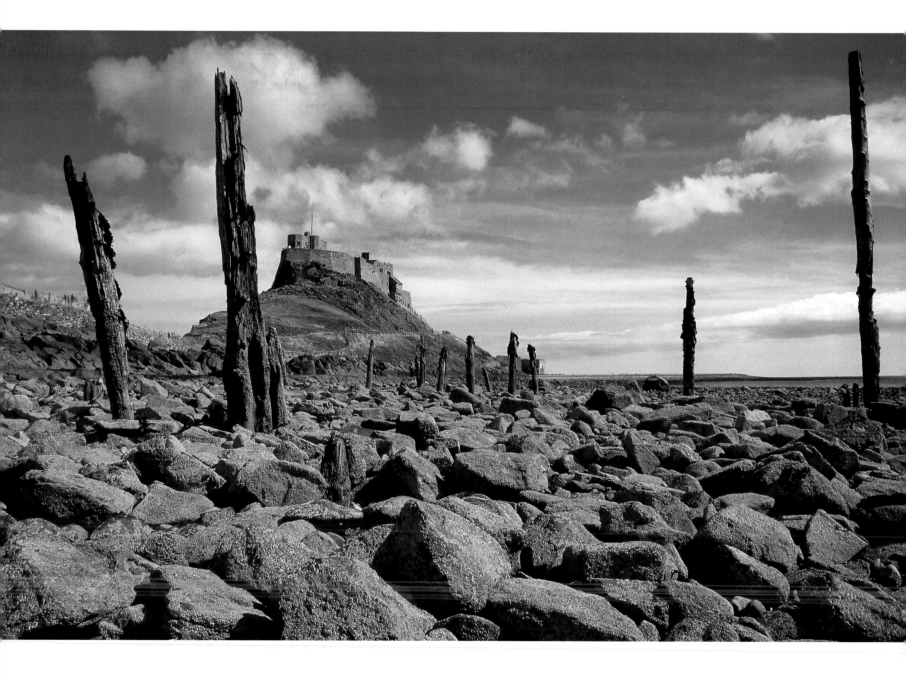

Often, in our attempts to capture the beauty of the landscape, we are tempted to leave out any trace of man-made structures. At best, they are a major distraction and many are downright ugly. Wires, main roads and factory chimneys come high on the list of landscape curses. Many potentially wonderful photographs are ruined by their inclusion in the midst of an otherwise terrific scene.

There are many occasions, however, when the addition of a human element such as a winding road, an ancient building or, indeed, people themselves, not only adds interest to a view, but can be the making of a great image. This can be particularly true when seeking out a central feature to include in an image, something to catch the eye; a crucial element in any successful photograph.

To convey the beauty of the landscape, the human element needs to sit comfortably in its environment, to complement it and to seem to belong to it. More often than not that means something quite old: an ancient monument, a tumbledown farmhouse, a church or temple, for example. Modern structures tend to jar rather than complement and, while they may be photogenic in their own right, do not sit well in landscape images.

As for the inclusion of people in an image, it is often better to render them small so that they become part of the landscape. In this way, they can be a central feature in an image that otherwise lacks one without taking it over, providing a sense of scale in a landscape, or emphasizing how insignificant human beings are against the vastness of land and sea.

An important reason for keeping people small is to prevent the human element taking over, turning a landscape view into a people image. A successful image should have just one person or a cluster of people, otherwise the image will end up with multiple central features, each competing for the viewer's eye. Using people to provide scale is useful for views where there are no other indications of size: a great expanse of sea can look like a small lake until a boatload of people is included, and massive desert sand dunes can resemble a beach until a camel or walkers traverse the ridge.

There are some occasions when it is useful to include jarring human elements in a landscape photograph; they can make a damning statement about humankind's disregard for the land. However, as a result, perhaps, images such as this are no longer landscape photographs, but environmental ones, loaded with a political message.

Lindisfarne Castle, Holy Island, Northumberland, UK

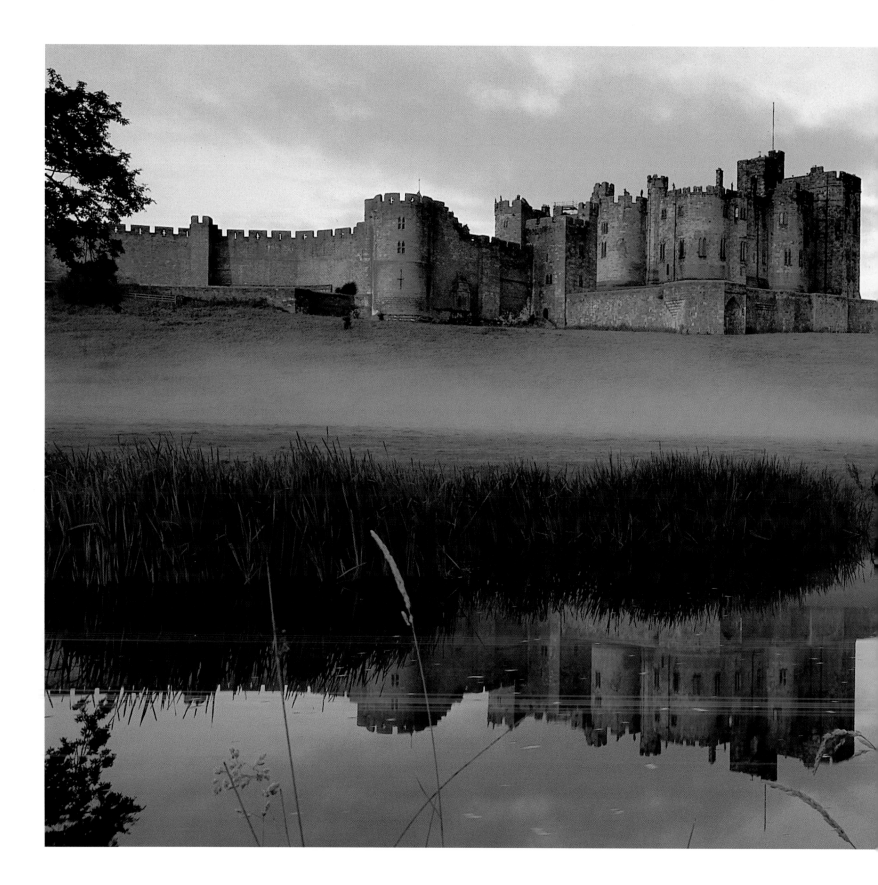

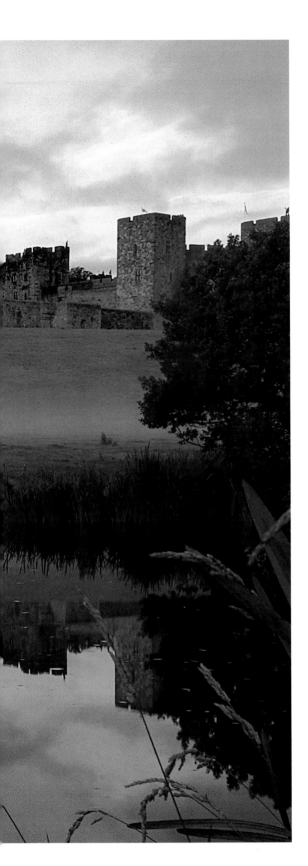

On the whole, I am not a great fan of including man-made structures in the landscape. More often than not, I prefer to exclude buildings and other unnatural features from my images. Sometimes, however, I come across examples where the landscape is enhanced by them, as with this image of Alnwick Castle in Northumberland, England.

Modern building styles tend to disregard the environment. In days gone by, however, we built structures that worked with the environment, as part of its overall design. For example, hills and rivers were used as natural defences, with walls and buildings following the contours of the land.

With this photograph, the natural defences that would once have guarded against marauding foes, provided plenty of challenges for this photographer. From the footpath, there are numerous views of the castle from different angles, and I considered various options before settling on this position along the bank. It is one of very few that allow an unimpeded view of the castle walls and I felt that it added to the overall presence of the imposing structure.

I also wanted to give the castle a sense of place, so needed to include some foreground interest other than simply the reflection in the water. The main problem was the wide, dense reed bed directly in front of me which, if included in its entirety, would have created a visual barrier in the foreground. What I did like, though, were the few tall grasses growing amongst the reeds. To combat the problem, I ended up with one tripod leg in the water and two bunches of reeds tied with string out of the image – not to mention two wet feet!

The glorious early morning light enhances the image, and using a 28mm wide-angle lens enables a better sense of depth and movement in the sky, giving an otherwise flat picture an element of visual energy. The result is a landscape in harmony, each element adding to the overall effect of the image.

Alnwick Castle, Northumberland, UK

Nikon F90X with a 28mm lens and 81B filter on a Manfrotto tripod, Fujichrome Velvia, 1/2sec at f/32

Catching a great dawn image relies not just on being out of bed in time to see one, but also finding a suitable subject for the image, something that will form a strong silhouette.

On this occasion, the silhouette was the Balinese Hindu temple of Ulu Danau, high up in the volcanic mountains that form the heart of Bali. Part of the temple sits in the shallows of Lake Bratan, providing a very unusual temple view and making it a much-photographed icon of Balinese tourism. But I wanted to catch something quite different from the usual tourist shots, something that captured the beauty of the structure and its location. Upon arrival at the temple one afternoon, I was gratified to notice that not only did the view from the shore look east but also that the hills on the far shore were very low, allowing the possibility of a dawn shot, with the temple silhouetted against the sky. Having found my location, I had only to wait for the morning, with fingers crossed that it would be a clear one.

I left my hotel the next morning at about five o'clock and struggled through the darkness, beset on all sides by howling dogs. I found my way to the lake shore, setting up the tripod and camera in time to see the outlines of the temple's roofs take shape against the slowly lightening sky.

Tropical dawns develop far more rapidly than those in temperate regions, so I did not have to wait long for an orange-red glow to form in the east. The sky became filled with burning rays, shooting across the sky towards the temple, providing one of the most spectacular dawns I have witnessed, along with one of the most beautiful architectural silhouettes one could possibly hope for.

The result is a powerful image: both a superb dawn landscape and a symbol of the beauty and harmony of ancient Balinese architecture. For me, this image, along with others I captured once the day had fully dawned, puts a man-made structure in perfect harmony with the natural environment.

nb Ulu Danau Temple, Lake Bratan, Bali, Indonesia

Mamiya RB67 with a 50mm lens on a Manfrotto tripod, Fujichrome Velvia, 4 seconds at f/8

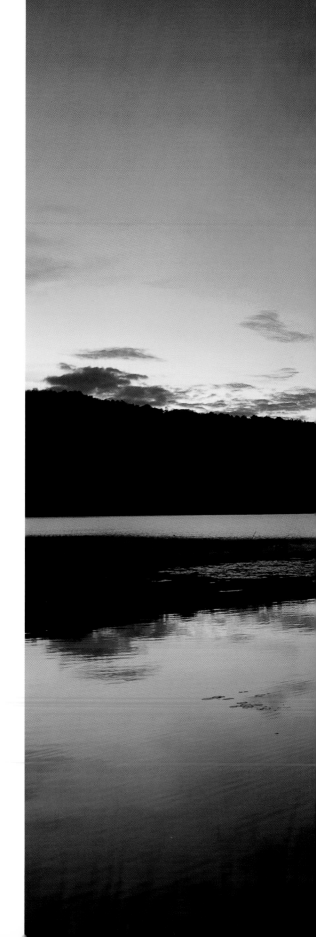

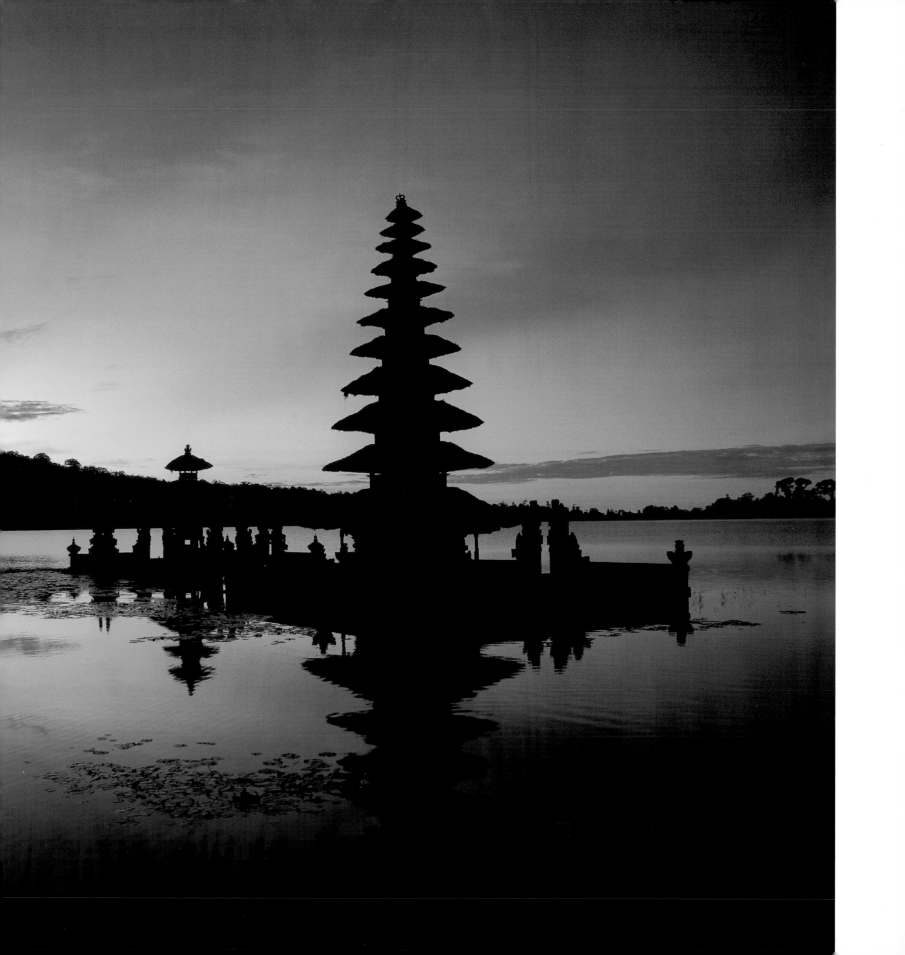

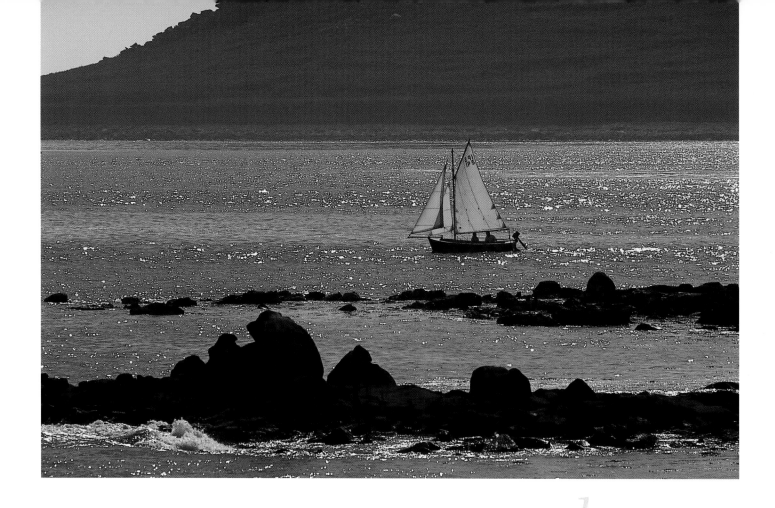

Most human activities, including recreation, seem often to be visually at odds with the natural environment: at the very least a distraction in the landscape, if not actually ruinous. How pleasant it is, then, to see an activity that sits comfortably with the natural environment, complementing and even enhancing the view.

I came upon this scene one day while wandering among sand dunes at the southern tip of Tresco in the Isles of Scilly, a cluster of tiny islands and rocks off England's southwestern tip. Down among the dunes, the sea was invisible, but when I climbed up onto the final bank that separated land from beach, I spotted this boat sailing south through the channel between Tresco and its neighbour, Bryher.

I could see that in a couple of minutes the boat would become backlit by the afternoon sun, and knew in an instant that the lighting, combined with the landscape and the idyll of messing about in a boat on such a glorious day, would all come together in a great image.

The problem was simply one of getting the right camera bits together, hauled up to my eye and focused in time. I had been wandering along in something of a dream, hardly thinking about the photography, and my camera was not even out of its bag, let alone poised for action. A frantic few minutes ensued while I clamped together the most powerful lens combination I had to make it possible to zoom in on the boat, and I was ready.

nb Isles of Scilly, Cornwall, UK

Canon EOS5 with a 70–200mm Sigma EX lens at maximum extension and a Sigma EX 2x converter, handheld, Fujichrome Provia 100F, 1/500sec at f/5.6

There was no time to set the tripod up, but fortunately the strong backlighting provided enough light to make that unnecessary. No sooner was the camera to my eye and focused, than the boat cruised through the strongest area of backlighting, providing a great series of summer sailing shots.

For me, recreation in the landscape takes two forms: either in harmony with nature, or fighting against it. In some cases, we can end up doing both. For example, the sailor who works with the wind to power a ship can also be fighting for his or her life as it swells into a storm force gale.

Given the choice, I prefer to have nature on my side. My work often entails gruelling challenges and so, when the time comes for a break, I choose to spend it in calm environments that offer little risk to life or limb. This preference for calm is prevalent in a lot of my early photography; ethereal images in predominantly warm, pastel colours in particular.

For this section, I wanted to portray the same sense of calm and serenity. The colours in this scene are neutrals, and the yellow of the canoe is warm and friendly. There are no harsh lines, though the slight diagonals of the boat and its wake convey a sense of movement. When I look at this photograph it makes me want to be there, enjoying the peace of the surroundings, away from the pressure of everyday life.

This is one of only a very few images in the book that I took without the use of a tripod. I was in a canoe following these two paddlers and used a vibration reduction lens to help limit camera shake. The exposure was relatively simple as I took a reading from the mid-toned foliage along the canal bank.

People rarely feature in my work, but this has been a commercially successful photograph, used to illustrate a number of magazine articles on flat-water canoeing.

CW Okefenokee National Wildlife Refuge, Georgia, USA

Nikon F5 with a 400mm VR lens, handheld, Fujichrome Velvia, 1/100sec at f/5.6

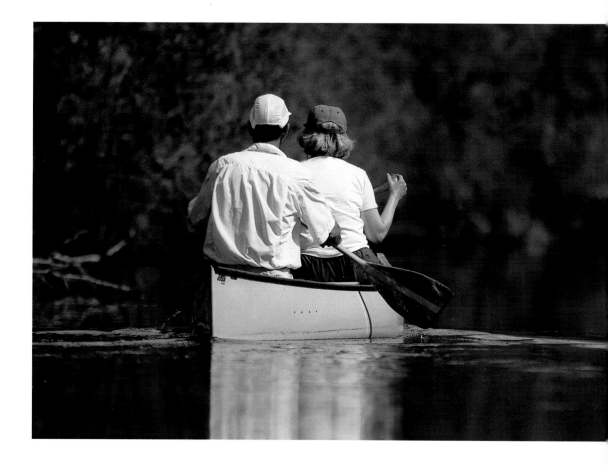

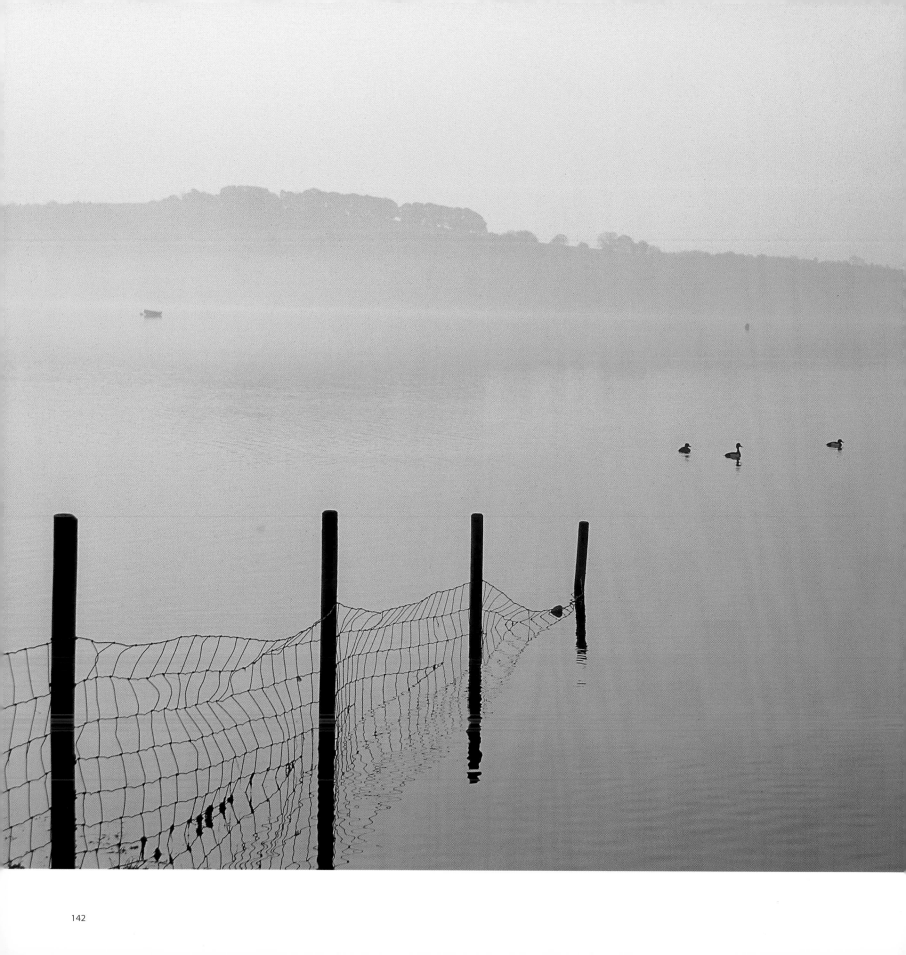

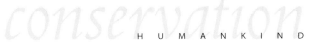

*I*n my opinion, conservation involves a paradox. In many cases, the only reason to conserve is to limit or rectify the damage humans have already done. We spend millions and vast amounts of time and energy trying to undo the harm we have caused. Such is the nature of humankind. Fortunately, conservation efforts around the world play a massive part in ensuring that the landscape and wildlife I shoot today will still be there tomorrow.

I believe the best form of conservation is that which benefits both people and nature, thus avoiding conflict between the two. Examples of this can be seen throughout the countryside. Reservoirs and artificial lakes are created to ensure a plentiful supply of water to local regions and communities while also providing a source of life to numerous other creatures: insects, birds, fish and mammals.

This image of Carsington Water in Derbyshire, England, shows how the hand of humankind does not always constitute a destructive force. With conservation in mind, it was opened in 1992 to store water from the River Derwent at times of heavy rainfall to return it to the river when it would otherwise be too low for treatment downstream. As well as being a haven for wildlife, the lake now provides recreational activities for the community and tourists.

I photographed this scene very early one morning, just as the sun was breaking the horizon. Sitting on the bank with my camera, I reflected on how sometimes we manage to get things right.

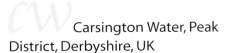

Carsington Water, Peak District, Derbyshire, UK

Nikon F5 with a 24mm lens and 81B filter on a Manfrotto tripod, Fujichrome Velvia, 1/2sec at f/32

143

It is not easy to take a landscape photograph that really captures the essence of environmental conservation. It is normally best depicted as a human activity, showing people planting trees, recycling waste materials, or working to save endangered species, for example. The end result of their work is not normally visually very spectacular and, hence, is barely photogenic, at least in terms of landscape photography.

A view of wind turbines, however, is a major exception; in this case a satisfying landscape view across a wild moor dotted with turbines that are part of Carno windfarm, one of Britain's biggest wind energy sites. In many ways, these wind turbines enhance what would otherwise be a rather bleak moorland landscape, offering a most unlikely spot a modern architectural or sculptural element, and is a visibly positive symbol of a more environmentally friendly future. And all with zero pollution: no danger here of an effluent spillage killing off rare plants or poisoning the local sheep.

I came to Carno in search of images for an article I was writing for a British magazine about wind energy. The site was not easy to find, hidden at the end of a long, narrow lane that climbed interminably from the main road in the valley below, up to the highest parts of the mountains. But once there, the site provided perfect images of over 50 turbines spread across a high, desolate moorland, lit by the golden light of a low winter sun. Everything, from the grass to the white turbines, seemed to glow in the light, and I wandered across the mountainside snapping away quite excessively. When day turned to dusk, I continued shooting the stark silhouettes of the turbines against the clear sky, although, by this time, the temperature was plunging. By the time I returned to the car, just after 5pm, it was covered in ice and the thermometer read −3°C (26°F).

nb Carno, Wales, UK

Mamiya 645 with a 55mm lens and polarizing filter, handheld, Fujichrome Provia 100F, 1/60sec at f/8

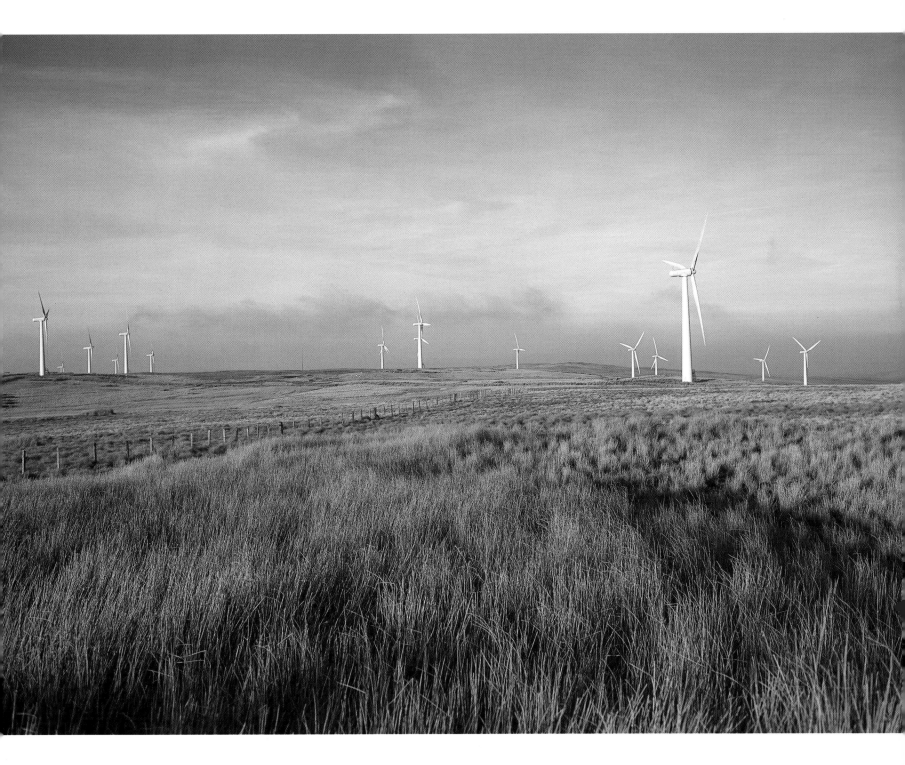

nh Jianfengling Nature
Reserve, Hainan Island, China

**Canon T90 with a 24mm lens and polarizing filter,
handheld, Fujichrome Provia 100, 1/45sec at f/11**

*H*umankind's devastating impact on our natural environment is all too evident in the landscape. However, deciding how to convey the impact of this, and then finding the right images to fit, can be a long and sometimes difficult process. The aim must be to generate images that not only show the end result of such damage, but do so in a graphic way that grabs the viewer's attention and leaves no room for doubt as to what has happened.

For me, this image fits that aim perfectly. The forest fringe, beautifully lit by the early morning sun, consists of a few tattered trees, the adjacent open ground littered with stumps and severed branches. The depiction of serious deforestation is heightened by the view of fragmented forest and cleared hillsides well into the distance, with the vague outline of as yet unharmed forest covering the furthermost hills. This image is all the more alarming when you know that this view is within Jianfengling Nature Reserve, one of the last surviving areas of tropical rainforest on China's Hainan Island. Apologists for the deforestation might point to the extensive patches of clearly visible green springing up among the tree stumps – evidence of noble efforts to replant the forest. Unfortunately, these saplings are eucalypts, a wholly inappropriate substitute for the lost native forest.

This image tells the damning story of cynical, systematic deforestation in the heart of one of southern China's major nature reserves. Yet, beyond being an environmental image that provides proof of illegal logging, it is also a beautful landscape image, gloriously lit by the early morning sunlight, mist (ironically, generated by the surviving areas of the rainforest) drifting soothingly across the hillsides. This works to take the edge of one's anger and provides a badly needed silver lining to the issue of deforestation.

*P*ollution and destruction of the environment take many forms: the burning of fossil fuels, the destruction of natural habitats, oil slicks – to name a few. Most are well documented, but no doubt many more lurk buried, waiting to be uncovered. Hopefully, not before it's too late.

One such form is light pollution. As our cities expand, so does the spread of electric lighting. And the more lights, the more power we require to run them. And the more power required, the more fossil fuel we burn. And the wastage is immense. A second effect is less obvious, and is something I noticed in the desert near Uluru (Ayers Rock) in Australia. Where there are no lights, the night sky is far more vibrant. Stars sparkle vividly and there seem to be more of them. It is a great shame, I believe, that there are children I have spoken to who have never seen a star.

In my opinion, a single image cannot highlight the effects of light pollution. Indeed, some may argue that this loss matters little in the modern world. I beg to differ. So, in this section, I wanted to demonstrate how words and pictures, given exposure in the media, can enhance awareness of issues facing society. As nature photographers, I believe we have a duty to help protect the environment in which we live and work.

CW Bourbon Street, New Orleans, Louisiana, USA

Contax G1 with a 45mm lens on a Manfrotto tripod, Fujichrome Velvia, 1 second at f/11

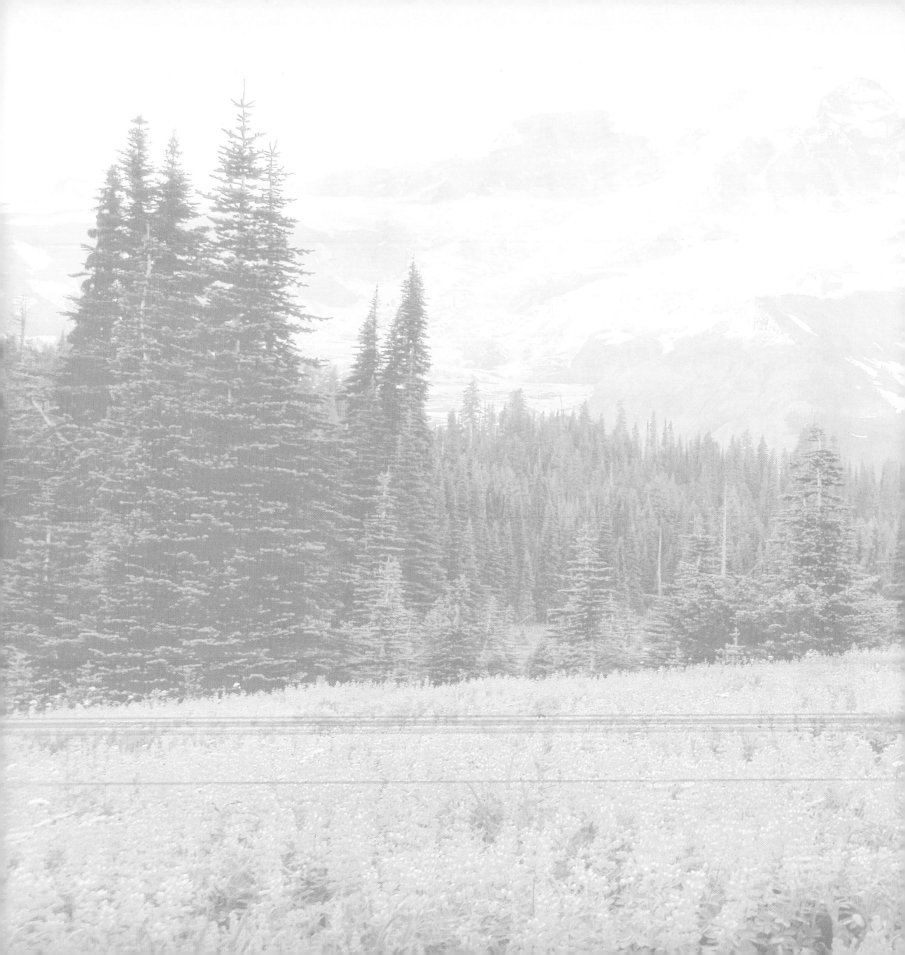

emotion

calm

fury

dynamism

permanence

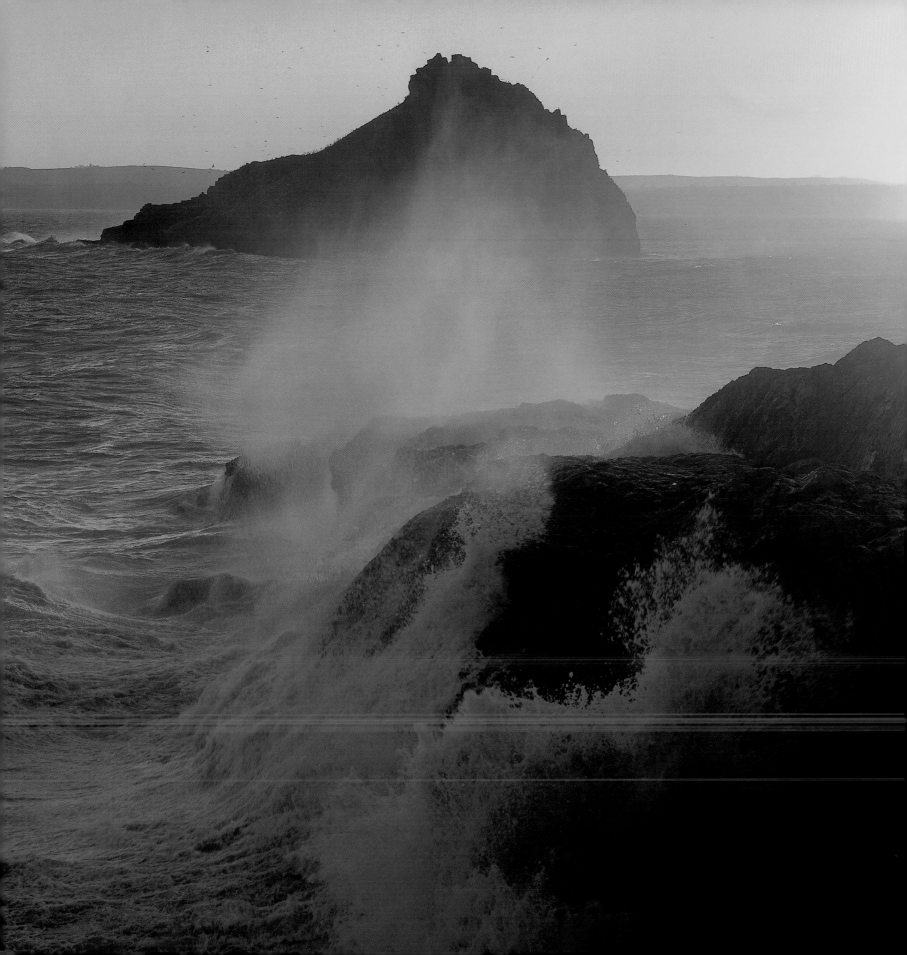

*i*n the preceding chapters, the principal aim has been to show evocative images of particular kinds of landscape but, here, specific landscapes are secondary. For this final section, it seems appropriate to include something that focuses on the psychological aspects of images, to show a few pictures that illustrate how lines and angles within a landscape can work with lighting and colour to convey a mood which has a psychological impact on the viewer.

There are a few simple rules, some of which are covered in greater detail in the following pages, but, generally speaking, well-spaced horizontal lines in an image produce a calming effect, something that can be enhanced by reducing the amount of detail in the image. Well-spaced vertical lines create a sense of strength and permanence – again, something that can be emphasized by reducing detail. Diagonals shake things up a bit, introducing a dynamic sense of movement. A powerful diagonal can transform a view from something rather bland into a strong one, but they have to be used with care: too many diagonals, especially in competing directions, and combined with lots of picture detail, can make for a confusing image that lacks a strong focal point, producing a sense of discord in the viewer.

The strongest landscape photography makes good use of the psychological effects of lines and angles, and the best photographers are well aware of how to use them. It would be easy to argue that this can't be so, since no photographer has control over lines in the landscape, and can only work with what the landscape provides. And that is the point: the great majority of landscape views, when seen through a viewfinder or the photographer's mind's eye, do not lead to great landscape photographs precisely because the lines and angles running through them simply fail to have sufficient emotive effect. A good landscape photographer will spot this, and only press the shutter when all the necessary elements come together to make a great image.

The following images convey feelings of calm, anger, dynamism and strength as a result of the way they make use of lines and angles, combined with different kinds of lighting and the inclusion of detail in the view or, conversely, very little, in order to enhance the subjects' outlines.

nb Hope's Nose, Torquay, Devon, UK

*T*he evocation of calm in a photograph is something that I find immensely pleasing. Producing such an image involves bringing together a number of factors that have the right psychological impact, many of them at the behest of nature, and therefore a matter of luck. Unsurprisingly, one of the most important is that the view itself be calm and contain little obvious movement. Stillness is, by definition, calming, so any components in a view such as reflective water or a light mist that will translate a sense of stillness into the final image is helpful.

Anything that simplifies the image so that the eye does not run back and forth over busy, confusing details will aid calm in an image. Soft light and a little mist are important elements that renders the details of an image invisible or at least muted, leaving only the overall outline of the main subject for contemplation. A single, simple subject with a straightforward, but nevertheless arresting outline further helps to simplify the image. Simplification is complete if it is virtually monochromatic, lit by some gently warming or cooling pastel colour. Finally, a calm image relies on the horizontal and diagonal lines, the presence in the view of horizontal lines,

or at least lines that only slope or curve gently. Strong diagonals, such as those produced by shafts of low sunlight, are inappropriate, as they generate a feeling of dynamism.

Without doubt, dawn and dusk offer the best opportunities for calm images, as shown with this fine example of a dawn view. Taiwan has some spectacular mountain scenery, with the beautiful Sun Moon lake well-known for its misty dawns. This image, taken from my hotel (I barely had to roll out of bed for this shot!), contains almost all the classic elements of a calm image. The mist and soft pre-sunrise light give a simple monochromatic image in which only the basic outlines of the mountains are visible, while the mirror-like water emphasizes the stillness of the view. The mountains provide the principal lines in the image and, while these are not truly horizontal, they are nevertheless quite gentle and rather rounded in shape, enhancing the calming effect. While the actual view had a gentle pink hue to it, I decided to use a warming filter to enhance still further the pleasing effect of the soft colour. The result is a wonderfully calm image of a classic gentle dawn.

nb Sun Moon Lake, Taiwan

Mamiya RB67 with a 110mm lens and 81B warming filter on a Manfrotto tripod, Fujichrome Velvia, 2 seconds at f/5.6

This image was taken in the Okefenokee National Wildlife Refuge in Georgia. I was out there on an assignment to photograph the wildlife and landscape of the region. The wildlife shooting had gone well, but circumstances had conspired against my attempts to capture the landscape. Those areas perfect for sunrise were closed off, while other seemingly ideal ones faced in the wrong direction for the best lighting conditions. Finally, on the last night of my stay, I spotted this location. Luckily, conditions were perfect. I set up my tripod on the lake edge and waited as a spectacular kaleidoscope of colour in the sky turned from dusky blue through to deep red over the course of just 30 minutes.

The Okefenokee swamp is a particularly calm environment. The canal trails and open lakes are as still as the night sky and the wildlife goes about its daily routines with a relaxed nonchalance. Nothing is a rush. My aim with this photograph was to capture an image that depicted the environment of the Okefenokee as I saw and felt it: a tranquil and peaceful world, isolated from the daily bustle of life. Placing the accent on the deep pink and orange colours of the sky by using the cooler blues gives the picture its warmth. The placement of the horizon across the centre of the frame gives the image a natural balance. The symmetry of the tree line and its reflection enhances the overall serenity of the scene. The image is saved from stasis by the tree trunk to the right, which adds an off-balance tension and creates visual interest in the photograph.

The resultant image is a useful demonstration of the use of colour and symmetry in creating tranquil and evocative landscape photographs.

 Okefenokee National Wildlife Refuge, Georgia, USA

Nikon F5 with a 35mm lens on a Manfrotto tripod, Fujichrome Velvia, 1 second at f/22

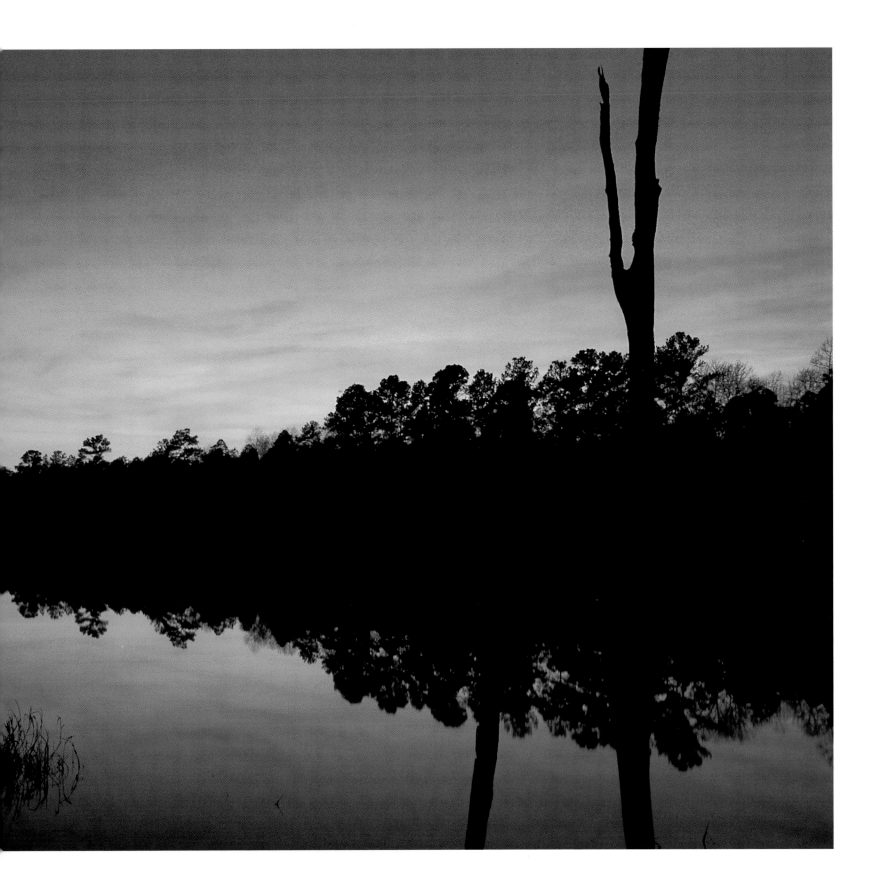

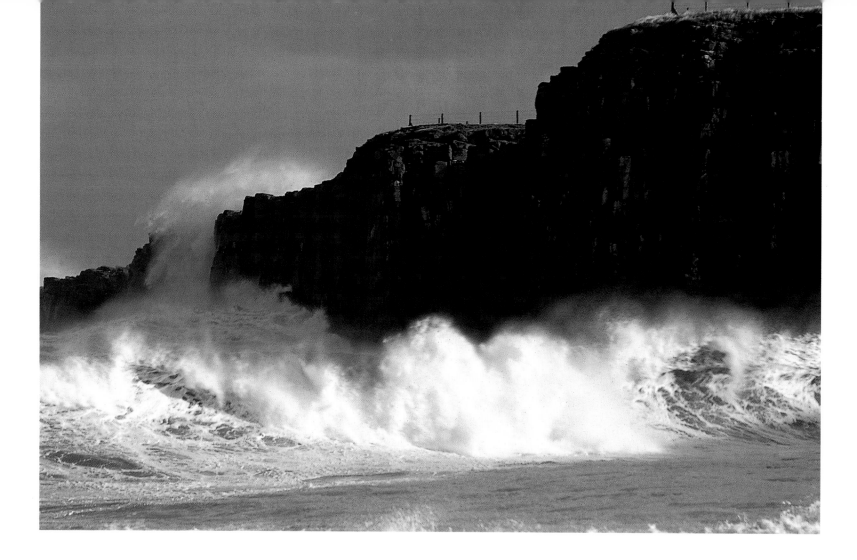

I may be biased – I was, after all, born there – but Northumberland is my favourite region in England for photographing landscapes. This sparsely populated and least visited county embodies everything I adore about the natural world: it is untamed. The rugged coastline that forms Northumberland's eastern border is frequently battered by the thunderous waves of the North Sea. For me, these unforgiving, monstrous waves are a reminder of the power of the elements to shape our world.

For anyone from Northumberland, the legend of Grace Darling forms a compelling part of our history. In 1838, in a tiny rowing boat with her father, this teenage girl ventured out into a ferocious storm to rescue sailors who had survived a shipwreck while sailing between Hull and Dundee.

This story inspired me when photographing this image. Standing close to the seashore, having ignored the advice of the helpful passerby who suggested I perch myself on top of the cliff, just where the peak of the wave was violently crashing, I composed the image so that the cliff face cut a diagonal line through the frame, adding to the visual energy,

CW Dunstanburgh, Northumberland, UK

Nikon F90X with a 35mm lens and 81B filter on a Manfrotto tripod, Fujichrome Velvia, 1/60sec at f/8

and waited for the right moment. As the waves crashed onto shore, they hit the natural rock barrier and climbed effortlessly up the cliff wall, their relentless force reshaping the coastline even as I pressed the shutter.

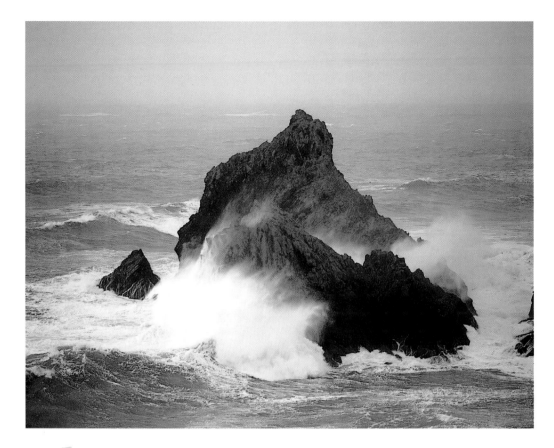

nh Kynance Cove, Cornwall, UK

Mamiya 645 with a 210mm lens on a Manfrotto tripod, Fujichrome Provia 100F, 1/250sec at f/5.6

*I*t is very tempting when storms hit to just put the camera away and hide at home. At the height of a storm, both light and visibility can be terrible; the high wind may make it difficult to hold the camera still, even on a tripod, and it is almost impossible to keep the camera dry. Let's face it, it is just plain miserable to be out in such awful weather.

Yet, one really should not give up on storm photography. The possible images can be truly dramatic, the ferocity of nature captured by the bleak grey of the scene and the strangeness of images caught through a spray-covered lens. That said, I have to admit that I have often been disappointed by my storm photographs; the crashing waves can look static in the final images. What happened to the power of those massive

rollers as they flung themselves over the rocks – the spray, the screaming wind, the deafening noise, and the sheer struggle to work in those conditions? I have learnt to accept that only a small proportion of the images will come close to reasonably capturing the drama of the storm.

The shot reproduced here, taken during a fierce January gale at Kynance Cove, close to Britain's most southerly tip, is one of them. I deliberately headed for this stretch of coast as it is an area that I know to be dramatic, with high cliffs and rugged offshore rocks, which would be fully exposed to the full force of this storm. When I arrived, the coastline was being hammered by huge waves, wind conditions on the clifftop so extreme that much of the time I could barely walk, let alone set up a tripod. On occasion, I found myself crawling along the ground to get into a reasonable viewing position, terrified that if I stood up I would be blown off the cliff. Rain and salt spray filled the air, and I had to clean the lens after every exposure.

Of the resulting images, this is one of my favourites. While the scale is hard to grasp, it is clear that these are huge waves crashing against the rocks, particularly when you realize that the further of the two islets is about 60m (200ft) high. The drama is intensified by the surf around the base of the islet, and the raggedness of the veil of spray coming off it, not flying straight up as it would in gentler conditions, but blown sideways and over the nearer islet. The result is an image of the fury of the elements at the height of a fierce winter storm.

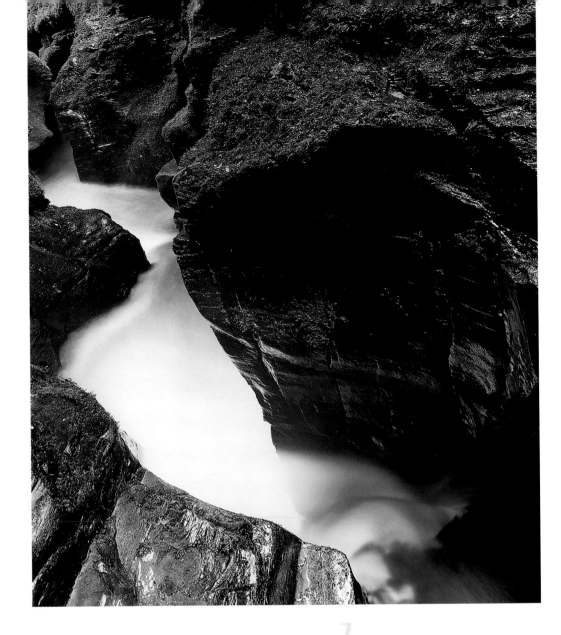

*S*trong diagonals make for a dynamic image, adding a sense of action. Its psychological impact has been utilized in art for many hundreds of years, from medieval Japanese garden design through to modern photography. And the more diagonals there are, the more powerful the effect, especially if they all converge towards an often unseen vanishing point.

Landscapes are full of diagonals, but they rarely fit a perfect pattern. Part of the art of landscape photography is being able to spot those views in which diagonals work naturally together – or can be manipulated into doing so – to produce strongly dynamic images. To manipulate a promising view into a great image involves careful consideration of viewpoint, angle and the right lens.

Moving in close to the foreground of your subject and using a wide-angle lens strengthens diagonal lines that lead away from your subject in the foreground, towards the middle and background. Such lines include the banks of a river, striations in rock surfaces, lines of bubbles, waves in water, and the outlines of tree trunks, all leading the eye away from the camera towards the back of the image and creating a strong sense of movement.

The close-up landscape shown here is a highly dynamic image, thanks to a series of strong diagonals. Taken in the narrow Lydford Gorge in southwest England, I loved the patterns of water rushing through these rocks, gouged out over the aeons into shapes that mimic the swirling water. I spent some time looking for a view that both emphasized the way the rock had been cut and captured

the dynamic feeling of this little gorge. I eventually hit upon this view, which I photographed with my widest-angle lens.

The stream creates a strong central feature, leading the eye through the image from right to left, and from the foreground towards the background. The zigzag adds visual interest without altering the right-to-left movement, which is emphasized by both the curves of the gouged-out rock walls and the faint striations embedded

nb River Lyd, Dartmoor National Park, Devon, UK

Mamiya RZ67 with a 50mm lens and polarizing filter on a Manfrotto tripod, Fujichrome Provia 100F, 8 seconds at f/16

within the rock itself. Striations in the rock at the very foot of the image, though moving in the opposite direction to the trend, help to guide the eye towards the white strip of water that leads through the image.

CW Mount Rainier,
Mount Rainier National Park,
Washington, USA

Nikon F90X with a 50mm lens and neutral density filters (0.9 and 0.3) on a Manfrotto tripod, Fujichrome Velvia, 1 second at f/32

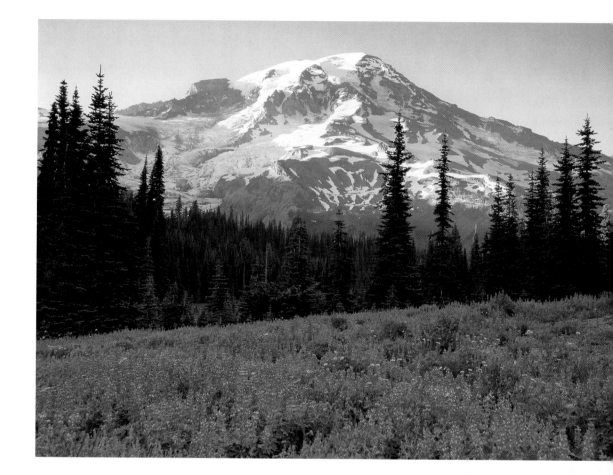

I have long had a fascination with mountains and mountain climbing, and have read many books by explorers such as Sir Edmund Hillary and Sir Chris Bonington. What captivates me most, is how an inanimate mass can be so alive and have such power over life and death. Thinking about this shapes much of my mountain landscape photography. Rather than simply capture a portrait of the mountain, my aim was to add dynamism to reveal something of the mystery and power of the life within.

Driving through Mount Rainier National Park, I spotted this view of the mountain and quickly backed up the car. What I had seen were the lines and angles that dominate this image. The line is the most elemental tool used in picture composition, and the movement of diagonal lines creates a visual energy. As important are the triangles created by the trees, both horizontally and vertically. These sharply pointing lines help to create a sense of danger.

The major technical difficulty taking this image was the contrast between the snow-capped mountain and the shady field of mountain daisies in the foreground.

The meter gave a difference in exposure of around four stops and I used two graduated neutral density filters to even the tones. I selected a small (f/32) aperture to ensure sharpness in both the foreground and background.

This photograph demonstrates that a standard 'chocolate box' scene can be transformed when the rules of design are applied to the composition. Attention to line gives this picture a sense of dynamism.

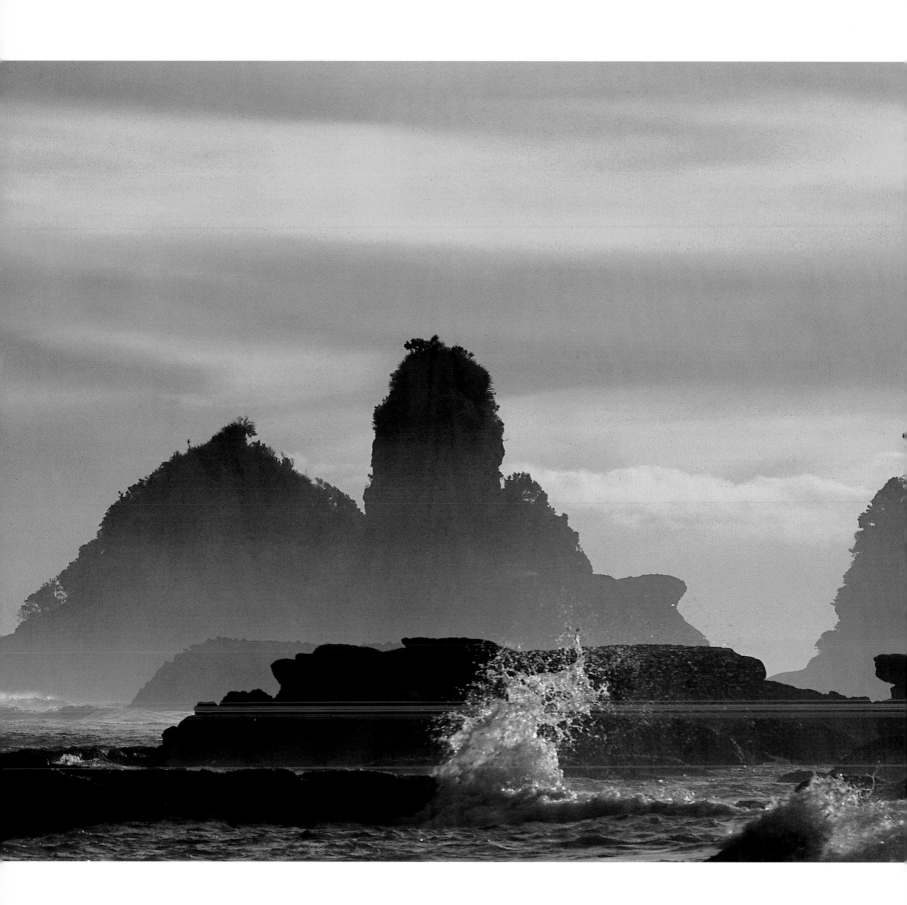

*I*n nature, permanence is a paradox, for nothing in this world is permanent. All living things are part of a cycle of birth, death and rebirth. Ocean tides ebb and flow, mighty ice-shelves are melted by the sun as the seasons come and go, and the planet evolves as nature adapts and re-forms.

The appearance of strength can also be deceiving. Things that seem to be outwardly fragile or delicate can have hidden strength, such as an eggshell or the flow of water, while other things that appear to be mighty can topple with the slightest provocation.

Strength and permanence, therefore, are illusions devised by Mother Nature. The illusion is part of the bewildering, chaotic sense of order that is the essence of nature. As landscape photographers, we purposefully assist it in contriving this magic show, perpetuating the illusion with our images.

For this picture, taken in New Zealand's Paparoa National Park, I have used line as the principal pattern in the landscape. The triangles and polygons form a graphic representation of strength and permanence. The symmetrical placement of the two prominent rocks further enhances the sense of stability, and the silhouette, rendered by the use of back lighting, emphasizes the sense of strength and solidity. To balance the otherwise static nature of the photograph, I waited until the incoming tide produced waves to ricochet off the square boulders in the foreground, giving the picture an added feeling of movement.

In many years' time, this scene may have changed, but the illusion of strength and permanence will remain captured in our photographs.

CW Paparoa National Park, South Island, New Zealand

Nikon F5 with a 200mm lens and 81B filter on a Manfrotto tripod, Fujichrome Provia 100F, 1/25sec at f/8

Vertical lines, provided they are reasonably well-spaced, create a sense of strength; a psychological effect that, as with the impact of diagonal lines, has been appreciated by artists for many years. Unfortunately, it can be surprisingly difficult to find truly vertical lines in a landscape. Even mountains, apparently the ideal subject for conveying the idea of 'strength and permanence', rarely have verticals, and are instead dominated by diagonal lines. Ancient trees with thick trunks might fit the bill but, as soon as you tip the camera back to look up, those parallel verticals suddenly become converging diagonals, which may spoil the intended effect.

There are a number of ways the photographer can manipulate a view to enhance vertical lines. Shooting in portrait format immediately offers you two strong verticals in the frame and emphasizes the height of a vertical subject in the view, while a shift lens will help to reduce the need to tip back the camera. A telephoto lens decreases the impact of diagonals which, otherwise, would fight against the effect of vertical lines. As with calm images, removing confusing detail and including as few colours as possible simplifies the view, thereby concentrating the viewer's attention on the outlines of the image.

In turn, this means that the main subject must have a fairly strong outline to have an impact.

The image here shows an early evening view of some of the famous karst limestone pinnacles of southwestern China, photographed one summer while I was cycling in the area. These remarkable mountains, rearing up abruptly from a series of flat river valleys, are about as vertical as a mountain range can be, and shown in simple outline produce images that suggest great strength and permanence.

In this shot, the use of a standard lens – 110mm is the standard lens for a Mamiya RB67 – has reduced the impact of many of the diagonals, leaving just the very steep, nearly vertical shapes of the mountains. The early evening light was already quite flat and blue, so much of the detail in the view was already disappearing fast, but the addition of a blue filter enhances this effect, resulting in an essentially monochromatic image. The outline of the mountains is the only dominant feature, producing a series of well-spaced, almost vertical lines. The final image, though not devoid of diagonals, has a feeling of strength, conveying the sense of a landscape that is unchanging.

nb Karst limestone pinnacles near Yangshuo, Guangxi province, China

Mamiya RB67 with a 110mm lens and 80B blue filter on a Manfrotto tripod, Fujichrome Velvia, 1/30sec at f/5.6

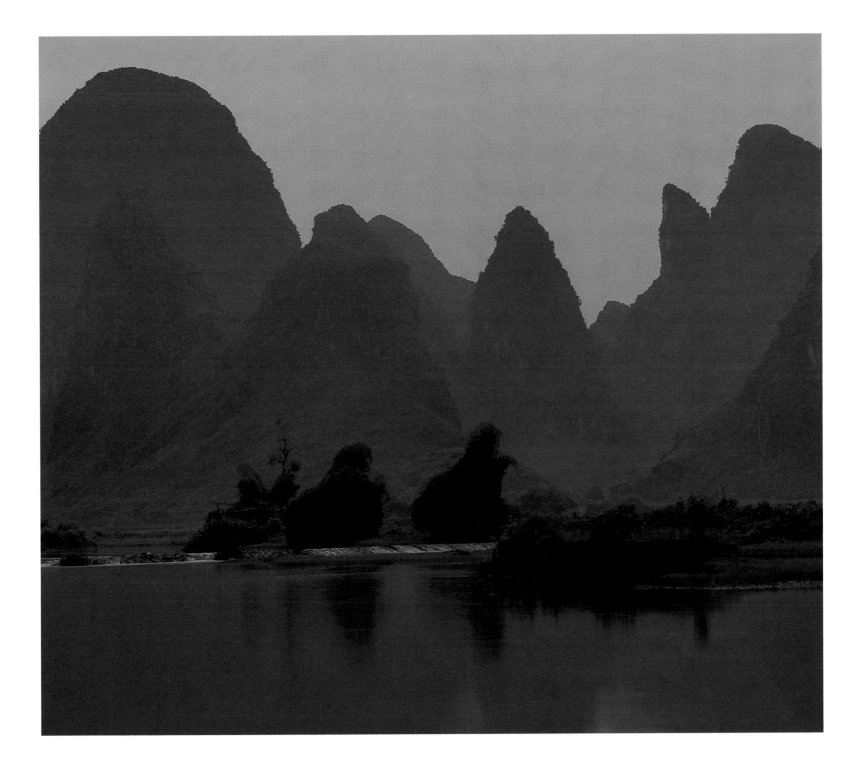

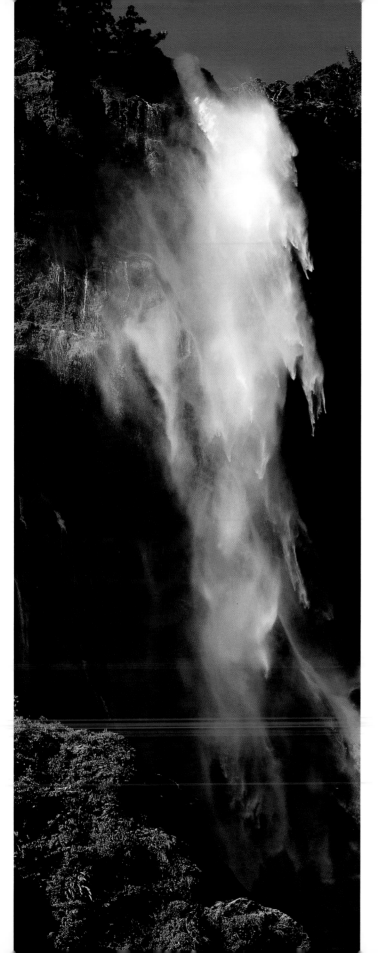

CW Stirling Falls, Milford Sound, Fiordland National Park, South Island, New Zealand

*I*f asked to sum up the foremost theme of this book, it is about seeing. Not simply the way in which our eyes observe and recognize shapes and patterns, but how we visualize the world with our hearts – without which our photographs would be incapable of communicating effectively.

This book demonstrates how we respond in unique, emotional ways to the same physical world, depending on how we perceive the subject. What one photographer 'sees' as a compelling image, another will pass by because he or she can make no heartfelt connection between sight and mind.

As viewers of nature photographs, our senses are overwhelmed when an image creates a connection with memories of moments of beauty already seen and experienced, or when they inspire fresh interpretations that challenge our conventional views of the world. The true art of landscape photography is the photographer's ability to capture in a two-dimensional image the full impact on our senses of a particular scene. For those who believe in 'f/8 and be there', or who allow their cameras to make automatic judgements on their behalf, such compelling images are bound to occur only rarely and by chance.

Powerful landscape images do not occur as a result of aimlessly wandering the planet waiting for meaningful images to appear before our eyes. Knowing the right place to be and the right time to be there is a skill we can learn by developing the ability to pre-visualize events and having the courage to follow the clues of our intuition. In much the same way that a predator knows where to hunt its prey, a successful photographer knows where to find his or her best subjects. Above and beyond the technical ability to take a photograph – knowing the rules of composition, the mechanics of a camera, the relationship between film and light – it is an ability to fully engage our intuitive, emotional brain that is the key to achieving consistent results.

With rare exceptions, all of the photographs in this book were planned events; images taken of a moment in time that encompasses our respective feelings on a particular theme. They are an extended personal statement through which we hope to share the rich diversity of the landscape, not simply as seen with our eyes, but as we experienced them in our heart and minds.

CW After years of indulging his passion for nature and photography, **Chris Weston** became a full-time professional photographer in 1998. A regular contributor to many major photography magazines and a collaborator on numerous photo projects, Chris also runs **Natural Photographic** which operates photographic tours around the world, including Africa, Asia and the Americas.

nh A specialist in travel, landscape and the environment, **Nigel Hicks** has been a full-time photographer and writer since 1990. A contributor to numerous magazines, he is also the established author of several photography titles focusing on the nature and wild places of China and the Philippines, including, among others: *Professional Nature Photography*, *Wild China* (with John MacKinnon, formerly of the Worldwide Fund for Nature), *National Parks & Other Wild Places of the Philippines* and *This Is The Philippines*.

index

Page numbers in **bold** refer to illustrations.

GMC Publications

BOOKS

WOODCARVING

Beginning Woodcarving	GMC Publications
Carving Architectural Detail in Wood: The Classical Tradition	
	Frederick Wilbur
Carving Birds & Beasts	GMC Publications
Carving the Human Figure: Studies in Wood and Stone	Dick Onians
Carving Nature: Wildlife Studies in Wood	Frank Fox-Wilson
Carving on Turning	Chris Pye
Celtic Carved Lovespoons: 30 Patterns	Sharon Littley & Clive Griffin
Decorative Woodcarving (New Edition)	Jeremy Williams
Elements of Woodcarving	Chris Pye
Essential Woodcarving Techniques	Dick Onians
Lettercarving in Wood: A Practical Course	Chris Pye
Making & Using Working Drawings for Realistic Model Animals	
	Basil F. Fordham
Power Tools for Woodcarving	David Tippey
Relief Carving in Wood: A Practical Introduction	Chris Pye
Understanding Woodcarving in the Round	GMC Publications
Woodcarving: A Foundation Course	Zoë Gertner
Woodcarving for Beginners	GMC Publications
Woodcarving Tools, Materials & Equipment (New Edition in 2 vols.)	
	Chris Pye

WOODTURNING

Adventures in Woodturning	David Springett
Bowl Turning Techniques Masterclass	Tony Boase
Chris Child's Projects for Woodturners	Chris Child
Colouring Techniques for Woodturners	Jan Sanders
Contemporary Turned Wood: New Perspectives in a Rich Tradition	
	Ray Leier, Jan Peters & Kevin Wallace
The Craftsman Woodturner	Peter Child
Decorating Turned Wood: The Maker's Eye	Liz & Michael O'Donnell
Decorative Techniques for Woodturners	Hilary Bowen
Green Woodwork	Mike Abbott
Illustrated Woodturning Techniques	John Hunnex
Intermediate Woodturning Projects	GMC Publications
Keith Rowley's Woodturning Projects	Keith Rowley
Making Screw Threads in Wood	Fred Holder
Turned Boxes: 50 Designs	Chris Stott
Turning Green Wood	Michael O'Donnell
Turning Pens and Pencils	Kip Christensen & Rex Burningham
Useful Woodturning Projects	GMC Publications
Woodturning: Bowls, Platters, Hollow Forms, Vases, Vessels, Bottles, Flasks, Tankards, Plates	GMC Publications
Woodturning: A Foundation Course (New Edition)	Keith Rowley
Woodturning: A Fresh Approach	Robert Chapman
Woodturning: An Individual Approach	Dave Regester
Woodturning: A Source Book of Shapes	John Hunnex
Woodturning Masterclass	Tony Boase
Woodturning Techniques	GMC Publications

CRAFTS

American Patchwork Designs in Needlepoint	Melanie Tacon
Bargello: A Fresh Approach to Florentine Embroidery	Brenda Day
Beginning Picture Marquetry	Lawrence Threadgold
Blackwork: A New Approach	Brenda Day
Celtic Cross Stitch Designs	Carol Phillipson
Celtic Knotwork Designs	Sheila Sturrock
Celtic Knotwork Handbook	Sheila Sturrock
Celtic Spirals and Other Designs	Sheila Sturrock
Complete Pyrography	Stephen Poole
Creating Made-to-Measure Knitwear: A Revolutionary Approach to Knitwear Design	Sylvia Wynn
Creative Backstitch	Helen Hall
Creative Embroidery Techniques Using Colour Through Gold	
	Daphne J. Ashby & Jackie Woolsey
The Creative Quilter: Techniques and Projects	Pauline Brown
Cross-Stitch Designs from China	Carol Phillipson

Decoration on Fabric: A Sourcebook of Ideas	Pauline Brown
Decorative Beaded Purses	Enid Taylor
Designing and Making Cards	Glennis Gilruth
Glass Engraving Pattern Book	John Everett
Glass Painting	Emma Sedman
Handcrafted Rugs	Sandra Hardy
How to Arrange Flowers: A Japanese Approach to English Design	
	Taeko Marvelly
How to Make First-Class Cards	Debbie Brown
An Introduction to Crewel Embroidery	Mave Glenny
Making and Using Working Drawings for Realistic Model Animals	
	Basil F. Fordham
Making Character Bears	Valerie Tyler
Making Decorative Screens	Amanda Howes
Making Fabergé-Style Eggs	Denise Hopper
Making Fairies and Fantastical Creatures	Julie Sharp
Making Greetings Cards for Beginners	Pat Sutherland
Making Hand-Sewn Boxes: Techniques and Projects	Jackie Woolsey
Making Mini Cards, Gift Tags & Invitations	Glennis Gilruth
Making Soft-Bodied Dough Characters	Patricia Hughes
Natural Ideas for Christmas: Fantastic Decorations to Make	
	Josie Cameron-Ashcroft & Carol Cox
New Ideas for Crochet: Stylish Projects for the Home	Darsha Capaldi
Papercraft Projects for Special Occasions	Sine Chesterman
Patchwork for Beginners	Pauline Brown
Pyrography Designs	Norma Gregory
Pyrography Handbook (Practical Crafts)	Stephen Poole
Rose Windows for Quilters	Angela Besley
Rubber Stamping with Other Crafts	Lynne Garner
Silk Painting	Jill Clay
Sponge Painting	Ann Rooney
Stained Glass: Techniques and Projects	Mary Shanahan
Step-by-Step Pyrography Projects for the Solid Point Machine	
	Norma Gregory
Tassel Making for Beginners	Enid Taylor
Tatting Collage	Lindsay Rogers
Tatting Patterns	Lyn Morton
Temari: A Traditional Japanese Embroidery Technique	Margaret Ludlow
Trip Around the World: 25 Patchwork, Quilting and Appliqué Projects	
	Gail Lawther
Trompe l'Oeil: Techniques and Projects	Jan Lee Johnson
Tudor Treasures to Embroider	Pamela Warner
Wax Art	Hazel Marsh

GARDENING

Alpine Gardening	Chris & Valerie Wheeler
Auriculas for Everyone: How to Grow and Show Perfect Plants	
	Mary Robinson
Beginners' Guide to Herb Gardening	Yvonne Cuthbertson
Beginners' Guide to Water Gardening	Graham Clarke
Bird Boxes and Feeders for the Garden	Dave Mackenzie
The Birdwatcher's Garden	Hazel & Pamela Johnson
Broad-Leaved Evergreens	Stephen G. Haw
Companions to Clematis: Growing Clematis with Other Plants	
	Marigold Badcock
Creating Contrast with Dark Plants	Freya Martin
Creating Small Habitats for Wildlife in your Garden	Josie Briggs
Exotics are Easy	GMC Publications
Gardening with Hebes	Chris & Valerie Wheeler
Gardening with Wild Plants	Julian Slatcher
Growing Cacti and Other Succulents in the Conservatory and Indoors	
	Shirley-Anne Bell
Growing Cacti and Other Succulents in the Garden	Shirley-Anne Bell
Hardy Palms and Palm-Like Plants	Martyn Graham
Hardy Perennials: A Beginner's Guide	Eric Sawford
Hedges: Creating Screens and Edges	Averil Bedrich
The Living Tropical Greenhouse: Creating a Haven for Butterflies	
	John & Maureen Tampion
Marginal Plants	Bernard Sleeman

Orchids are Easy: A Beginner's Guide to their Care and Cultivation	
	Tom Gilland
Plant Alert: A Garden Guide for Parents	Catherine Collins
Planting Plans for Your Garden	Jenny Shukman
Plants that Span the Seasons	Roger Wilson
Sink and Container Gardening Using Dwarf Hardy Plants	
	Chris & Valerie Wheeler
The Successful Conservatory and Growing Exotic Plants	Joan Phelan
Success with Orchids in the Greenhouse and Conservatory	
	Mark Issac-Williams
Tropical Garden Style with Hardy Plants	Alan Hemsley
Water Garden Projects: From Groundwork to Planting	
	Roger Sweetinburgh

PHOTOGRAPHY

Close-Up on Insects	Robert Thompson
Double Vision	Chris Weston & Nigel Hicks
An Essential Guide to Bird Photography	Steve Young
Field Guide to Bird Photography	Steve Young
Field Guide to Landscape Photography	Peter Watson
How to Photograph Pets	Nick Ridley
In my Mind's Eye: Seeing in Black and White	Charlie Waite
Life in the Wild: A Photographer's Year	Andy Rouse
Light in the Landscape: A Photographer's Year	Peter Watson
Outdoor Photography Portfolio	GMC Publications
Photographing Fungi in the Field	George McCarthy
Photography for the Naturalist	Mark Lucock
Viewpoints from Outdoor Photography	GMC Publications
Where and How to Photograph Wildlife	Peter Evans

ART TECHNIQUES

Oil Paintings from your Garden: A Guide for Beginners	Rachel Shirley

MAGAZINES

WOODTURNING ◆ WOODCARVING
FURNITURE & CABINETMAKING
THE ROUTER ◆ NEW WOODWORKING
THE DOLLS' HOUSE MAGAZINE
OUTDOOR PHOTOGRAPHY
BLACK & WHITE PHOTOGRAPHY
TRAVEL PHOTOGRAPHY
MACHINE KNITTING NEWS
BUSINESSMATTERS

The above represents a full list of all titles currently published or scheduled to be published.
All are available direct from the Publishers or through bookshops, newsagents and specialist retailers.
To place an order, or to obtain a complete catalogue, contact:

**GMC Publications,
Castle Place, 166 High Street, Lewes, East Sussex BN7 1XU, United Kingdom
Tel: 01273 488005 Fax: 01273 478606
E-mail: pubs@thegmcgroup.com**

Orders by credit card are accepted